ELVIS PRESLEY
TREASURES

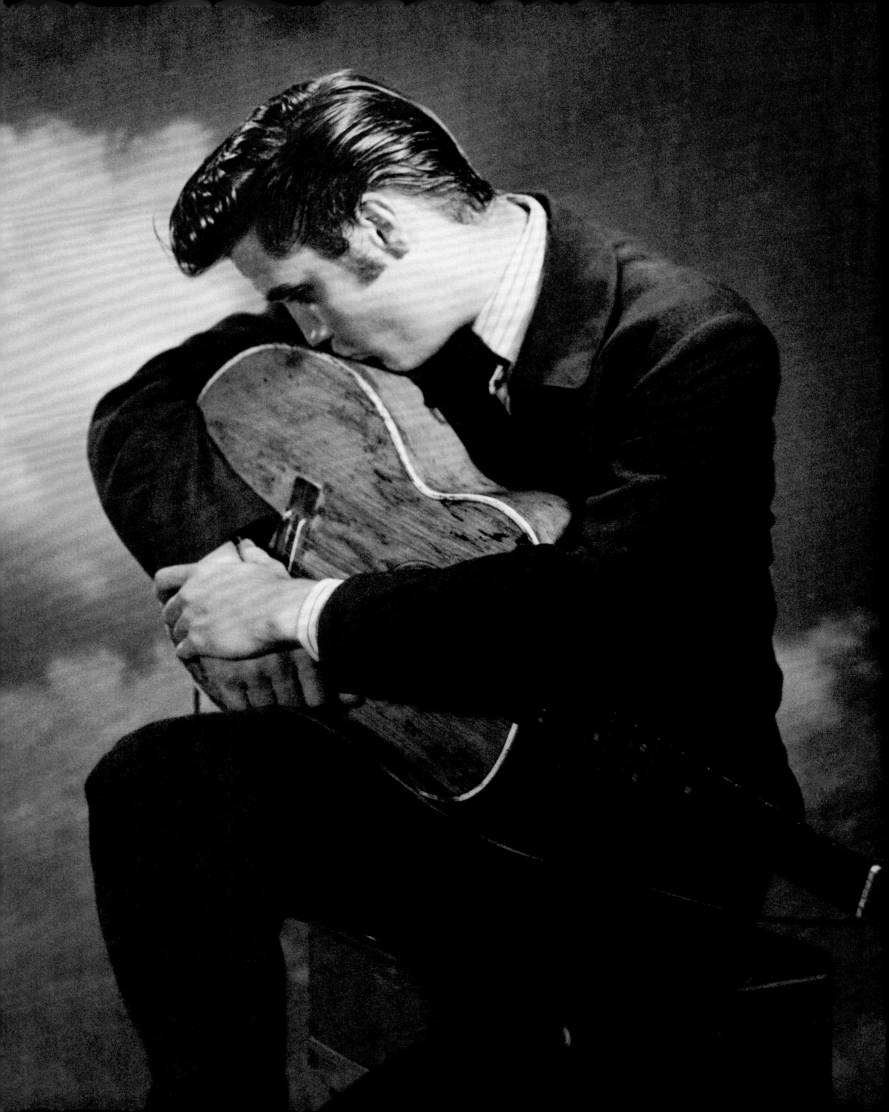

ELVIS PRESLEY
TREASURES

The Story of the King of Rock 'n' Roll
Told Through His Personal Mementos

Gillian G. Gaar

weldon**owen**

CONTENTS

**INTRODUCTION
BY ANGIE MARCHESE** 7
Vice President of Archives and Exhibitions
Elvis Presley's Graceland

PART 1
EARLY LIFE 8

PART 2
BECOMING ELVIS 32

PART 3
MAKING IT BIG 48

PART 4
ELVIS AT HOME 88

PART 5
BECOMING A LEGEND 120

PART 6
THE KING'S PERSONAL STYLE 144

PART 7
ELVIS OFFSTAGE 168

PART 8
HONORING THE KING 196

THE ELVIS CHRONOLOGY 208
A Timeline of Elvis's Life and Legacy

DISCOGRAPHY 216

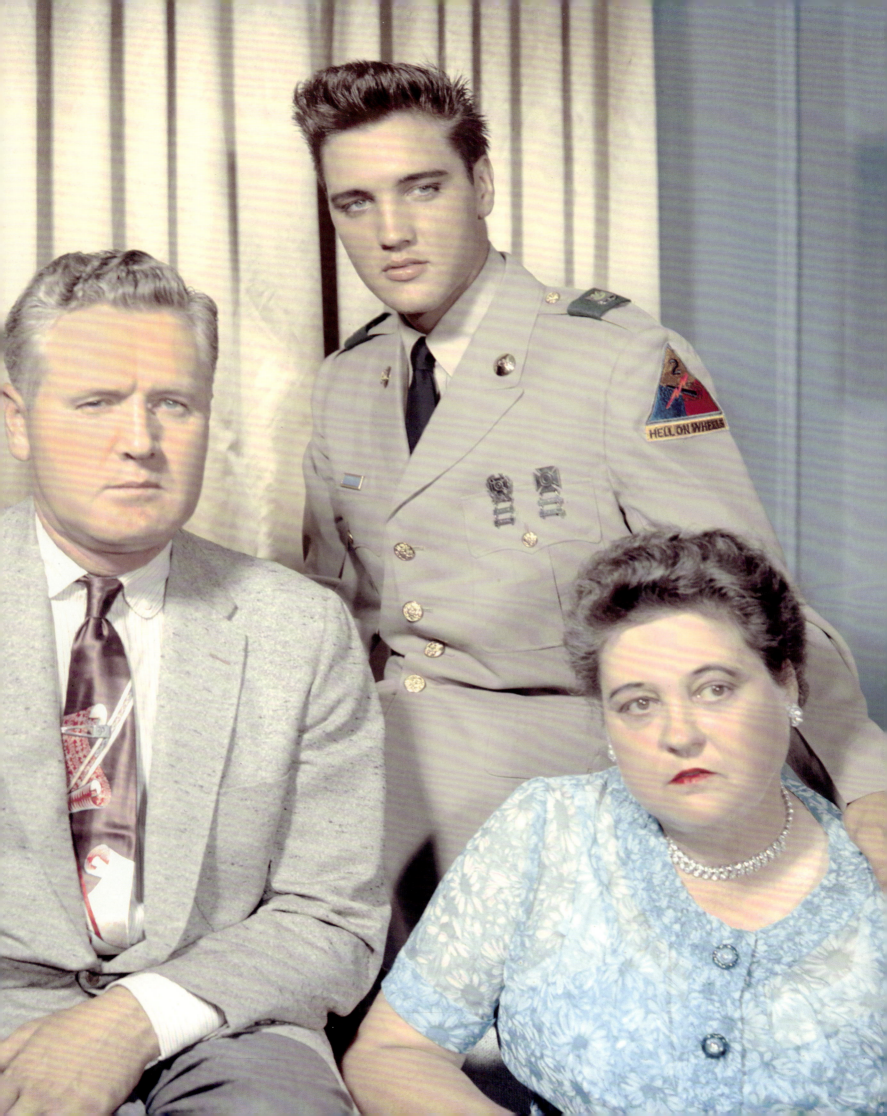

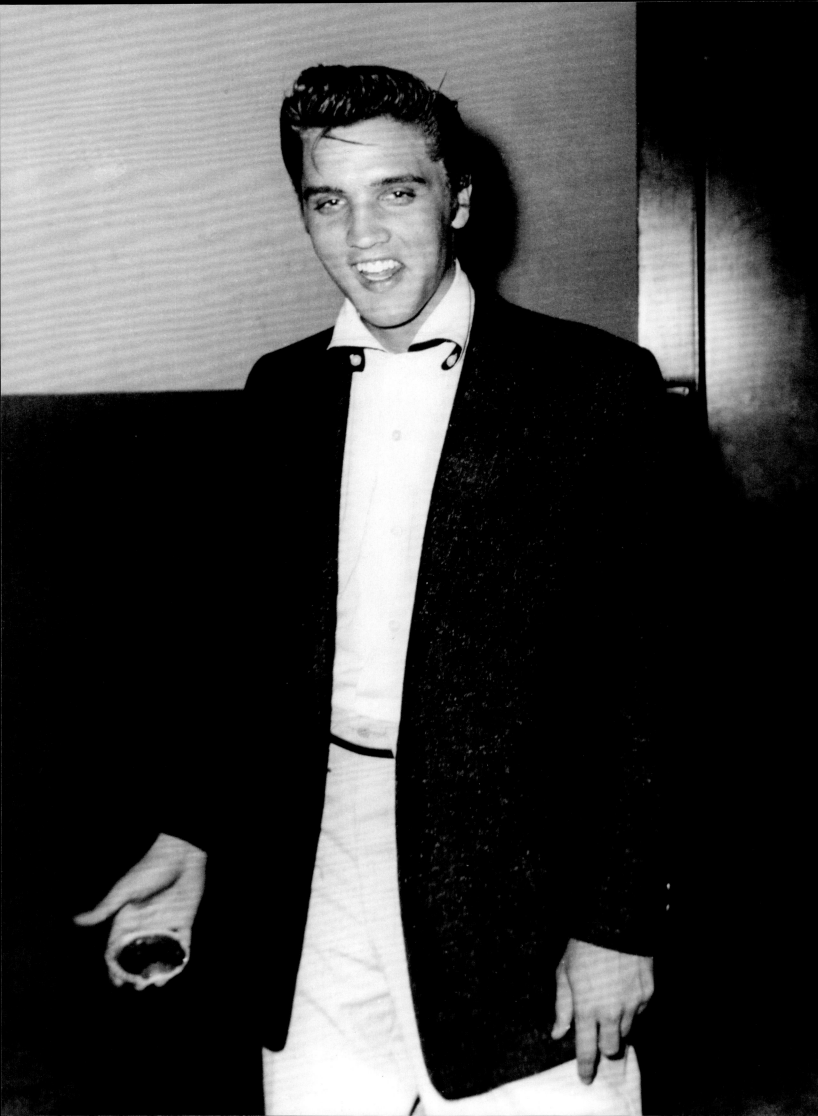

INTRODUCTION

Elvis Presley continues to be one of the most prolific artists and entertainers the world has known. His music transcends time. His influence is still felt nearly 47 years after his passing. Since his passing in 1977, Graceland, the home he purchased in 1957, has become the center of the Elvis world. Beyond the fantastic rooms and all the treasures and wonders within, there's just something in the air, a presence of warmth, in this special place. A feeling that makes even the most casual visitor feel as though he is dropping in on a dear old friend.

The Graceland Archives is a treasure trove housing more than 1.5 million artifacts. It is through these items that it is still possible to get close to Elvis Presley, to understand who he truly was, both as an artist and as a person. These artifacts are not just old photographs, documents, clothes, and cars. These items tell a story, each piece capturing a moment in time. Each one giving you a direct connection to the icon that is Elvis Presley. Elvis was an influencer before influencers were a thing. Through his music, he transformed an entire industry. Through his sense of style, he shaped the way a generation dressed, walked, and even wore their hair—trends that are still very relevant today.

As archivists, we are also storytellers. Through our archives and collections, we keep the past alive by preserving and, most of all, by sharing the stories these objects represent. We do this through amazing exhibits, experiences, and projects such as this book. Preserving the past, rekindling memories, and creating new ones—this is what we do, it is who we are. The artifacts chosen for this project all have a story to tell. They document a life lived to its fullest and tell the story of a young boy from Tupelo, Mississippi, who will forever be known as the King of Rock 'n' Roll. They also offer a glimpse of Elvis the man, the son, the father, the friend. The Elvis that only a few got to experience behind the gate of Graceland. Elvis put so much of himself into his work and communicated so much with his audience on an intimate level. Being able to share part of the Graceland Archives with you is a great honor. I hope that through this book you discover who Elvis Presley was and why he continues to be a major influence on pop culture today.

Angie Marchese
Vice President of Archives and Exhibitions
Elvis Presley's Graceland

Page 2: *Love Me Tender* press photo, 1956.

Page 5: Elvis with his parents, Vernon and Gladys, 1958.

Opposite page: Elvis enjoying his second lemon tart, backstage in Richmond, Virginia, 1956.

Following page: Elvis with (from left) Dixie Locke, Bessie Wolverton, and his cousin, Gene Smith, at the Southside High School's junior prom, May 6, 1955.

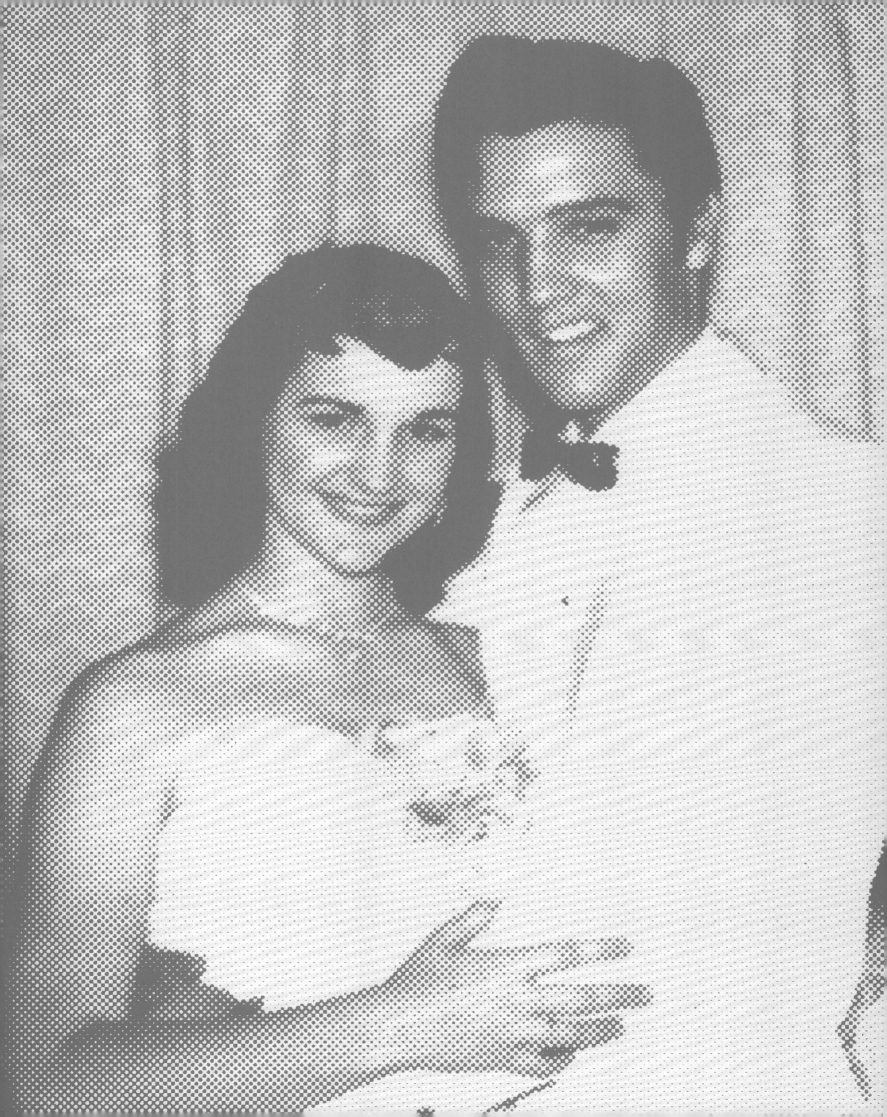

PART 1 EARLY LIFE

▼ *FAMILY BIBLE* ▼

A FAMILY'S FAITH

A family Bible is more than just a representation of one's faith. It could be, perhaps, one of the few books a family owned, perhaps the only book a family owned. It could be an heirloom, passed down from generation to generation. It could be a record of family life, with important dates—births, deaths, marriages—often written down in it. The Bible is more than just a book. It's a part of a family's history.

Which is why people don't replace the family Bible. It stays with them. And the creases and folds, and the way the finish is worn off on the leather cover of this Bible, owned by Elvis's father, Vernon, reveals what a much-loved family possession this Bible was. Elvis began attending church when he was around two years old (a year younger than he is in the photo here where he's seen with Vernon and his mother, Gladys) and maintained an interest in religion throughout his life. He prided himself on his knowledge of the Bible, an education that began with him studying the pages of this book.

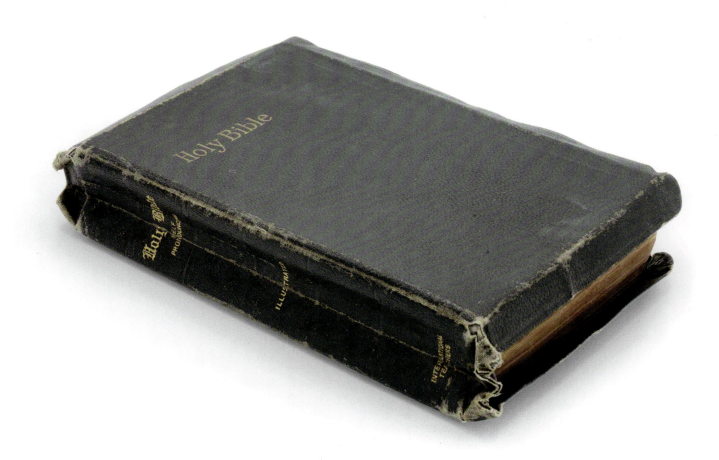

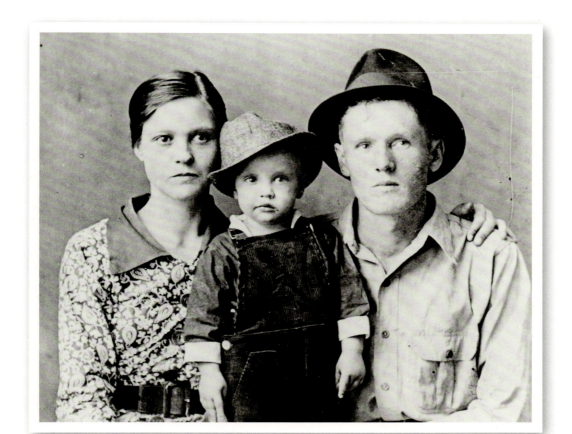

A three-year-old Elvis with his parents, 1938.

VERNON'S POSTCARD FROM PRISON

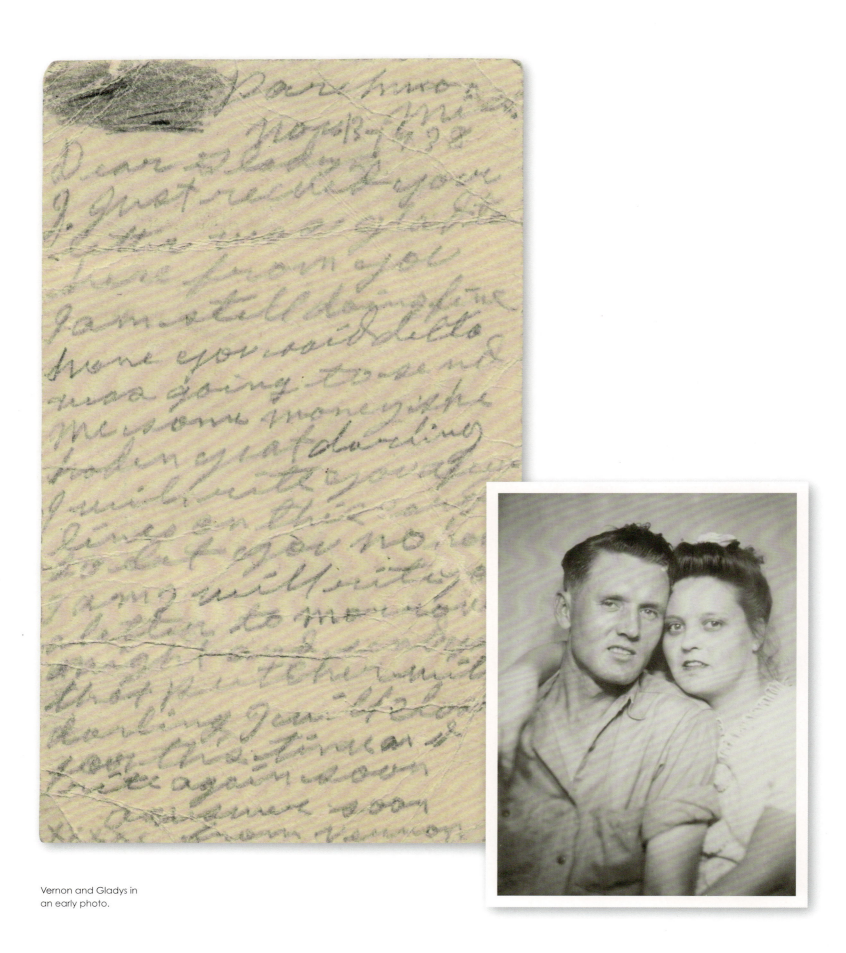

Vernon and Gladys in an early photo.

THE LIFELINE BETWEEN LOVED ONES

In May 1938, Vernon Presley was sent to Parchman Farm prison in Mississippi for altering, and then cashing, a check. It wasn't an easy time for the Presley family; Gladys and Elvis had to leave their home and move in with relatives. But they also kept Vernon's spirits up by visiting him most weekends. They also exchanged letters and postcards, something that provided a lifeline to families that were separated. When Vernon wrote this postcard on November 13, 1938, he filled up every bit of precious space that he could. After acknowledging that he had received Gladys's latest letter, he asks about the possibility of his sister Delta Mae Presley sending him some money. Touchingly, though Vernon is the one is prison, he assures his wife "I am doing fine" and adds that he will write her the next day. Happily, Vernon's sentence was commuted after eight months, and he was reunited with his family on February 6, 1939.

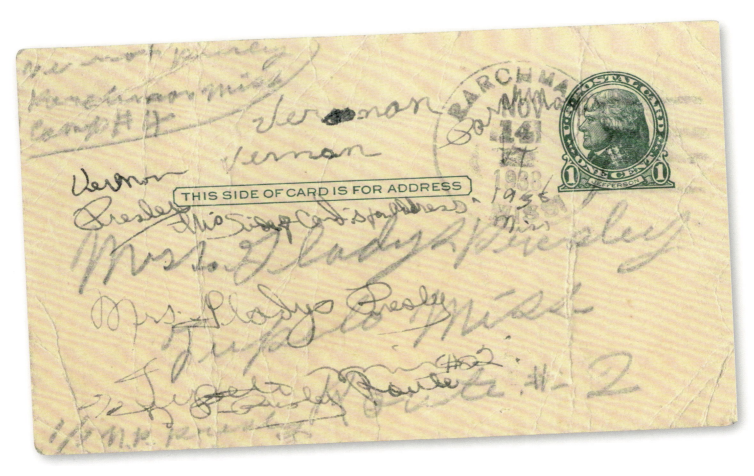

▼ *VERNON'S TAX RETURN* ▼

REPORTING TO UNCLE SAM

Vernon's tax return for 1943 showed the "Pressley" household income was $1,232.88, more than minimum wage (which was 30 cents an hour), but less than the average yearly income for the time (around $1,900). Vernon worked hard to support his family. As 1943 began, he was working for the Dunn Construction Company in Millington, Tennessee, going home to Tupelo on weekends. He next worked for the Pepsi Cola Bottling Company in Tupelo, then moved the family to Pascagoula, Mississippi, where he worked at the Moss Point Shipyard alongside his cousin, until both families moved back to Tupelo. Vernon then found work as a truck driver for L. P. McCarty and Sons. Vernon's and Gladys's jobs were low-paying, and frequently short-lived. Eventually, the search for better jobs would send the family north. The Presleys would make the move to Memphis in 1948.

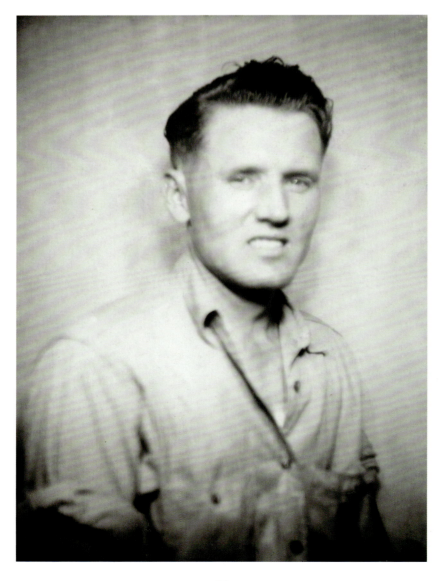

Vernon Presley.

READ THIS FIRST: You probably have paid a substantial part of your 1943 tax bill through withholding or directly to the government. You may have *underpaid* or *overpaid*. File this form. It tells you and your government whether you owe any more, or are entitled to any refund.

Treasury Dept., Internal Revenue Service
FORM 1040 A

OPTIONAL U. S. INDIVIDUAL INCOME AND VICTORY TAX RETURN · CALENDAR YEAR 1943

[This form *may* be used instead of Form 1040 if gross income is not more than $3,000 and is *only* from the sources stated in items 1 and 2 below.]

Do not write in these spaces
Serial No.
Amount paid, $
(Cashier's stamp)

NAME: VERNON E. PRESSLEY
Please print. If this return is for a husband and wife, use both first names.

ADDRESS: TUPELO, MISSISSIPPI
Print street and number or rural route. City or town. State

OCCUPATION: _____ Social Security No. (if any): 425-26-8732 Cash—Check—M. O.

Your Income

1. Enter the TOTAL amount, before deductions for taxes, dues, insurance, bonds, etc., that you received in 1943 as salary, wages, bonuses, commissions, etc. (Members of armed forces read instruction 6)

List Employer's Name	City and State	Amount
L. P. McCarty & Son	Tupelo, Miss.	$539.60
Moss Point Shipyard	Moss Point, Miss.	352.50
Pepsi-Cola Bottling Co.	Tupelo, Miss.	89.50
Dunn & Smart Cons. Co.	Millington, Tenn.	251.28

2. Enter here any amounts you received in 1943 in dividends, interest, and annuities.....

3. Now add items 1 and 2 to get your TOTAL INCOME and enter it here.............. 1,232.88

Your Credit for Dependents

4. List the persons—other than wife or husband—who on July 1, 1943, obtained their *chief support* from you if they were not yet 18, or were mentally or physically unable to support themselves.

Name of Dependent	Relationship	If 18 years or over, give reason for listing
Son		

You are allowed a credit of $385 for each dependent. However, if you are not a married person living with wife or husband, you may nevertheless be the head of a family as defined in No. 6 on the other side of the form. If you are the head of a family *only because of the dependents you listed above*, allow $385 for each listed dependent *except one*. Enter total dependency credit here......... 385.00

5. Subtract item 4 from item 3. Enter the difference here. (Enter item 3 if item 4 is blank) 847.88

Your Tax Bill and Forgiveness

6. Turn over this form and check the box at the top which applies to you. Then, using the figure you entered in item 5, find your income tax in the table. Enter the amount here.......... none

7. In the space on the back of this form, figure your Victory tax on item 3. Enter the tax here..... 17.66

8. Now add items 6 and 7. Enter the total here................... 17.66

9. If you filed a tax return on 1942 income, enter the amount of tax here. However, before entering anything, read *carefully* instruction 4.................... none

10. Enter item 8 or item 9, whichever is larger.................. 17.66

11. FORGIVENESS FEATURE: Don't fill in A, B, and C below if either item 8 or 9 is $50 or less.

 A Enter item 8 or 9, whichever is smaller..............
 B Take three-fourths of A above. Enter this amount or $50, whichever is larger. This is the *forgiven* part of the tax....
 C Subtract B from A. This is the *unforgiven* part of the tax. Enter it here....

12. Add item 10 to the amount in item 11C, if any. Enter the total here. This is your total income and Victory tax..................................... 17.66

What You've Paid and What You Owe

13. **A** Enter here your income and Victory taxes withheld by your employer.... 30.22
 B Enter here the total sums you paid last year on your 1942 income tax bill...
 C Enter here any 1943 income tax payments last September and December...
 D Now add the figures in A, B and C and enter the total here........... 30.22

14. If the tax in item 12 is more than the total payments in item 13, you owe the difference. Enter it here. If the payments are greater, write "NONE" and skip items 15 and 16......

Terms of Payment or Refund

15. You may postpone, until not later than March 15, 1945, payment of the amount you owe up to one half of item 11C. Enter the postponed amount here........................

16. Enter the amount you are paying with this return (subtract item 15 from item 14).......

17. If the TOTAL of your 1943 payments (item 13) is larger than your tax (item 12), enter the difference. You have overpaid your 1943 tax by this amount................ 12.56

Check (√) what you want done: Refund it to me ☐ Credit it on my 1944 estimated tax ☐

I declare under the penalties of perjury that this return has been examined by me, and to the best of my knowledge and belief, is a true, correct and complete return.

Date_____, 1944 (Signature)_____ (Signature)_____
(If this return includes income of both a husband and wife, it must be signed by both)

TOLD BY UNCLE REMUS *LIBRARY CARD*

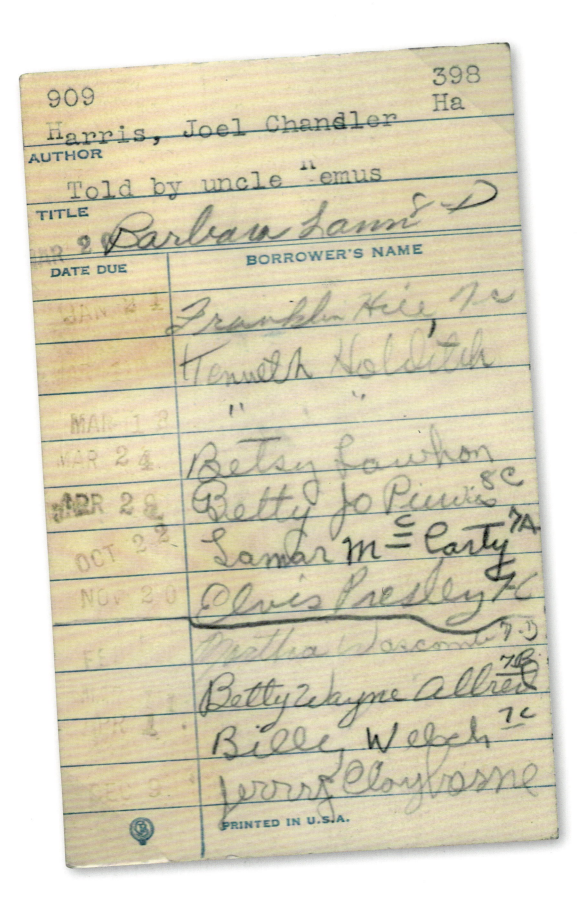

THE YOUNG READER

Elvis was an avid reader from a young age, and remained one throughout his life. This library checkout card (which listed who had checked out the book and when it was due back) shows that he was the seventh person to check out a copy of *Told By Uncle Remus* from his local library, one of the many collections of author Joel Chandler Harris's classic short stories. Libraries were an especially welcome resource for families who couldn't afford to buy their own books, and Elvis was a regular visitor.

Elvis (second row from top, far right) in his sixth grade class photo, 1947.

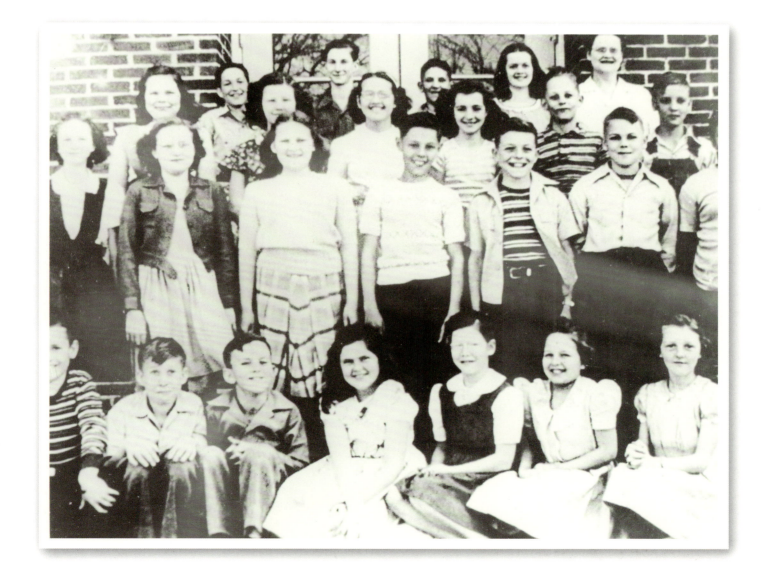

▼ CRAYOLA BOX OF CRAYONS ▼

THE COLORS OF THE RAINBOW

Elvis's family didn't have much money when he was growing up in Tupelo, so he treasured the few possessions he did have. Many children are given boxes of crayons to draw with, but Elvis made sure to keep his box in good condition. He also carefully wrote his name on the box not just once, or twice, but three times—clearly, he wanted anyone who picked it up to know that this was *his* box of crayons! Crayola Crayons were first sold in 1903, in boxes ranging from six to thirty different-colored crayons, and they remain a popular gift item for children to this day.

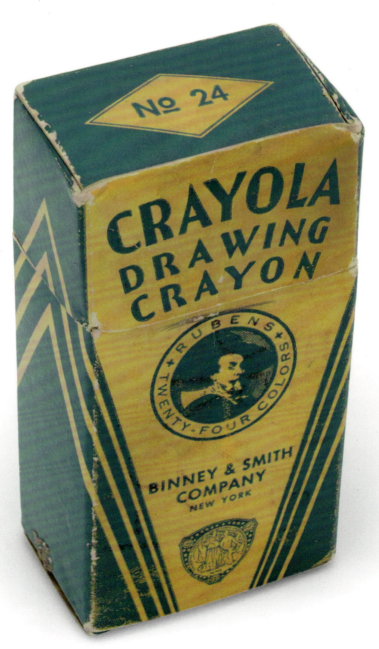

CRAYOLA
REG. U. S. PAT. OFF.
GOLD MEDAL CRAYON

For stenciling trace or draw design on fabric. Fill design areas with CRAYOLA. Remove loose particles with point of knife. Place color side down between layers of glazed paper. Apply a hot iron for a moment or two lifting the iron after each application. Do not move iron across design as this may cause

A MOTHER'S TREASURED PICTURES

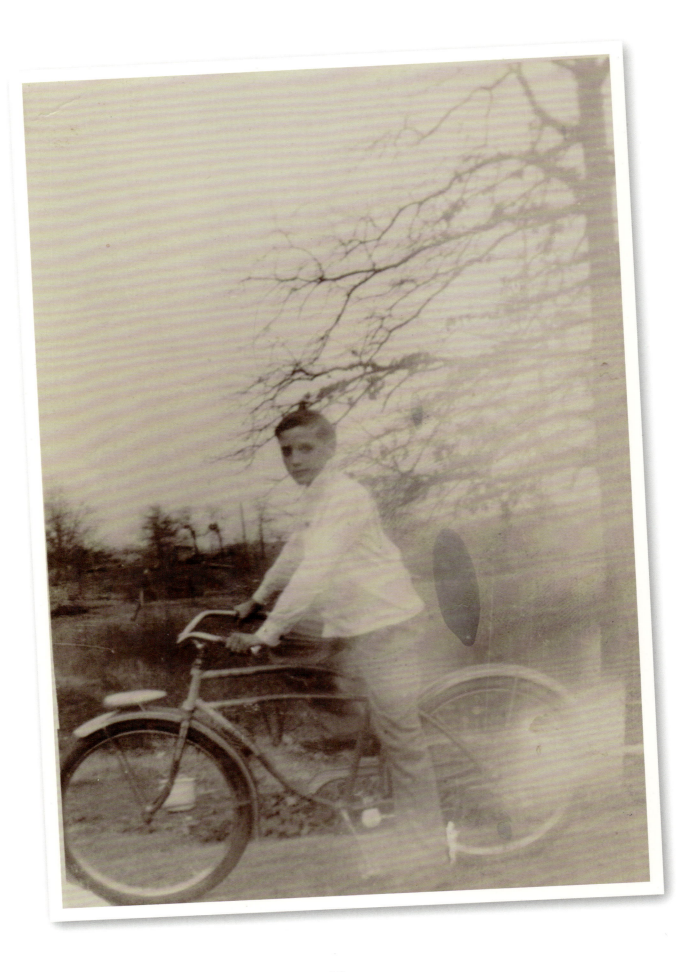

A BOX OF MEMORIES

These days, when people can see the pictures they take instantly, and walk around with hundreds of images on their cell phones, it easy to forget that there was a time when a photograph was a very precious item. Many families couldn't afford to buy a camera, let alone pay for the additional expenses of purchasing film, paying to have it developed, and getting a photo album or frame to display the picture.

The Presleys didn't own a camera when Elvis was growing up. So, photos of him before his career took off are precious. The few photos the family had were carefully stored by Elvis's mother in a shoebox. The box held photos such as this school photo of Elvis, taken by a professional photographer when he was in the seventh grade; he turned thirteen during the school year. The photo at the left shows shows Elvis on his beloved bicycle, which he would race around at high speed, to his mother's dismay (she was afraid he might get hurt). Who knows how many times Gladys took these pictures out to look at, marveling as she watched her boy growing up. Even after money was no longer an issue and she could buy as many photo albums as she wanted, she saved this box and these photos—treasured memories from another time.

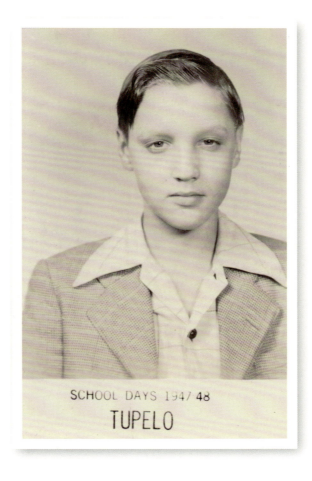

▼ *HIGH SCHOOL CLASS PHOTO, MORTARBOARD TASSEL, DIPLOMA* ▶

HIGH SCHOOL DAYS

Elvis's first day at Humes High was November 8, 1948, when he entered the eighth grade. During his years at Humes, he would meet a few people who would remain good friends throughout his life, such as George Klein, who became a Memphis DJ and television personality. And one of the proudest days of his life was when he received his diploma at Humes High School's graduation ceremony on June 3, 1953. The ceremony was held at Ellis Auditorium downtown, where Elvis had frequently gone to see the All-Night Gospels Singings held at the venue. Elvis probably got a little thrill knowing he was walking on the same stage where he'd seen such acts as the Statesmen and the Blackwood Brothers perform. Elvis's grades marked him as an average student, but he was also the first member of his family to graduate from high school. His mother saved the ceremony's program and tassel from his mortarboard, and his diploma took pride of place on display in the family home. In the picture of Humes High's Class of 1953, Elvis is in the second row from the bottom, in the middle of the row.

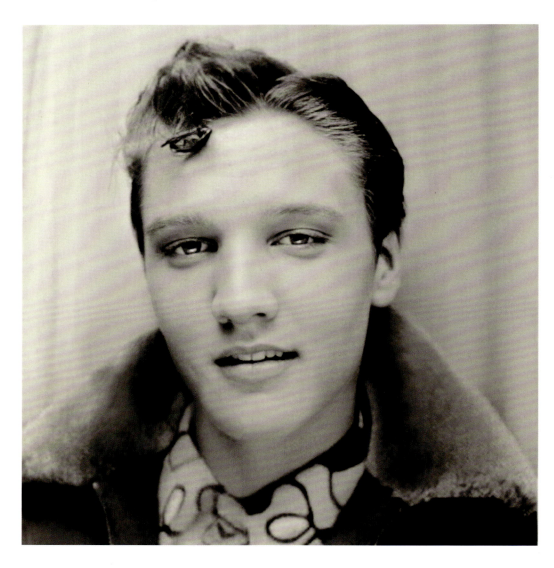

A seventeen-year-old Elvis in a photobooth picture, Memphis, 1952.

22

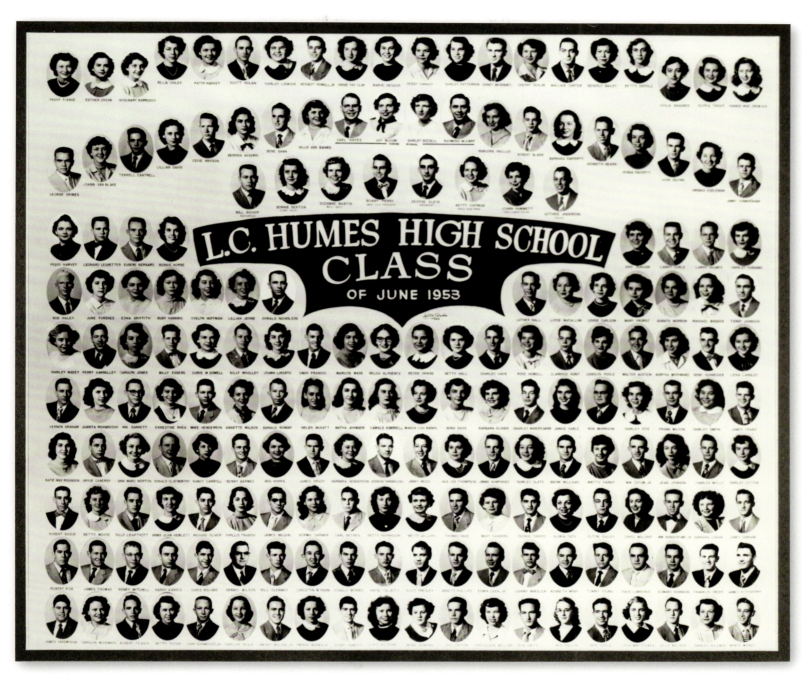

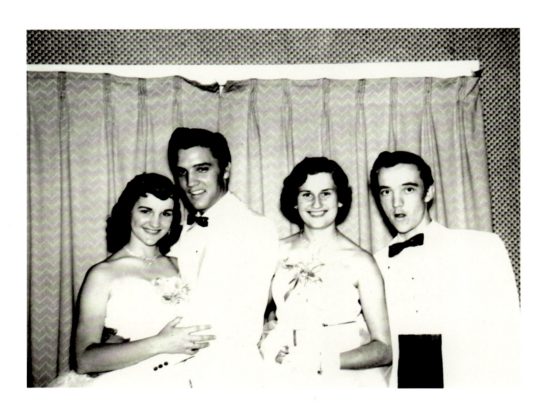

Elvis with (from left) Dixie Locke, Bessie Wolverton, and his cousin, Gene Smith, at the Southside High School's junior prom, May 6, 1955.

BLACKWOOD BROTHERS HANDBILL

HEAR THEM

RECENTLY RE-ORGANIZED

BLACKWOOD BROS. GOSPEL QUARTET

AT ELLIS AUDITORIUM AUG. 27

—IN—

Sunday School Sing

9:40 A. M. AUGUST 29, 1954

First Assembly of God

1084 E. McLEMORE

(1,000 FREE SEATS)

- your choice of a Blackwood record FREE for bringing 3 visitors

(OVER)

MUSIC IN A TIME OF NEED

Elvis Presley had loved the Blackwood Brothers gospel singing group since he was a teenager. And he was thrilled when the group, originally formed in Choctaw County, Michigan, in 1934, relocated to Memphis in 1950, where Elvis was living. Now he'd have even more opportunity to see them. Especially since he attended the same church the group did, the Assembly of God in South Memphis; when the group wasn't on the road, they frequently performed at the church. The group also had an auxiliary group, the Songfellows, formed by another member of the family. Elvis auditioned for the Songfellows, but was turned down.

This handbill is for a performance following a tragedy that befell the group. While on tour, two members of the group died in a plane crash on June 30, 1954. The funeral, held the next day, with Tennessee governor Frank Clement on hand to deliver the eulogy, was the largest in Memphis history. After grieving their loss, the surviving members of the group decided to continue. Elvis attended the funeral with his girlfriend, Dixie Locke, and likely attended this show as well. He later arranged to have the Blackwood Brothers perform at his mother's funeral.

EMPLOYMENT APPLICATION

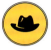 SEEKING GAINFUL EMPLOYMENT

Even before he graduated, Elvis was preparing for life beyond high school, when he expected he would be joining the workforce fulltime. He filled out this card at his local employment office on March 26, 1953; his caseworker's remarks noted that he wanted to find work immediately to "help Father work off financial obligations." Among his courses and training he listed "Woodshop, 3 years" and "ROTC, 2 years." His caseworker described him as "Rather flashily dressed—'playboy' type;" even then, his dress sense made him stand out. But the caseworker also noted his good nature underlying the flash: "has worked hard past three summers, wants a job dealing with people." For "Leisure time activities," Elvis wrote: "Sings, playing ball, working on car, going to movies." "Sings"—Elvis had listed his ultimate occupation without even realizing it.

Elvis with friends outside of the Lauderdale Courts apartments during his high school years, c. 1953.

DO NOT WRITE BELOW THIS LINE

SPECIAL INFORMATION

Speech club
Biology Club
Wants factory work at once — must help father work off financial obligations.

Owns an automobile.

EMPLOYMENT & COUNSELING STATEMENT

Making occupational choice. Took tests for clues. GATB scores indicate applicant mechanically inclined, but should avoid fine works with fingers. Plan Appl. not too interested in machinist appr. but thought might like industrial maint & repair. 8-3-53 Expressed desire for a job where he could keep clean. 4-6-54 Reevaluation by Appl. Thinks maint. appr. job would be fine — Really wants to operate "big lathes".

LEISURE TIME ACTIVITIES

Sings, playing ball, working on car, going to movies.

COMMENTS

Rather flashily dressed — "playboy" type denied by fact has worked hard past 3 summers. Wants a job dealing with people.

INTERVIEWER: Neis M. Harris

DO NOT WRITE BELOW THIS LINE

1. PRINT LAST NAME: Presley	FIRST: Elvis MIDDLE: Aron	
5. SOC. SEC. NO.: 409 52 2002		
2. ADDRESS: 462 Alabama	4. TELEPHONE NO.: 37-4185	
6. DATE OF BIRTH: Jan 8 1935	7. SINGLE	
8. HEIGHT: 5 ft 11 in	9. WEIGHT: 150	10. WHITE
12. DO YOU HAVE: TOOLS — ; LICENSE YES; AUTOMOBILE YES		
14. EDUCATION: High School 4		

Humes H.S. — 53
Speech 2 yrs.
Woodshop 3 yrs.
ROTC 2 yrs.
Science 2 yrs.

TITLES / CODES:
Multiple Spindle Drill Press 6-78.081
All Around Mech. Rpr. 4-82.100
Public Contact 1-x5.

SKILLS, KNOWLEDGE, ABILITIES
614

DATES:
5-6-53
7-1-53
8-3-53
6-4-54 Tue
6-21-54

Pub Contact malpr.
PC 1-x5, 4-x2.4

TEST RESULTS
3-26-53
GATB Forms 1, 9, 11, 13, 15, 16, 19
G V N S P Q A T F M
128 104 102 133 45 120 101 70 108

WILLING TO LEAVE CITY ☐YES ☑NO
WILLING TO LIVE AT WORK ☐YES ☑NO

FORM ES-511 (6/22/48) — APPLICATION CARD — TENNESSEE DEPARTMENT OF EMPLOYMENT SECURITY

CROWN ELECTRIC PAY STUB

CROWN ELECTRIC COMPANY, Inc.

Elvis Presley
NAME OF EMPLOYEE

DATE OF PAY 6-4-54

PAY ENDING 6-2-54

40 HOURS @ 1.00 $ 40.00

3 OVERTIME HOURS @ 1.50 $ 4.50

GROSS PAY $ 44.50

LESS FED. TAX I.C.A. 89

WITHHOLDING TAX 5.70

INSURANCE

TOTAL DEDUCT $ 6.59

NET PAY $ 37.91

DETACH THIS STATEMENT FOR YOUR RECORDS

A WORKING MAN

Elvis held a number of jobs before performing became his main occupation. On April 20, 1954, he began working at the Crown Electric Company. The owners, James and Gladys Tipler, were given a heads-up by the employment office when Elvis was sent over for an interview: "Don't be fooled by his appearance." Elvis's hair was longer than most, but the Tiplers found him polite and respectful and hired him to be a truck driver, delivering supplies to building sites around town. This pay stub shows net earnings of $37.91 for the week ending June 2, 1954. Elvis always handed over his paychecks to his father, keeping only enough to take care of his expenses for the following week; gas money, and a bit extra to take his date to the movies and out for a hamburger. It was the last steady job Elvis would have before his career took off.

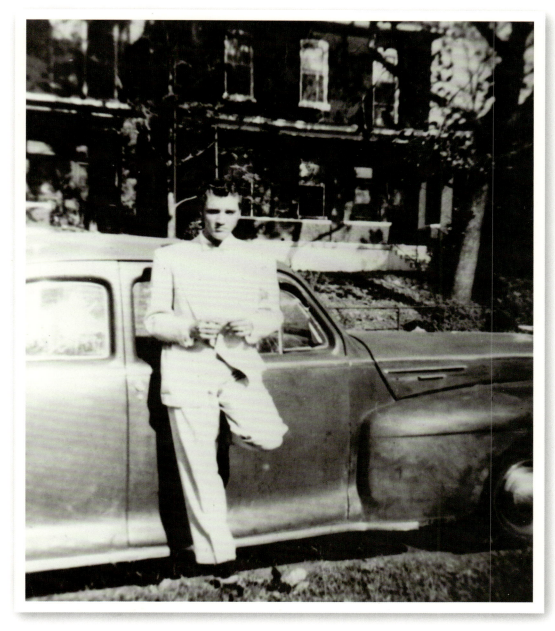

Elvis c. 1954.

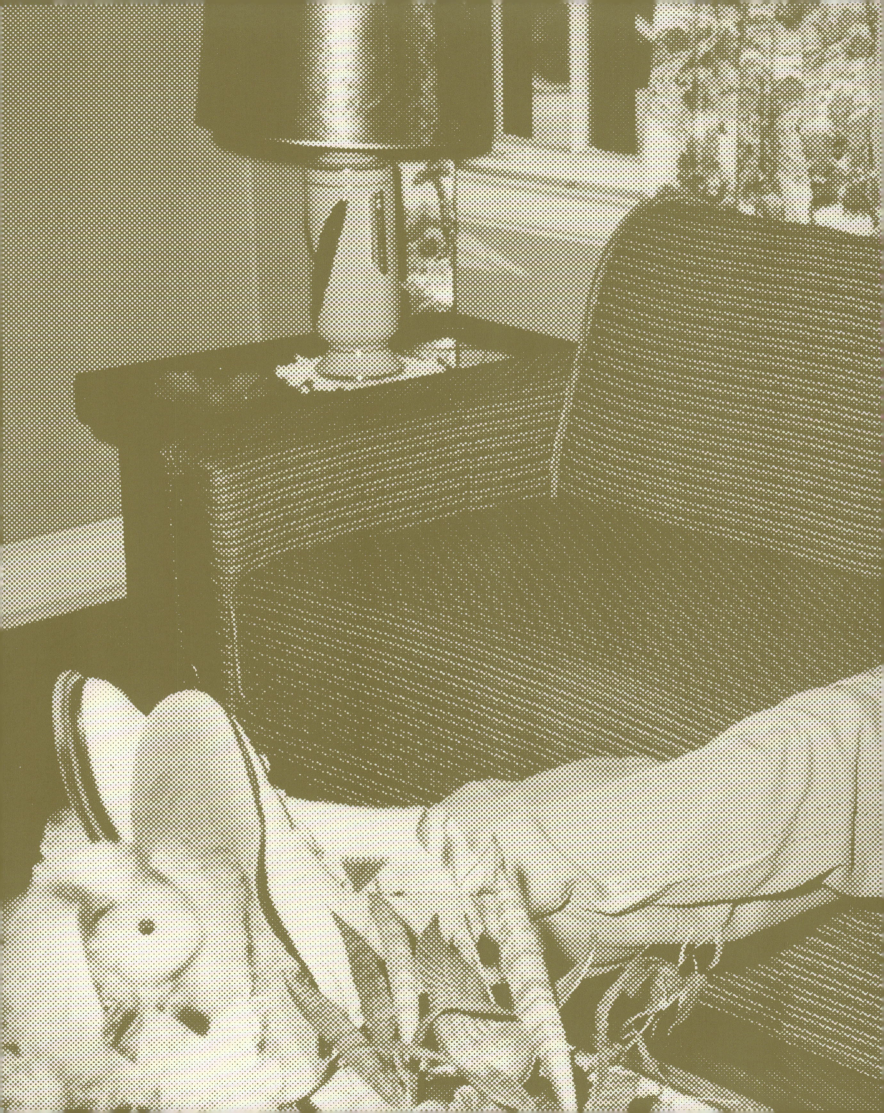

PART 2 BECOMING ELVIS

TELEGRAM FROM ELVIS TO VERNON

CHECKING IN FROM THE ROAD

Once Elvis released his first record in July 1954, things began moving quickly for him. He made just four live appearances that July. By November, he was playing more than twice as many shows, including his weekly engagement on the *Louisiana Hayride* (a live radio show broadcast from Shreveport). He was also playing farther and farther afield. Following his November 20th appearance on the *Hayride*, he traveled to Gladewater, Texas, for a show on November 23, then to Texarkana, Arkansas, for a show on November 24, then back to Texas for three shows in Houston on November 25–27, with an additional appearance on the *Hoedown Jamboree* show in Houston on the 27th. He always kept in touch with his parents when he traveled, either calling or sending a telegram. And since he'd quit his job as a truck driver with Crown Electric, he always made sure he contributed to the family's finances by sending his earnings home. This telegram, sent on November 26 during his time in Houston, confirms he's sending money home, although he stresses "Don't tell no one how much I sent," perhaps not wanting others to know about his increasing income. And there's further good news: "I will send more next week." That's Elvis, taking care of business.

> "Hi babies heres the money to pay the bills. Don't tell no one how much I sent I will send more next week. There is a card in the mail. Love Elvis."
>
> —Elvis's telegram to his parents

WESTERN UNION
MONEY ORDER MESSAGE

QUICK SERVICE — **LOW RATES** — Form 3300C

Money Sent by Telegraph and Cable to All the World

W. P. MARSHALL, PRESIDENT

No. NB-HSA706 OFFICE: MEMPHIS TENN DATE: NOV 26 1954 19___

To VERNON PRESLEY
MR., MRS. OR MISS

462 ALABAMA ST
ADDRESS

The Money Order paid you herewith is from ELVIS PRESLEY
NAME

at HOUSTON TEX
PLACE

and included the following message:

HI BABIES HERES THE MONEY TO PAY THE BILLS. DONT TELL NO ONE HOW MUCH I SENT I WILL SEND MORE NEXT WEEK. THERE IS A CARD IN THE MAIL LOVE
ELVIS

TRANSIT TIME OF THIS MONEY ORDER ___ MINUTES

THE WESTERN UNION TELEGRAPH COMPANY

Previous page: Elvis relaxing in the Audubon Drive house, 1956.

▼ REALTOR LISTING CARD, MIRROR, AND LAMP FROM THE AUDUBON HOUSE ▶

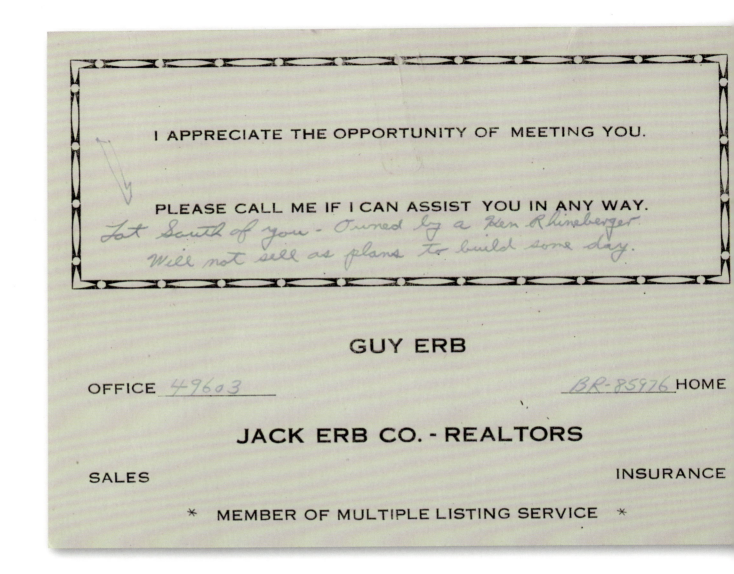

The realtor card for the Audubon Drive house listing.

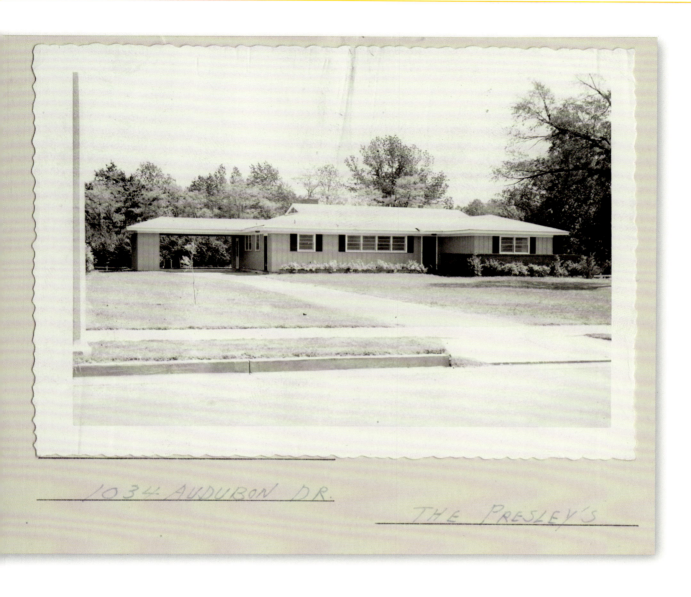

THE FIRST HOME

Even as he was growing up, Elvis promised his mother he would buy her a home one day. That dream came true on March 3, 1956, when he placed a down payment to purchase a ranch-style home at 1034 Audubon Drive in Memphis, the final sale completed on March 12. It was evidence of a remarkable change in the family's fortunes. Just three years before, the Presleys had been living in government-subsidized housing; now, Elvis was the proud owner of a three-bedroom, two-bath ranch-style home that he quickly upgraded by adding a swimming pool. The realty card features a photo of the house before the Presleys moved in, when it would become the star attraction of the neighborhood with hordes of fans clustered outside hoping to see Elvis, who would often spend hours outside signing autographs for them. The Presleys also had fun buying new furnishings for their home, such as the lamp and mirror on the next pages. But, soon enough, complaints from the neighbors, and the Presleys' own desire for more privacy, would have them seeking out a new place to live. The lamp and mirror would be the only pieces to make the move to Graceland.

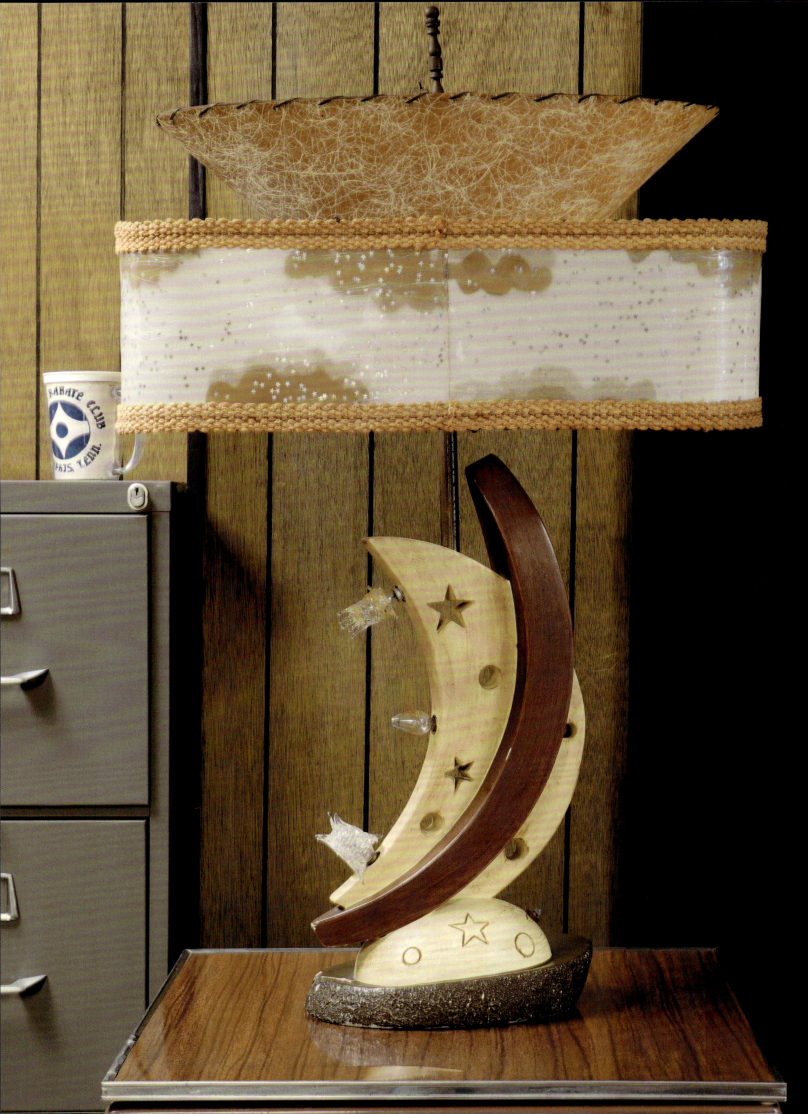

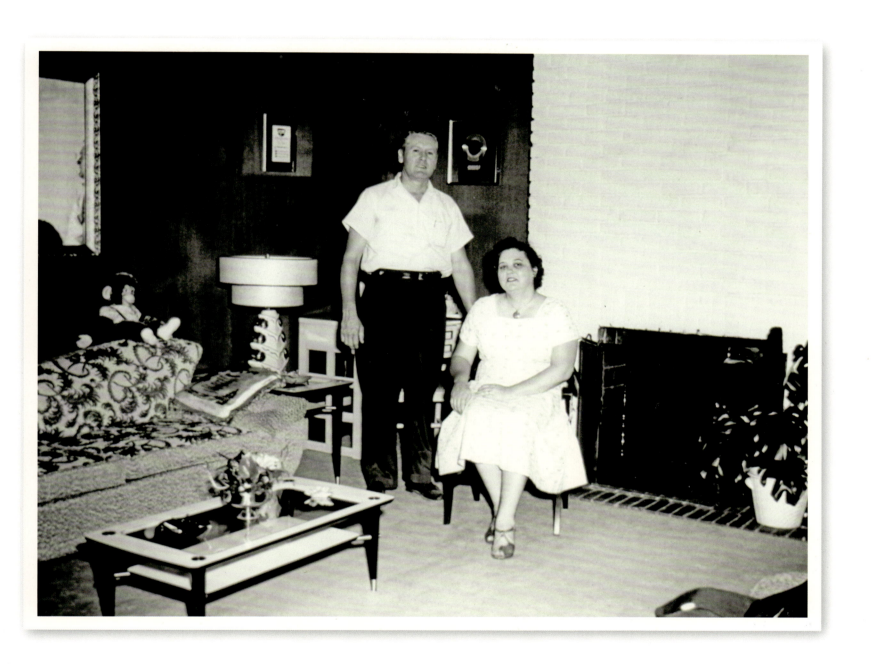

Opposite page: The lamp from the Audubon house now in its place at Graceland—the lamp sits in Vernon's office.

Above: Vernon and Gladys in the living room of the Audubon Drive house, c. 1957.

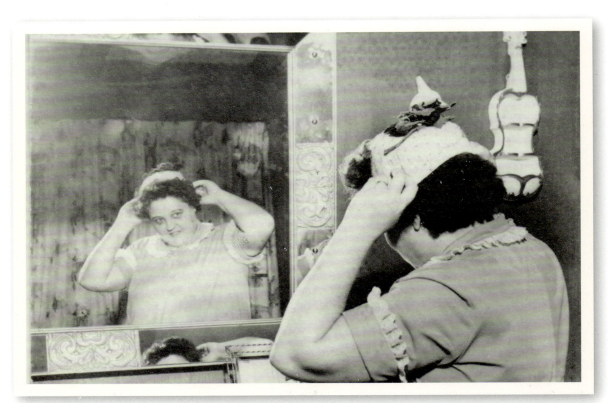

Right: One mirror, two homes: Gladys is reflected in the mirror at the Audubon Drive house, c. 1956; Elvis in 1957 looking at his reflection in the music room at Graceland, where the mirror resides to this day.

Opposite page: The mirror taking pride of place in the music room at Graceland. The lamp on the previous page and this mirror are the only two pieces that made the move from Audubon Drive to Graceland.

Following page: Elvis relaxing with his mother at the Audubon Drive house, May 1956.

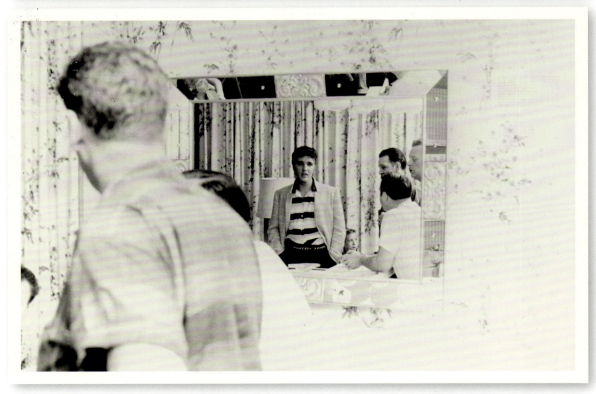

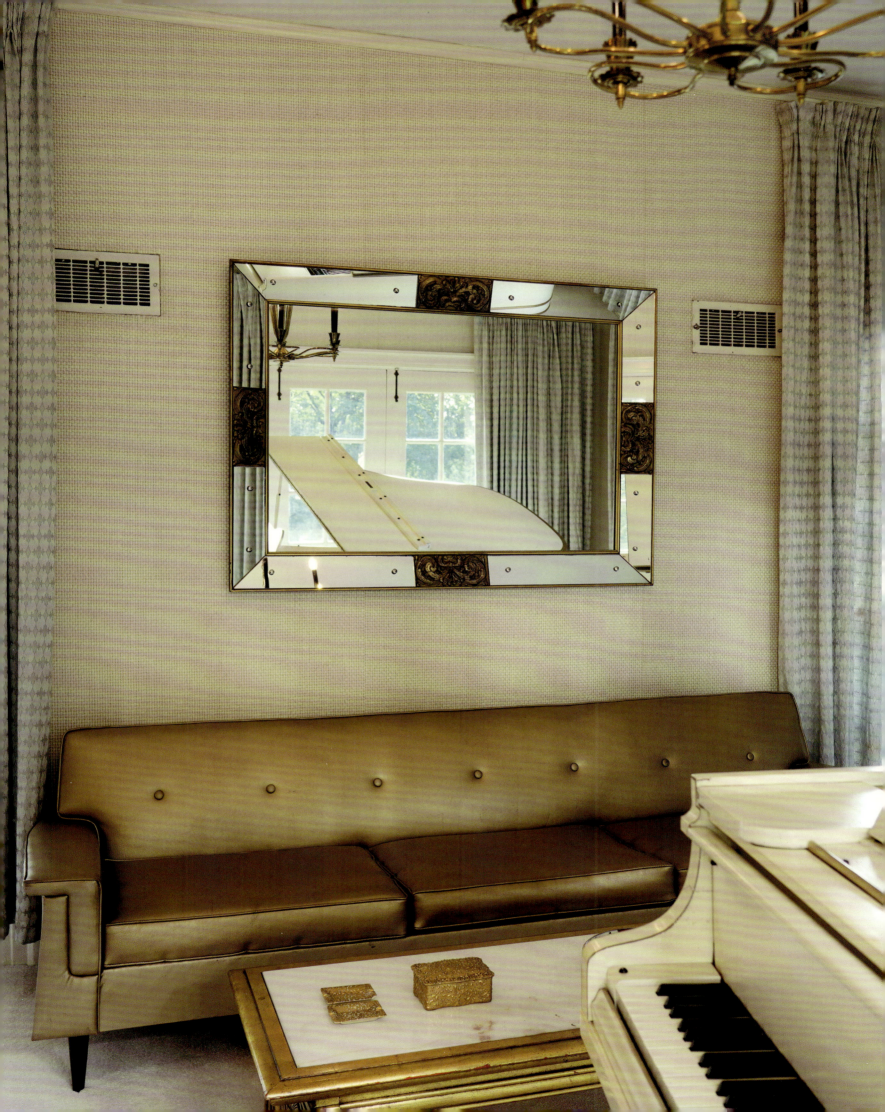

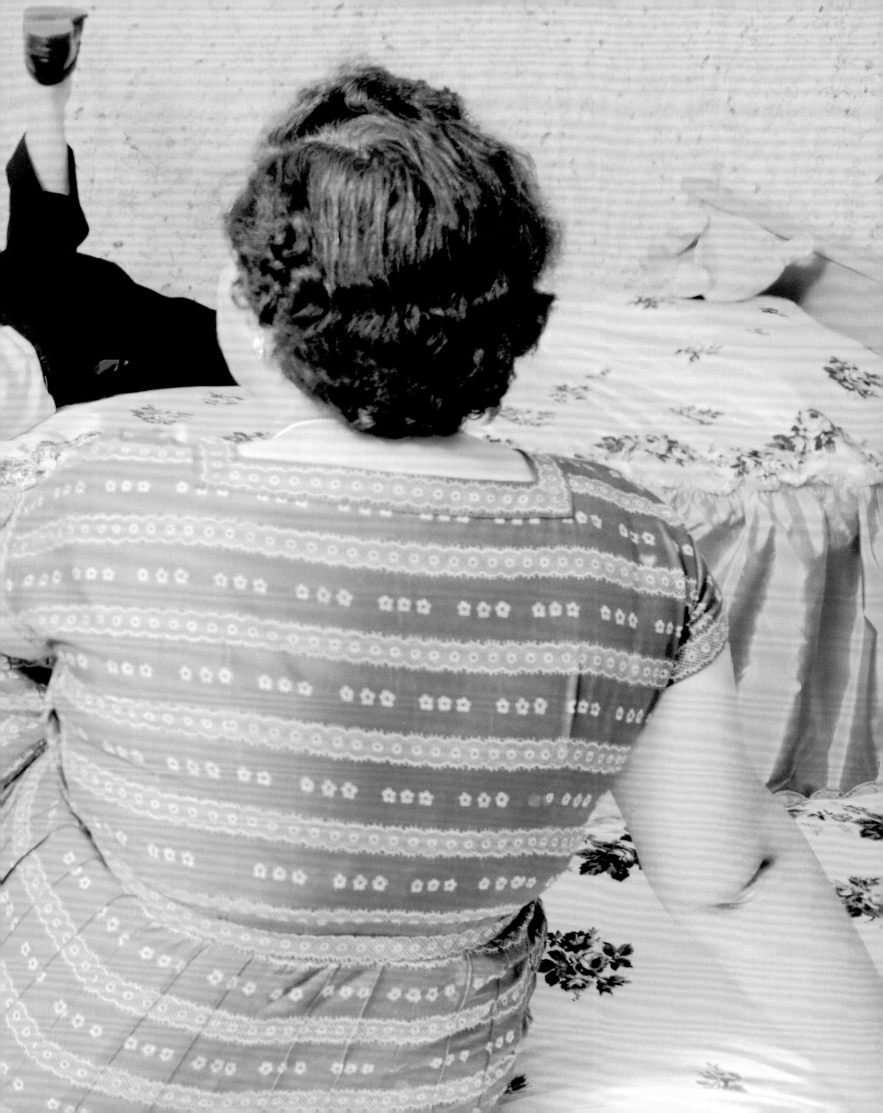

GLADYS'S NEW YORK CITY SOUVENIR LOCKET

A LOCKET FOR MY BEST GIRL

As Elvis's earning power increased, he not only splashed out on flashy clothes for himself, he began buying increasingly lavish presents for his family and friends. On March 23, 1955, Elvis made his first trip to New York City. It was a business trip and he auditioned for the *Arthur Godfrey's Talent Show* television program. He failed to pass the audition, but he'd return to the Big Apple in less than a year, when he'd generate quite a storm on TV. And he did pick up a souvenir while he was in town—a gold locket that he gave to his mother. In July of that year, Elvis had professional publicity photos taken by William Speer, who ran a photography studio at 1330 Linden Avenue in Memphis. The photos came out so well that his parents booked their own session with Speer. Vernon wears a suit and tie, and Gladys is seen in a short-sleeved dress—and wearing the locket Elvis gave her. Elvis's parents look happy and relaxed, and, in 1964, Colonel Parker had a painting made of one of the photos, presenting it to Elvis as a gift. Interestingly, Gladys never replaced the generic photos that were inside the locket: stock photos of a man and woman in front of the Empire State Building.

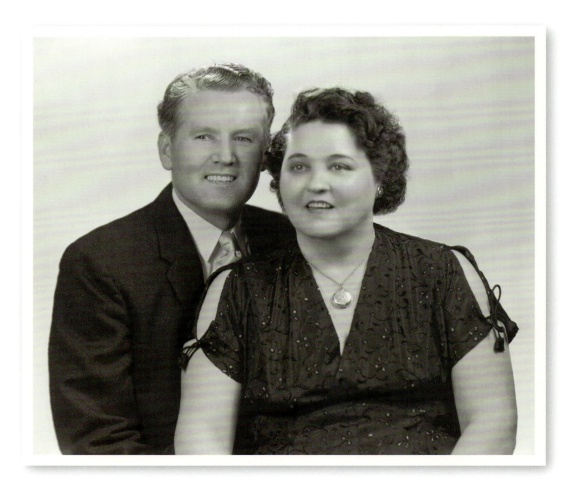

Gladys wearing the locket in a studio portrait with Vernon.

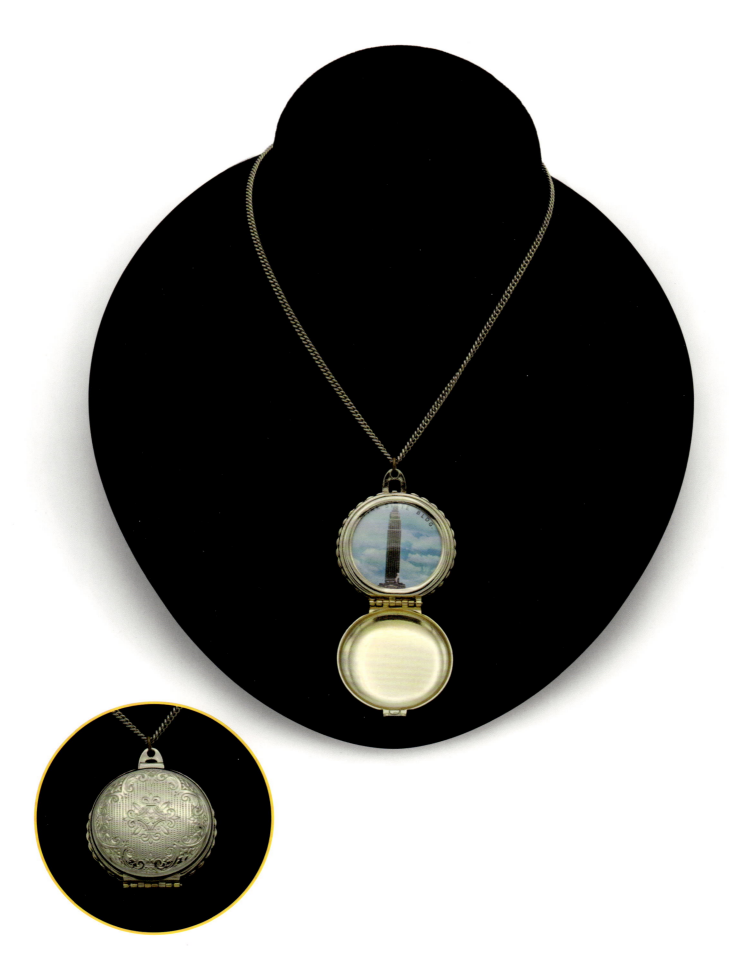

45

▼ *1956 GIBSON GUITAR* ▼

THAT GLORIOUS GIBSON

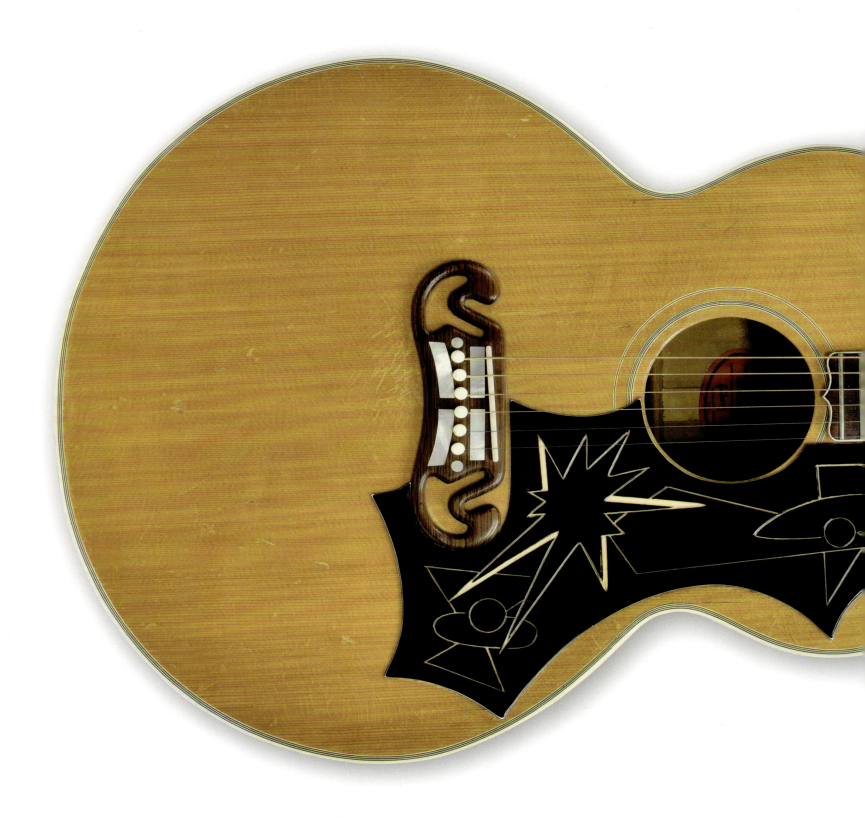

46

Elvis received this Gibson J-200N acoustic guitar in October 1956. He first played it in concert on October 11, when he played the Cotton Bowl in Dallas, Texas, and used it frequently in the studio as well. He later had a tooled leather cover custom-made for the guitar. He was so comfortable with the instrument, Paramount purchased the same model of guitar for him to use in the movies *Loving You* and *King Creole*. After he returned from the army, Elvis asked his guitarist Scotty Moore to have the instrument refurbished. Scotty arranged for the guitar to be repaired and refinished, with some additional touches added. Elvis's name was inlaid on the fretboard, with stars on either side—a most impressive look. The pick guard was replaced by a new one featuring a modern design of geometric shapes and a starburst. He played it at his 1961 shows in Memphis and Hawaii, after which it went into "retirement." But it was front and center when Elvis returned to live performance in 1969, as can be seen in numerous photographs of his Las Vegas engagement. He continued playing the guitar in concert through 1971.

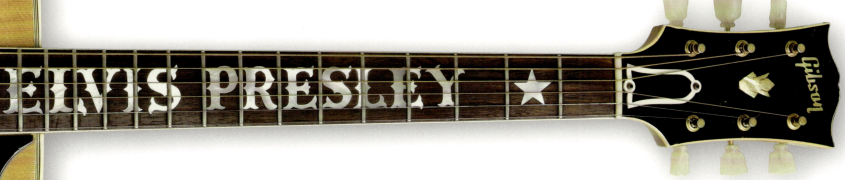

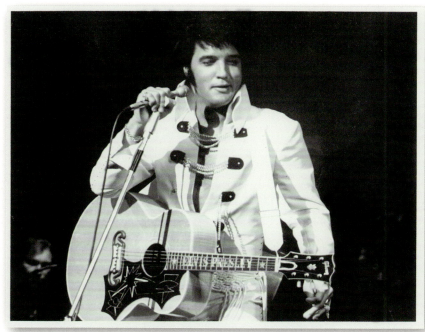

Elvis performing with the Gibson in Las Vegas, 1970.

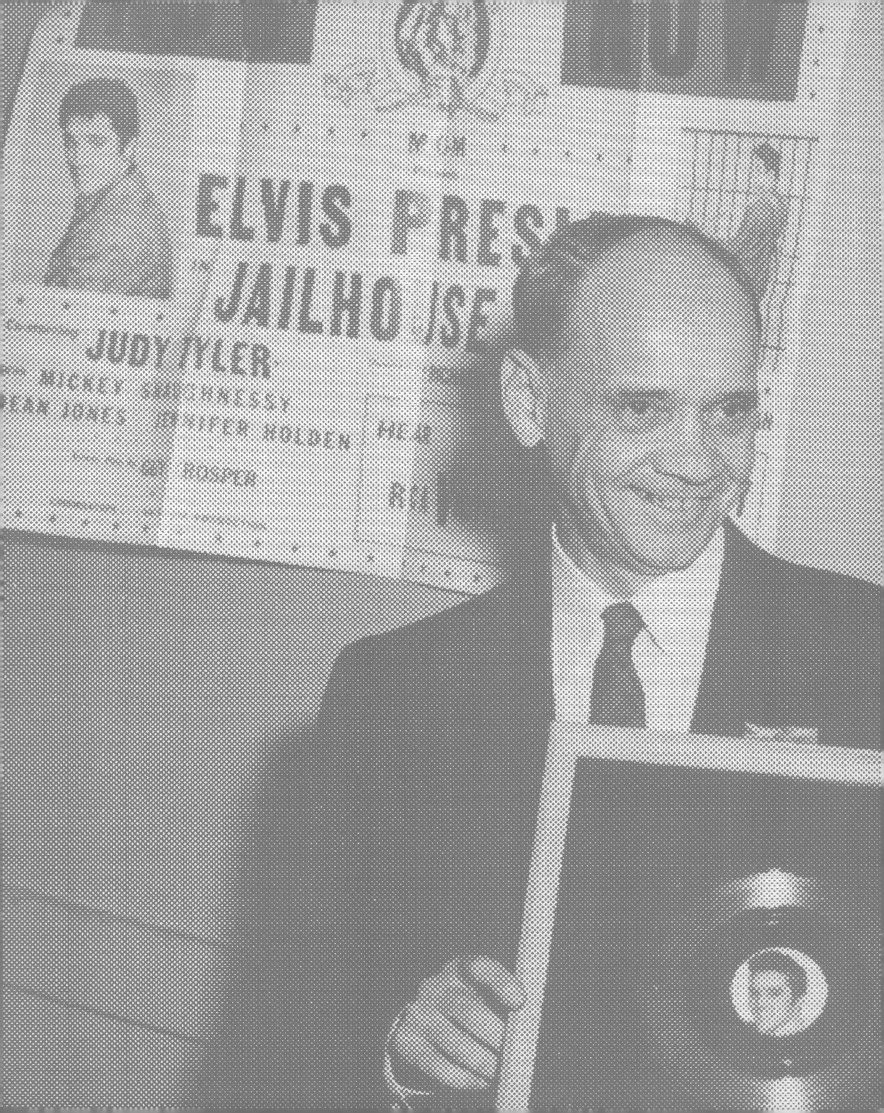

PART 3 MAKING IT BIG

▼ **FAMILY COPY OF ELVIS'S FIRST ALBUM** ▼

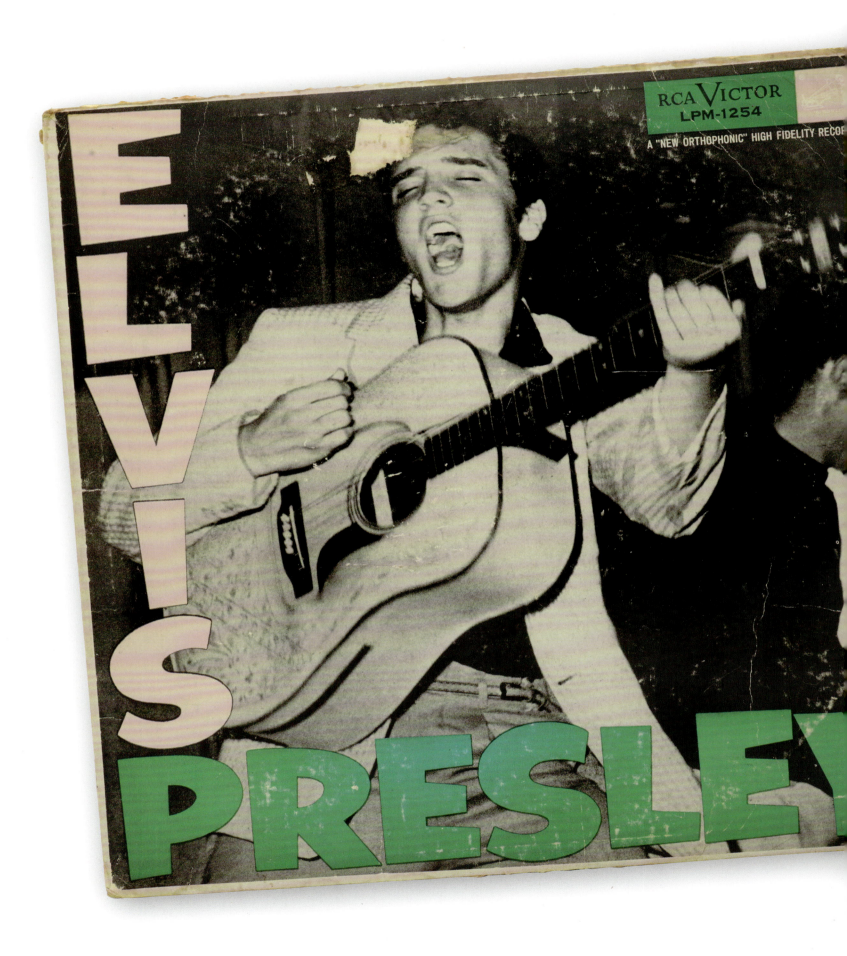

GOING GOLD

There's nothing like holding a copy of your very first album in your own hands. Who knows how many times Elvis picked up this copy of *Elvis Presley*, released in March 1956, and marveled at his accomplishments? And his parents clearly played it dozens—perhaps hundreds—of times, as the cover shows plenty of wear and tear. It's an album that's a classic, from that iconic cover shot, taken at a show at the Fort Homer Hesterly Armory in Tampa, Florida, on July 31, 1955, showing him in full battle cry, to the vibrant music within. There's a riveting version of Carl Perkins's "Blue Suede Shoes;" a playful cover of "Money Honey," originally recorded by Clyde McPhatter, one of Elvis's favorite singers; and Ray Charles's "I Got a Woman," a song Elvis would perform in concert for years to come. It was Elvis's first No. 1 album as well (staying at the top for 10 weeks) and the first rock album to sell a million copies. And Elvis was just getting started. No wonder this record was taken out so often to listen to again and again.

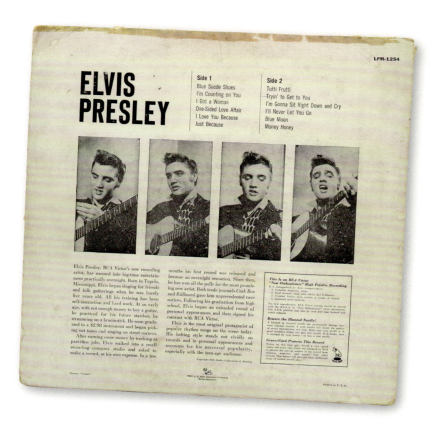

Previous page: Elvis presents Gus Arieta, salesman for the RCA San Francisco distributor, a gold record for 25 years with RCA and for selling more than 1 million of Elvis's records, 1956. The inscription on the award reads: "To Gus Arieta in Appreciation For Selling Over 1 Million Of My Records, Elvis Presley."

TRIPLE CROWN AWARD AND GOLD RECORD FOR "HEARTBREAK HOTEL"

THE FIRST MILLION SELLER

"Heartbreak Hotel" was Elvis's breakthrough single, that helped make him a national star. Elvis heard a demo of the song while attending the Country Music Disco Jockey Convention in Nashville in November 1955, and he immediately decided to record it at his first session for RCA on January 10, 1956. The haunting, brooding number about a brokenhearted lover crying at the titular hotel was released as a single later that month. Boosted by Elvis's six appearances on the television program *Stage Show*, the single had sold a million copies by the end of April, and on May 5 gave Elvis his first number one on the *Billboard* Top 100. The single also became Elvis's first gold record. The single received another special honor from *Billboard*: two Triple Crown Awards. The award pictured here is for "Heartbreak Hotel" topping the retail, disc jockey, and jukebox charts for Country and Western records. The single also received the same Triple Crown Award for topping the retail, disc jockey, and jukebox charts for Pop records, making Elvis the first "double-Triple Crown" winner in *Billboard* history.

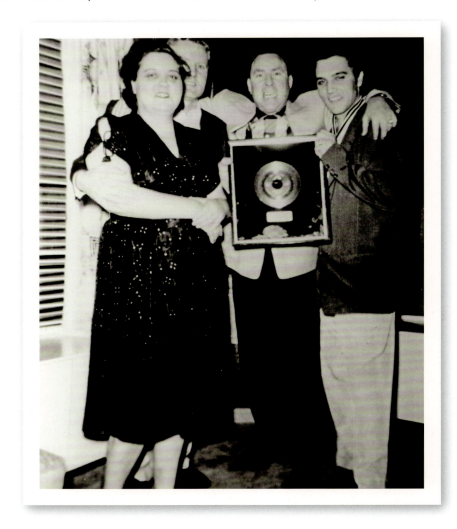

Elvis showing off his first gold record with his parents and disc jockey Dewey Phillips at the Audubon Drive house, 1956.

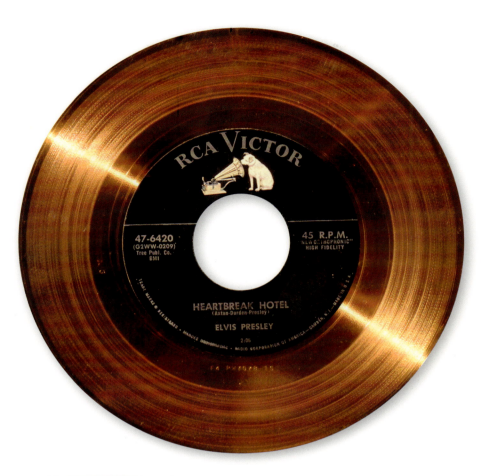
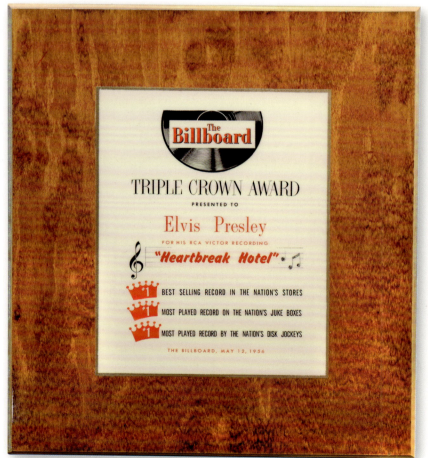

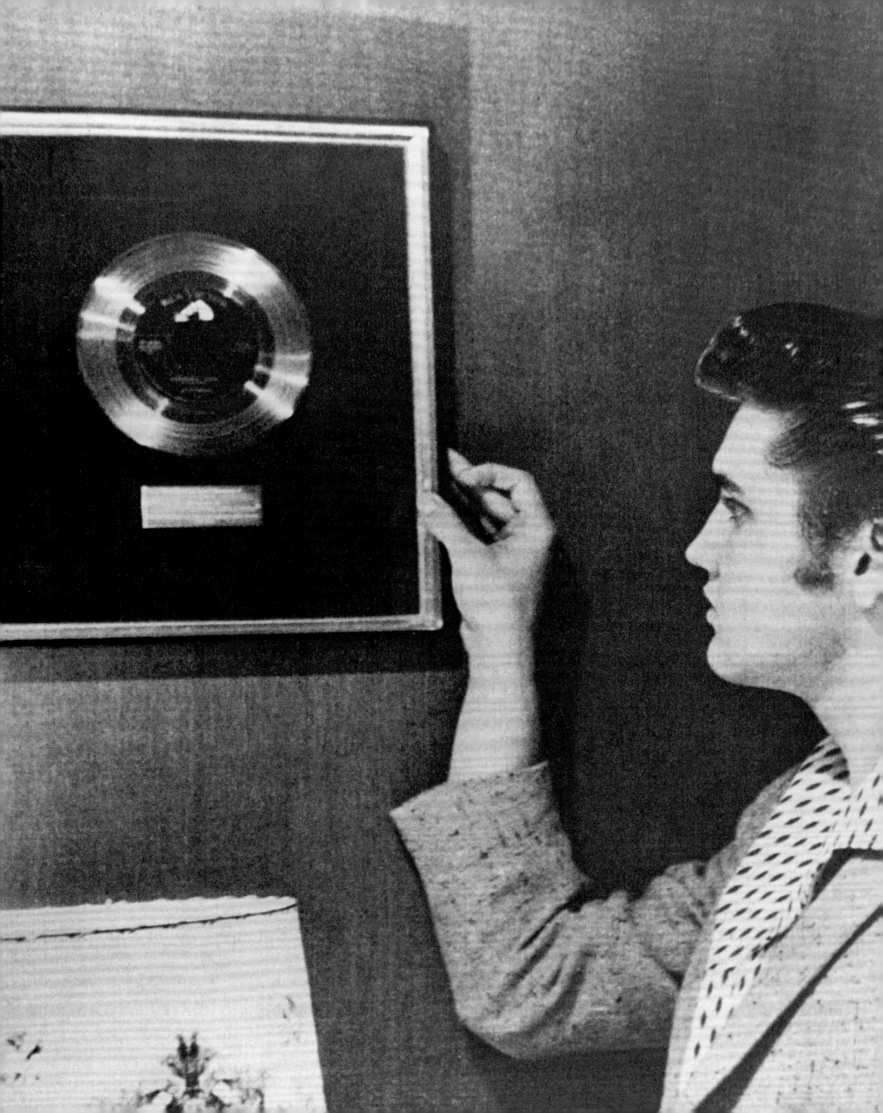

> "I ain't no saint, but I've tried never to do anything that would hurt my family or offend God ... I figure all any kid needs is hope and the feeling he or she belongs. If I could do or say anything that would give some kid that feeling, I would believe I had contributed something to the world."

—Elvis

▼ ELVIS PRESLEY FAN HAT AND SHOES ▼

ELVIS MERCH

Elvis fans wanted to get their hands on anything that made them think of their idol. So, in addition to the sale of his records, a merchandising boom was born. Photos and songbooks were the starting point; every traveling musical act had them. But that was just the beginning. You could also buy Elvis buttons, dolls, jewelry, bubblegum cards, head scarves, handkerchiefs, toy guitars, scrapbooks, pocket mirrors, lipsticks ("Keep me always on your lips," said one ad), and a record case to hold all your Elvis 45s—among other things. Items of clothing were especially desirable; what better way to keep Elvis close to you? The sneakers were navy blue, imprinted with outlines of a guitar and Elvis's name and face in light blue, and they came in a specially designed box that was a keepsake of its own, with Elvis's picture and a printed signature reading "Best Wishes, Elvis Presley." The hat is in the "bucket" style, which was popular in the 1950s, and imprinted with Elvis's face and the names of his songs. Wear both at the same time, and you were confirming your Elvis love from head to toe.

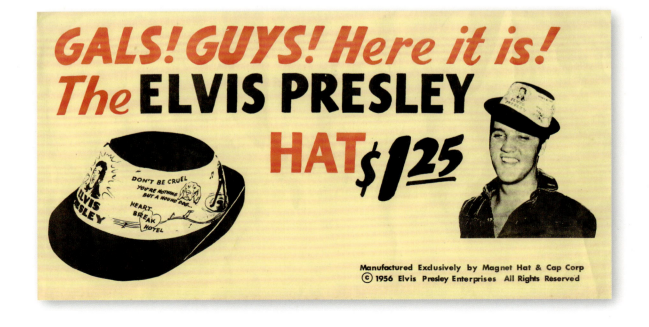

56

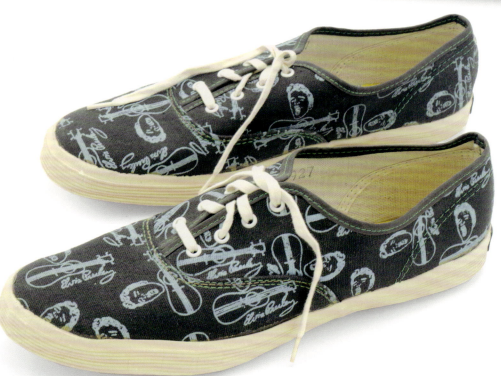

Here, Elvis is wearing the white version of the printed shoes in a publicity shot, 1956.

57

THE KEY TO TUPELO

THE HOMECOMING

On September 26, 1956, Elvis returned to his hometown of Tupelo in triumph. A decade after he'd won a prize for singing "Old Shep" at the Mississippi-Alabama Fair and Dairy Show, he was back at the same event, this time as "America's number-one entertainer in the field of popular music," as the state's governor, J. P. Coleman, put it. Elvis, his parents, and two friends arrived to find Tupelo all decked out for the festivities, with a huge banner proclaiming "Tupelo Welcomes Elvis Presley Home" hung across the town's main street. He performed two sets at the fair, wearing a blue velvet shirt that actress Natalie Wood had given him. During the first set, Coleman and Tupelo mayor James Ballard joined him onstage at one point, Ballard handing him the key to city and saying, "The people of this community and of this city admire you and certainly are proud of you." Elvis thanked him and went on with the show. It was a momentous day, one that drew the biggest crowds to Tupelo since President Franklin D. Roosevelt visited in 1934.

Mayor James L. Ballard (left) presents Elvis with the guitar-shaped key to the city of Tupelo at the Mississippi-Alabama Fair and Dairy Show, September 26, 1956.

Following page: Elvis performing at the Fair later that day.

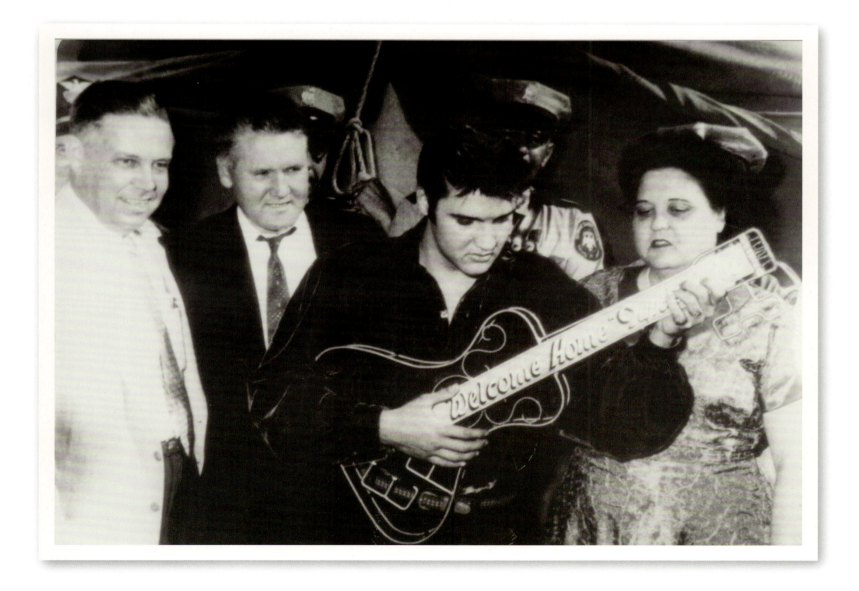

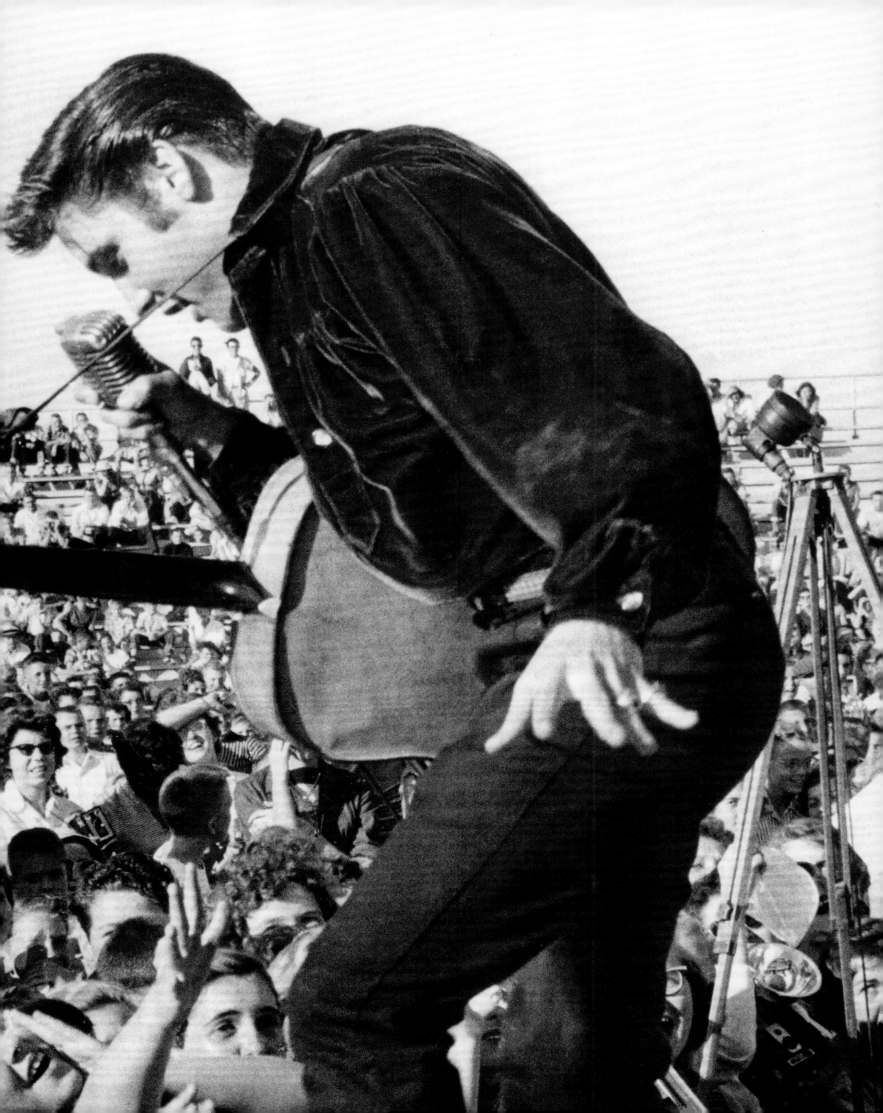

THE TV GUIDE COVER

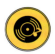

COVER BOY

This is the very first issue of *TV Guide* to feature Elvis on the cover, for the week of September 8–14, 1956. He was on the cover dozens of time after that, of course. But this was the Presley family's own copy, soon to become part of their growing collection of magazine covers and articles about Elvis's astonishing success. Elvis was chosen for the cover because of a very special upcoming performance—his debut on *The Ed Sullivan Show* on September 9. It was the top-rated television variety show in the country, and this would be the first of Elvis's three appearances on the program (although Charles Laughton served as host on this first show, as Sullivan was in the hospital recovering from a car accident). The accompanying four-page story: "Elvis Preseley—The People Who Know Say He Does Have Talent," traced his rise on television, finally reaching the top on Ed Sullivan. When this copy was first available, it sold for fifteen cents. Nowadays, it would cost you hundreds of dollars. But *TV Guide* is still in existence, meaning you can scoop up the next issue with Elvis on the cover before it becomes a pricey collectible.

Elvis and Ed Sullivan at a press conference announcing his first appearance on Sullivan's show, September 1956.

Following page:
Elvis performing "Hound Dog" on his next appearance on Sullivan's show, October 28, 1956.

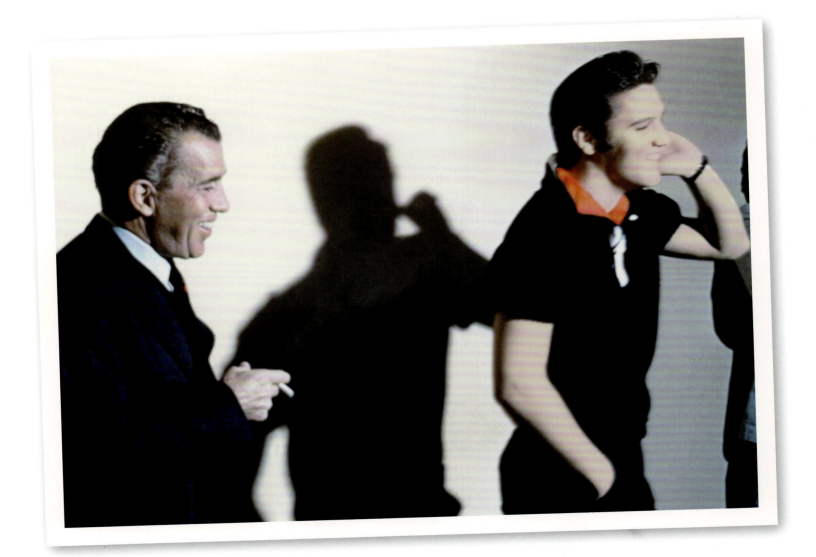

62

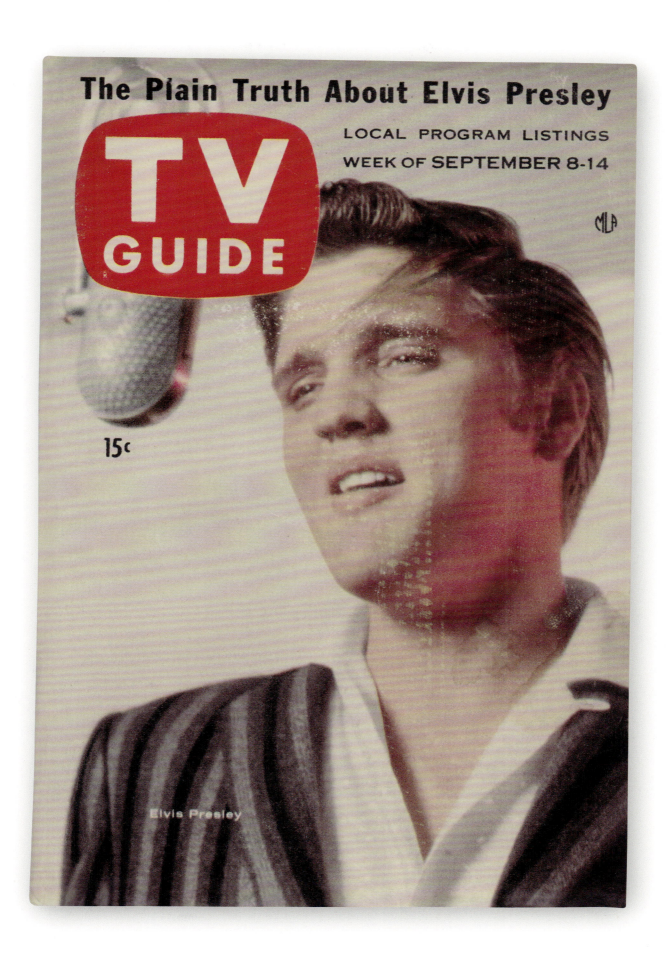

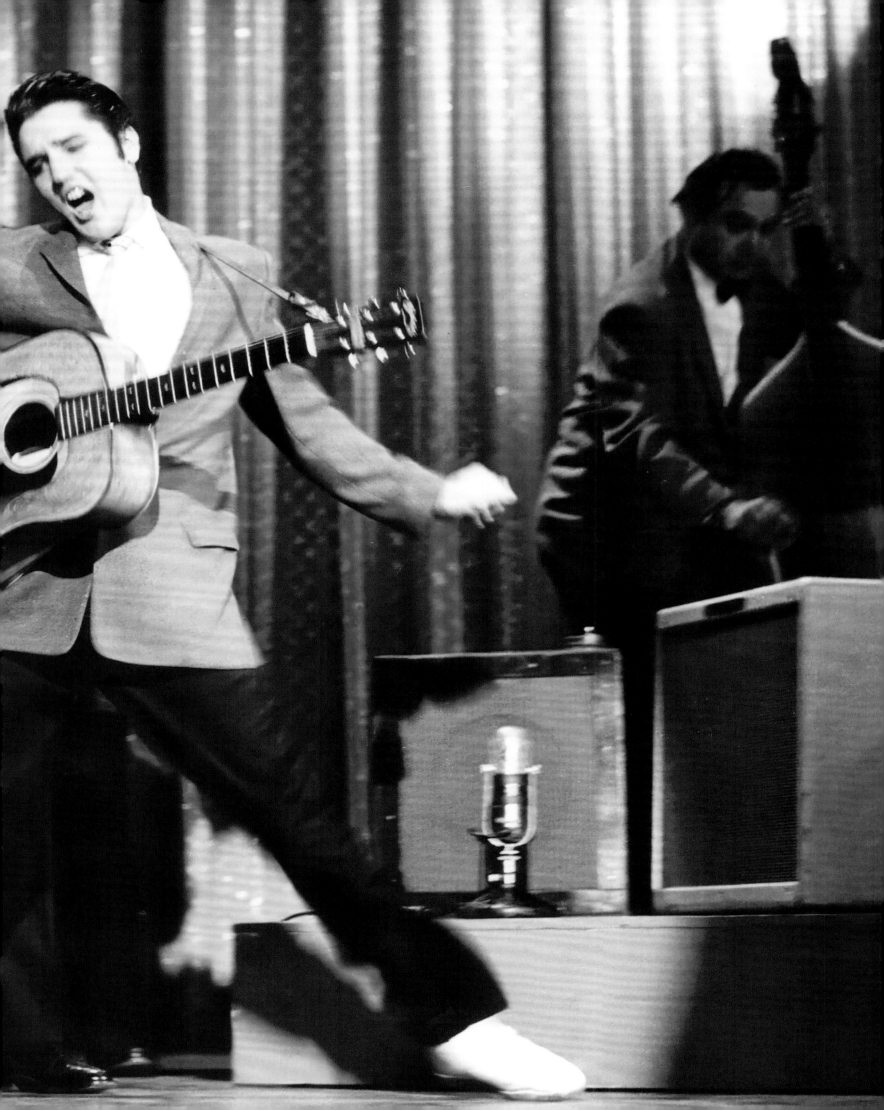

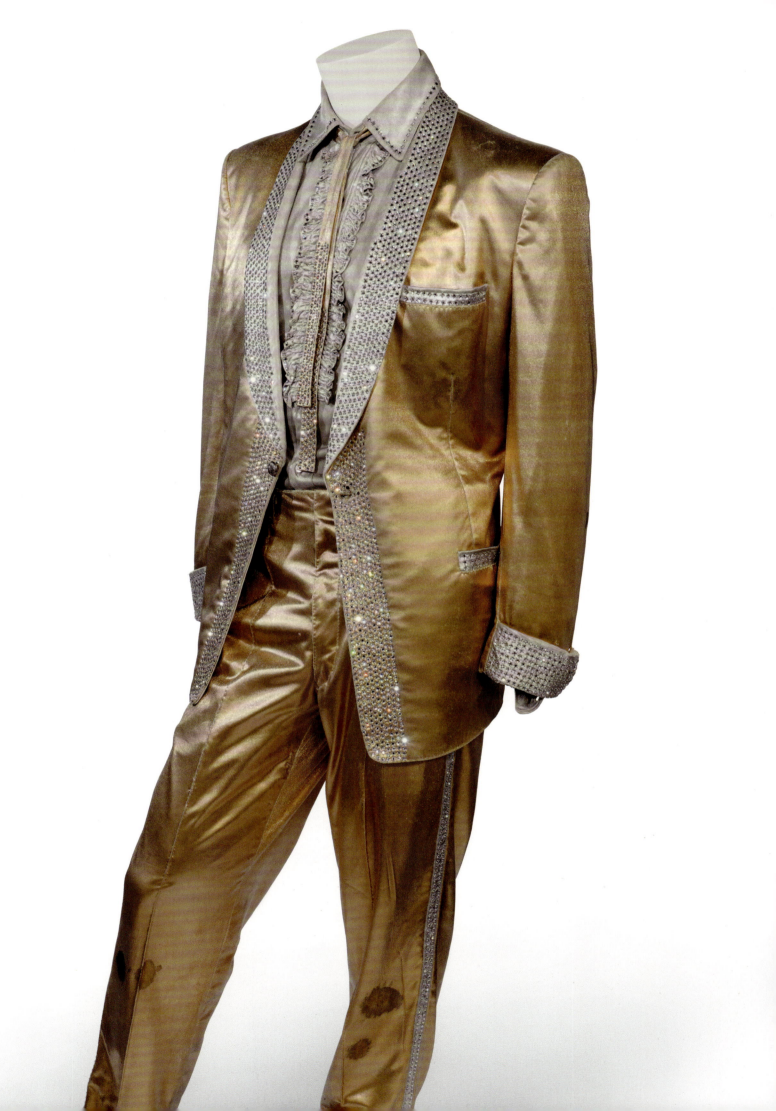

▼ THE GOLD SUIT ▼

A TOUCH OF GOLD

On March 28, 1957, Elvis dazzled audiences by coming on stage for a show in Chicago wearing what was likely his most fabulous outfit—a gold suit. The ensemble was the creation of Nudie Cohn, "Rodeo Tailor to the Stars," who designed clothes for country and western stars like Roy Rogers and Dale Evans. Colonel Parker commissioned a suit for Elvis, which Cohn made out of gold lamé (though some sources say gold leaf), trimmed with silver and featuring rhinestones on the collar, cuffs, pockets, and down the outside of each trouser leg. It was worn with a matching frilly shirt, a gold western tie, and gold shoes. Total cost: $2,500. But Elvis only wore the complete suit a few more times (the last time was in Toronto on April 2, 1957), preferring afterward to wear the jacket with black dress pants. He last wore the jacket at his March 25, 1961, performance in Honolulu. But you can see him in the full suit on the cover of *50,000,000 Million Elvis Fans Can't Be Wrong: Elvis' Gold Records Vol. 2*, released in November 1959.

Opposite page: The marks on the knees of the pants are wear from Elvis's signature move of falling to his knees in performance.

Below left: One of the few times Elvis wore the entire ensemble in concert, St. Louis, March 29, 1957.

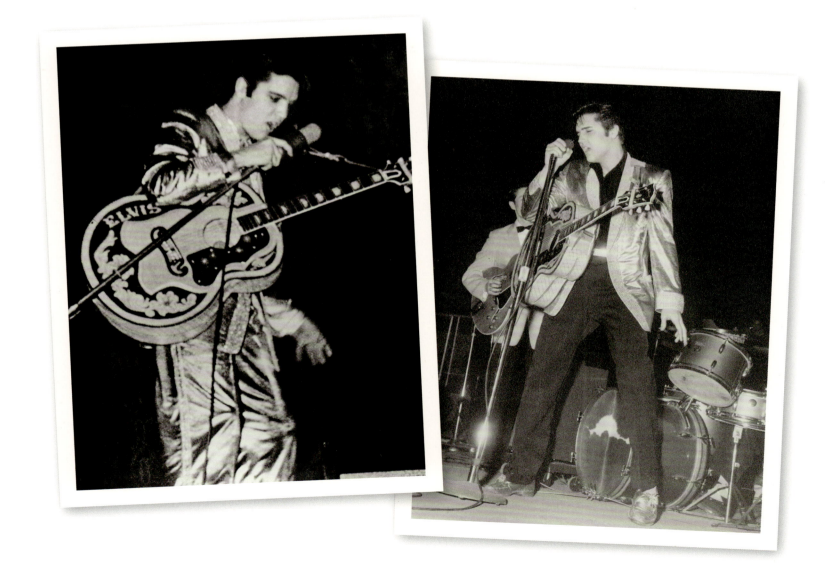

ELVIS'S SCREEN ACTORS GUILD CARD

A UNION OF STARS

Before Elvis could make a movie, he had to join the Screen Actors Guild (SAG). SAG was the actors' union, representing the interests of actors employed by the motion picture industry (in 2012, the union merged with the American Federation of Television and Radio Artists, becoming SAG-AFTRA). Elvis joined SAG in 1956, when he made his first film, *Love Me Tender*. He was issued this card just in time for the filming of *Jailhouse Rock*, which began on May 13, 1957. Elvis was only able to make one more film, *King Creole*, before going into the army. But he made sure to keep his SAG membership in good standing, so he was ready to go as soon as his army hitch was up, and moviemaking became the focus of his career. Elvis made twenty-seven feature films during the 1960s, including such hits as *G.I. Blues*, *Blue Hawaii*, and *Viva Las Vegas*. His films also produced such hit songs as "Return to Sender," from *Girls! Girls! Girls!* and "Bossa Nova Baby" from *Fun in Acapulco*.

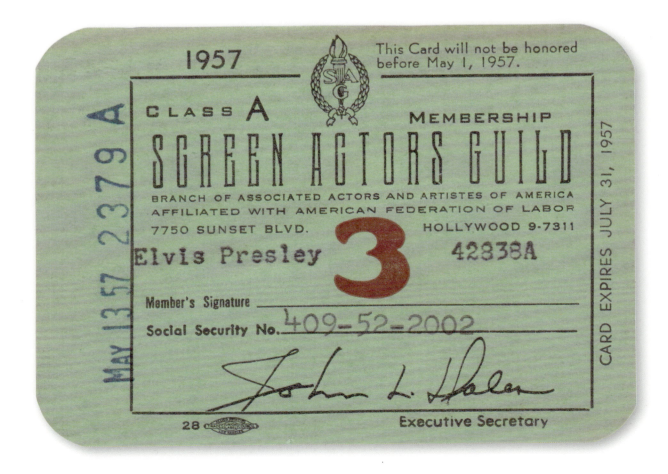

Opposite page:
Elvis with director Richard Thorpe behind the scenes during the filming of *Jailhouse Rock*, 1957.

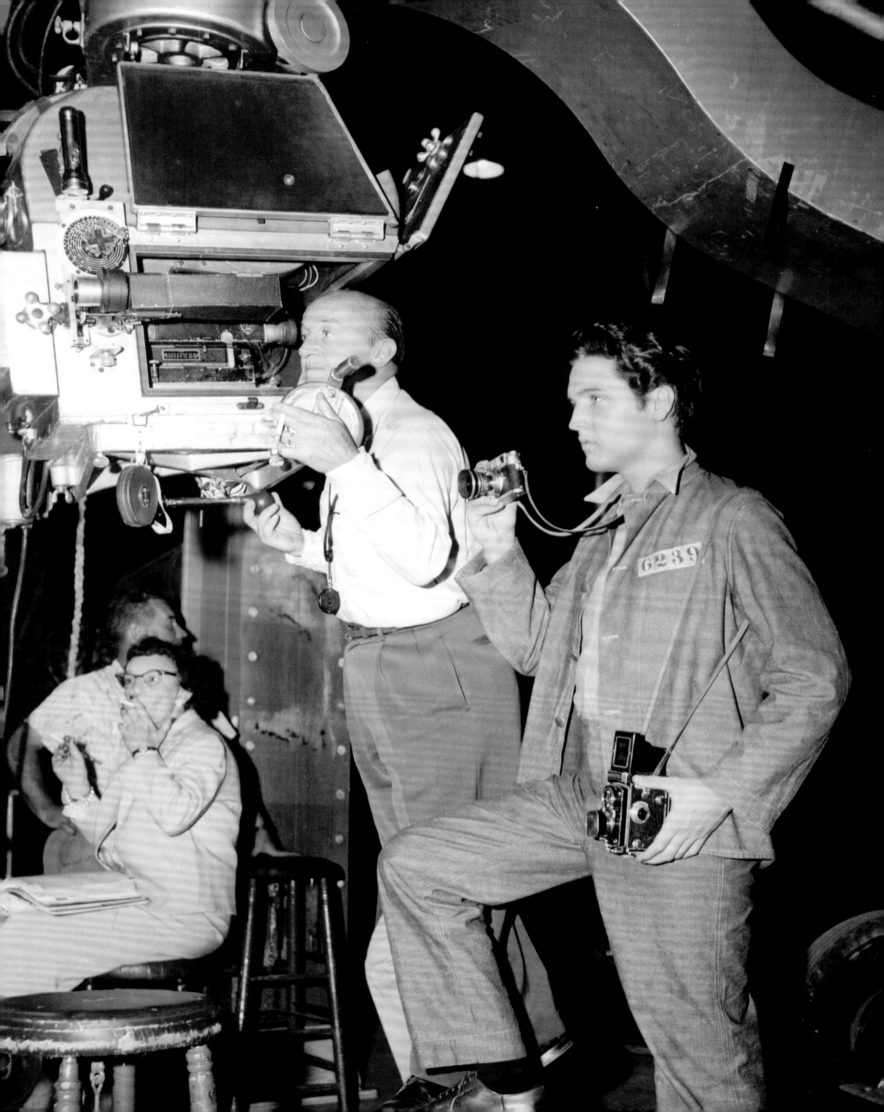

LOVE ME TENDER *TELEGRAM*

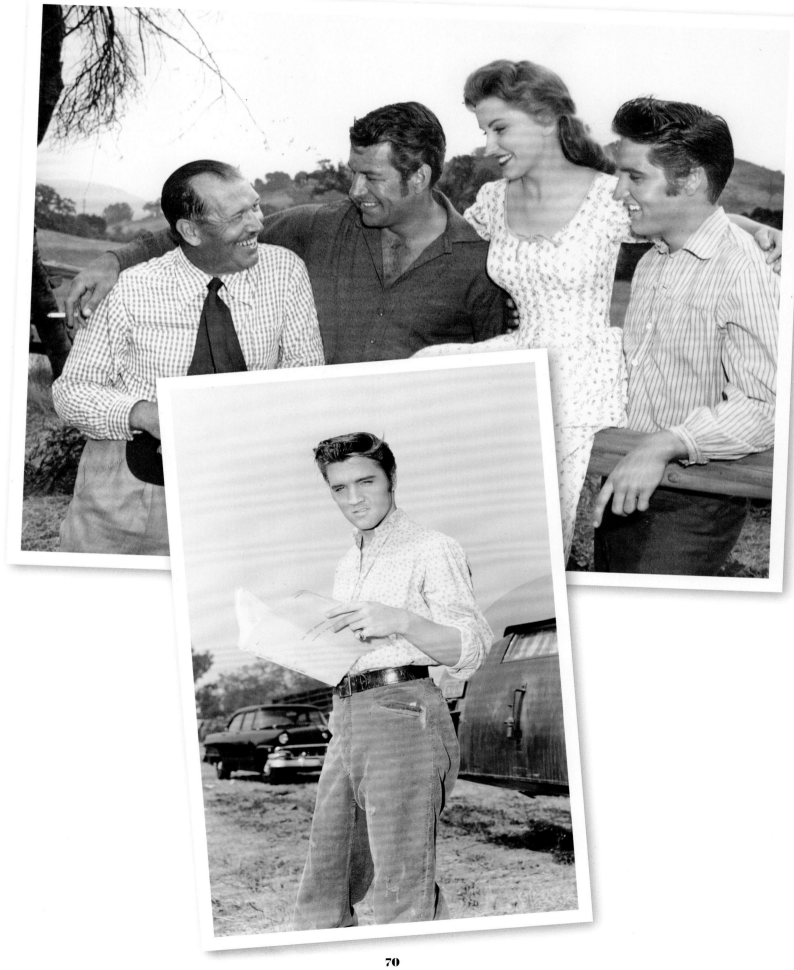

FROM TEEN IDOL TO HOLLYWOOD STAR

Elvis loved movies and dreamed of being a film star when he grew up. So, he was thrilled when he was sent to Hollywood in March 1956 to take a screen test. His on-screen charisma was obvious, and a deal was quickly worked out for him to star in his first motion picture, originally titled *The Reno Brothers*, with filming set to begin in August. The story was set after the Civil War, with Elvis playing one of two brothers in love with the same woman. By the time work on the film was completed, it had been renamed after one of the songs in the movie: *Love Me Tender*. The single of the song gave Elvis another No. 1 hit (and another gold record). There were fifteen hundred fans waiting in line to see the film when it opened in New York City. In its first week, box office earnings put it second to *Giant*, James Dean's last movie. Elvis, a major James Dean fan, could hardly believe that his first film had put him in the same league as his idol.

Opposite page, top: Elvis with costars Debra Paget and Richard Egan and director Robet D. Webb in a promotional photo from *Love Me Tender*.

Opposite page, bottom: Elvis reviews his script.

```
WESTERN UNION TELEGRAM
Aug. 13, 1956

COLONEL TOM PARKER
ROOSEVELT HOTEL NRLNS

DEAR TOM: CONGRATULSTIONS, TWENTIETH DEAL SET ELVIS TO
REPORT ON COAST BETWEEN AUGUST 20 TO 27 TO START HIS
FIRST PICTURE "THE REO BROTHERS" FOR WHICH HE WILL RECEIVE
$100,000. FOR TEN WEEKS PLUS CO-STAR BILLING. FOX HAS AN
OPTION ON ELVIS SERVES FOR TWO MORE PICTURES $150,000.
FOR THE FIRST AND $200,000. FOR THE SECOND. WARMEST
REGARDS:
        ABE LASTFOGEL
```

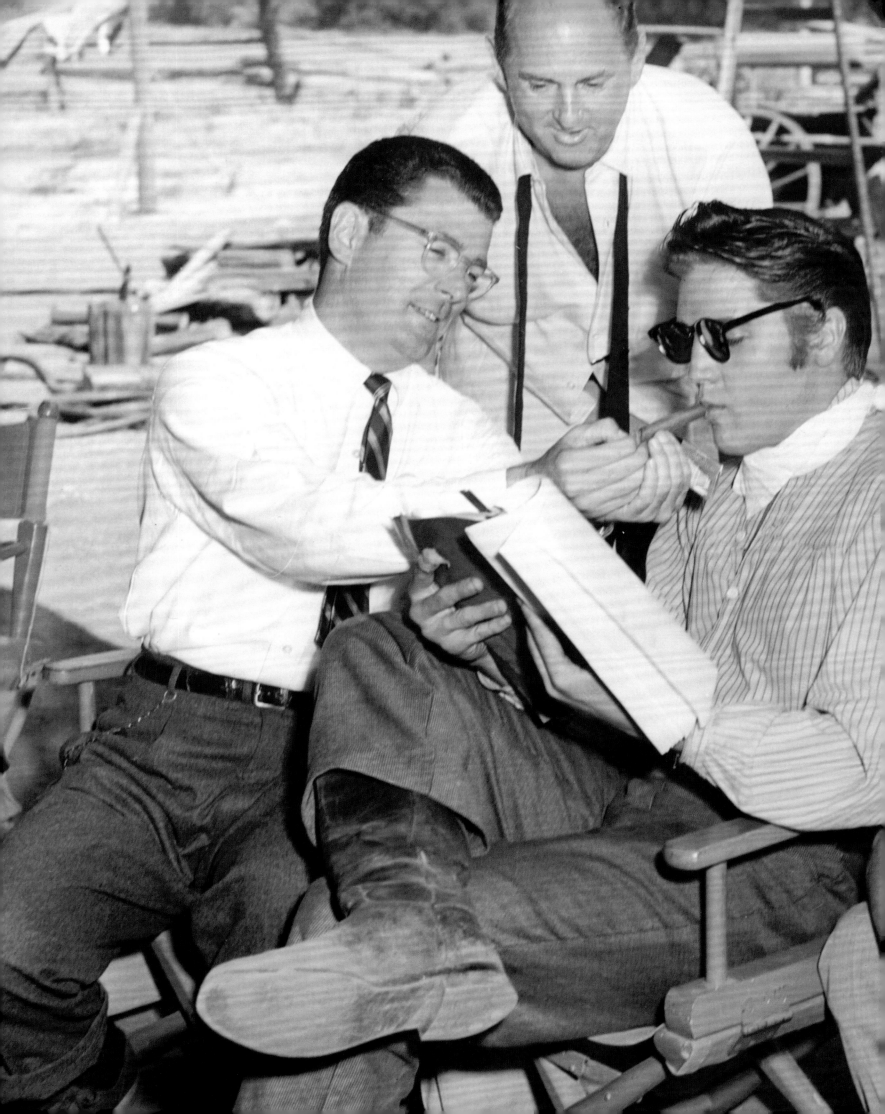

Elvis and crew members joking between takes on the set of *Love Me Tender*.

ELVIS'S JAILHOUSE ROCK SCRIPT

DANCIN' TO THE "JAILHOUSE ROCK"

This "Untitled Presley Story" later became *Jailhouse Rock*, not only one of Elvis's best films, but also one of the best rock 'n' roll movies ever made, one that should be required viewing for any rock fan. Elvis plays an ex-con who becomes a rock 'n' roll star, navigating a few bumps in the road and romantic difficulties along the way (all resolved by the final reel, of course). The highlight is undoubtedly the big production number set to the title song, the best dance sequence of any Elvis movie. The multileveled set was designed to look like rows of jail cells, with the "prisoners" having the time of their lives dancing to Jerry Leiber and Mike Stoller's classic song. Choreographer Alex Romero drew on Elvis's own uninhibited dancing style in putting the number together, and Elvis also got a few dance tips from future *West Side Story* star Russ Tamblyn. After premiering in Memphis on October 17, 1957, *Jailhouse Rock* opened nationally in November and quickly became a strong box office contender.

Opposite page: Elvis performing the title song in *Jailhouse Rock*.

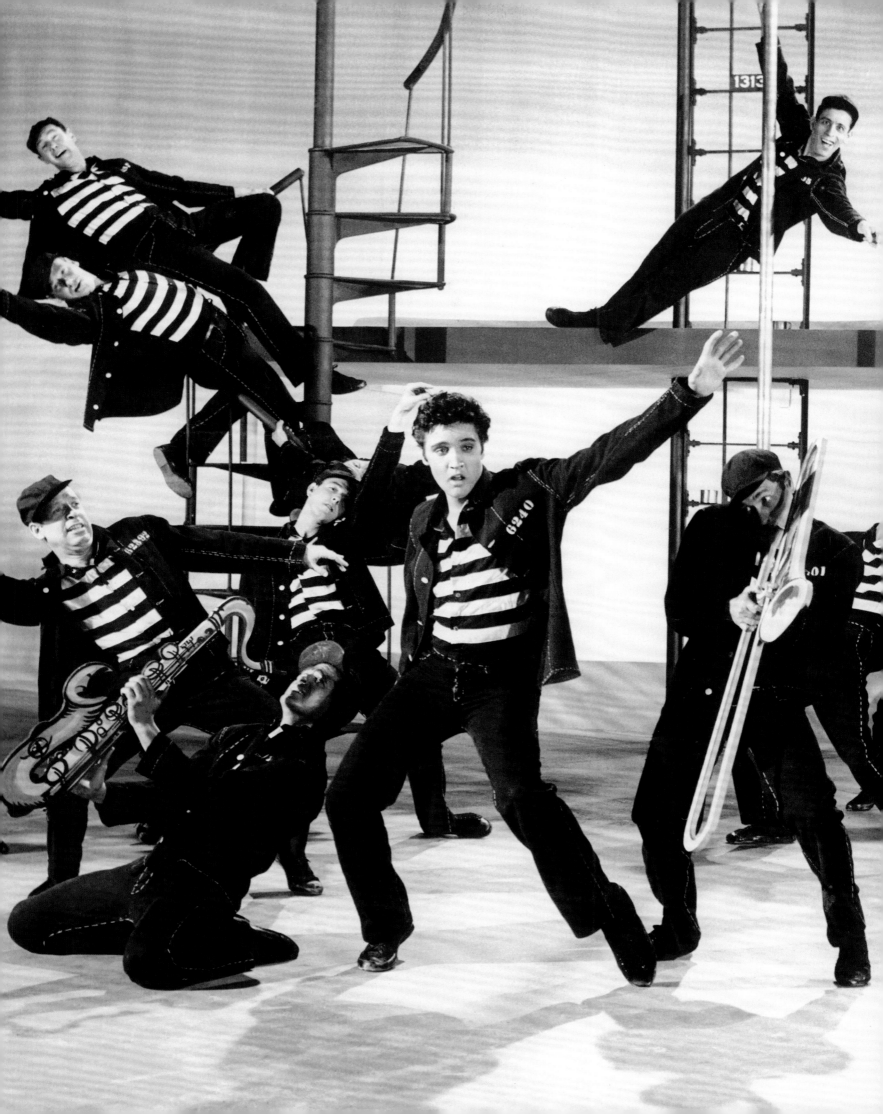

OPERATOR PERMIT, ARMY TRUNK, ARMY HELMET

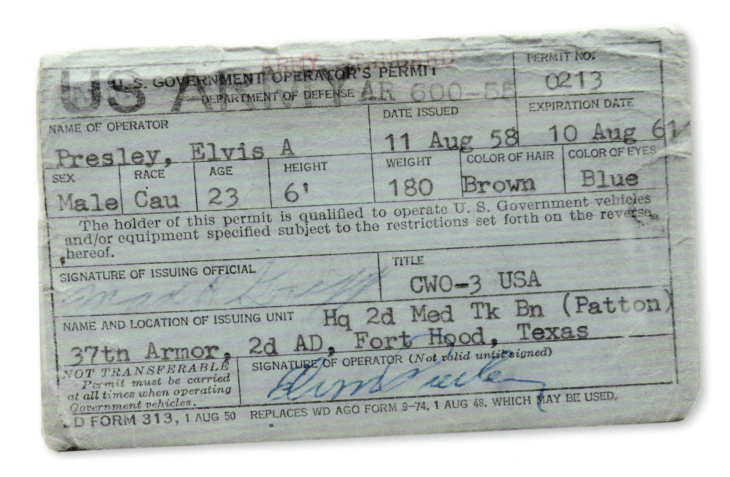

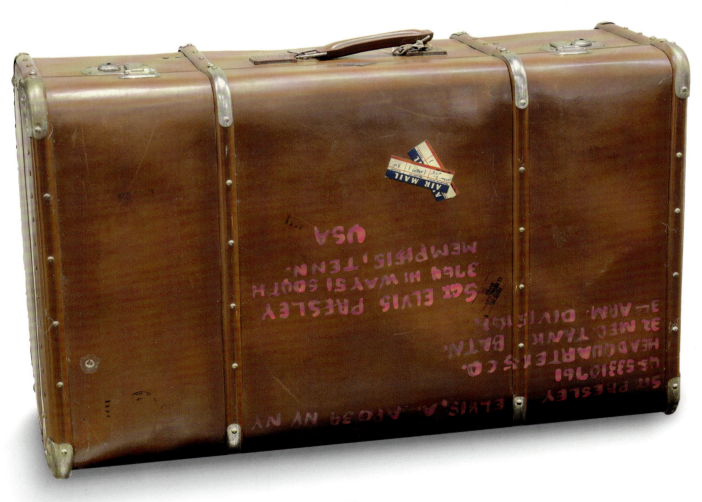

PRIVATE PRESLEY

On December 20, 1957, Elvis picked up his draft notice at his local draft board. He immediately wrote to ask for a deferment, as his next movie, *King Creole*, was about to start filming, and the studio had already invested a considerable amount of money in the project. His request was granted, and Elvis's induction date was set for March 24, 1958. He was first stationed at Fort Hood in Killeen, Texas, where he received this Operator's Permit, allowing him to drive government vehicles. By October 1958, he was in Friedberg, Germany, part of the 32nd Tank Battalion, Third Armored Division.

Elvis served as a regular soldier and was allowed very few luxuries. Upon arriving in Germany, Elvis spent the first few nights in his army bunk at Ray Barracks in Friedberg. After his father, grandmother, and friend from Memphis arrived in Germany, Elvis was granted the right to live off base in nearby Bad Nauheim—first in a hotel and later in a house that he rented for the duration of his stay in Germany. His friend made sure every part of his uniforms—including this helmet—was kept in top condition.

Elvis worried how his career would fare being out of the public eye for so long, but his two-year army hitch passed quickly. The tag on his trunk reveals that by the time of his discharge, Elvis was now Sergeant Presley. Mission accomplished.

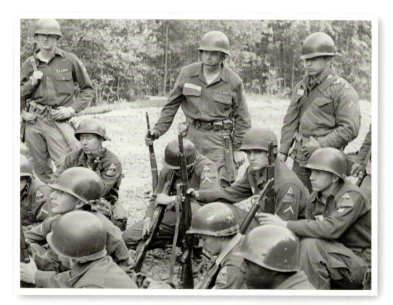

Elvis with members of the 32nd Tank Battalion, Third Armored Division, 1959.

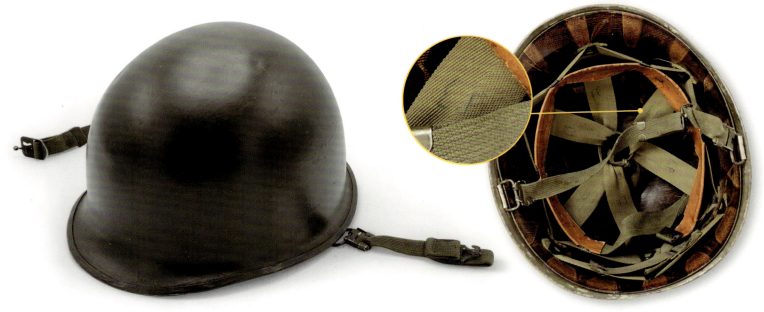

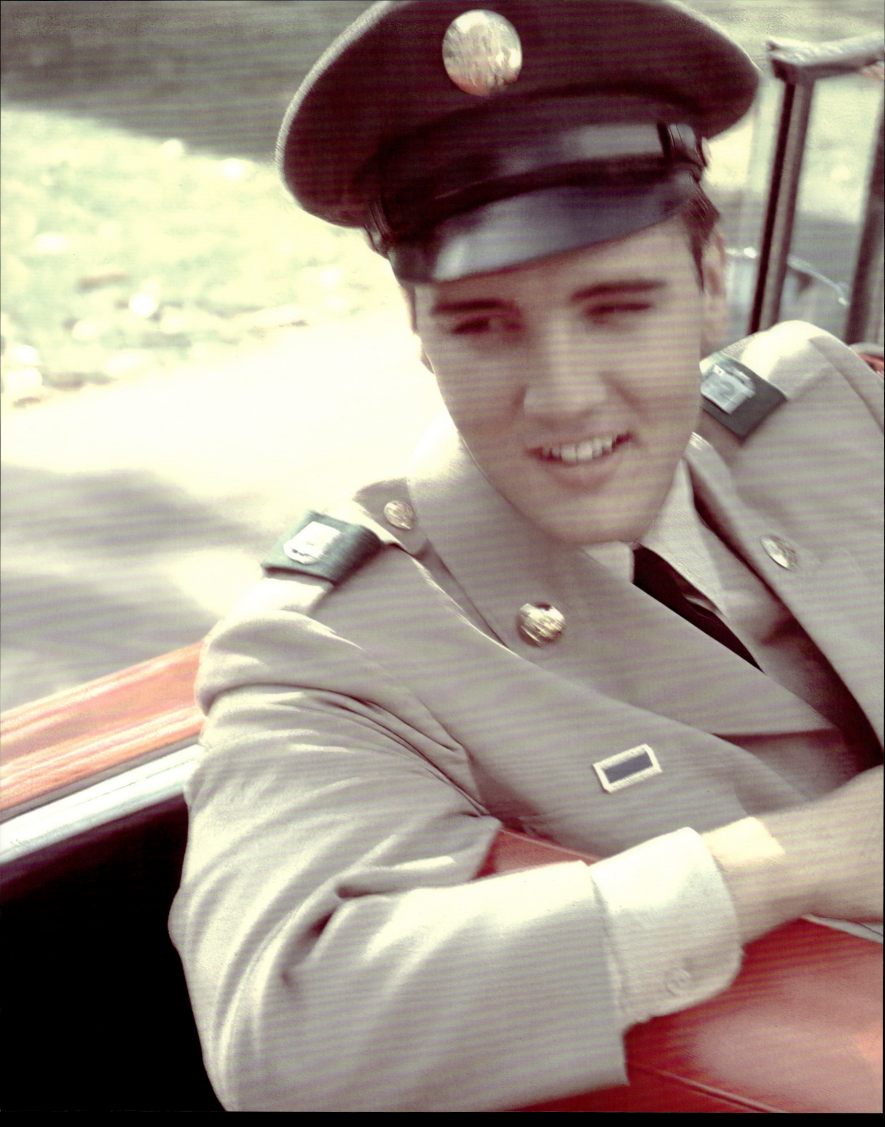

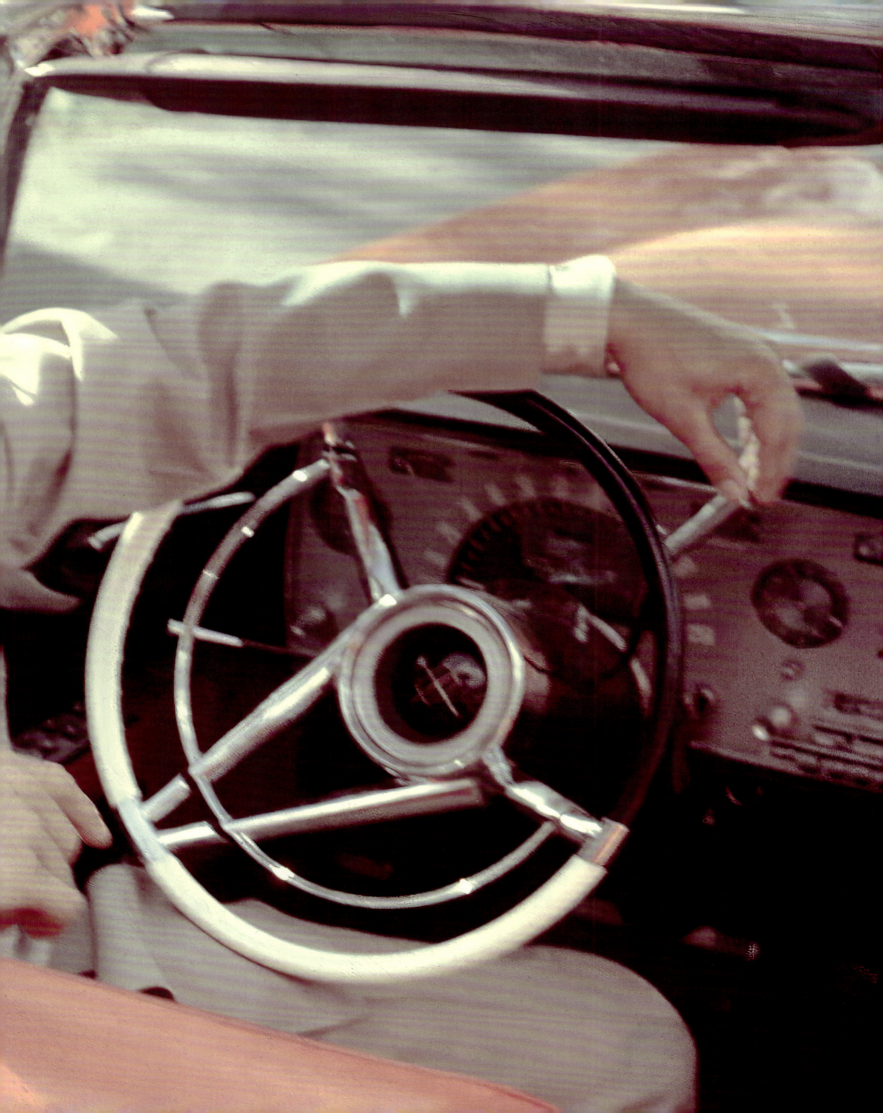

▼ BONGOS (GIFT FROM PRISCILLA) ▼

CHRISTMAS IN GERMANY

What do you get the man who has everything—and who, if he doesn't have it, can buy it pretty easily? That was the dilemma facing Priscilla Beaulieu when she spent her first Christmas with Elvis in December 1959. Elvis was in the final months of his time in the army, still in Germany, celebrating the holiday with his family and friends in Bad Nauheim. Priscilla spent considerable time looking at different shops, trying to find something that Elvis would like, with a price that would fit her budget. Finally, she settled on a pair of Sonor bongos that she noticed in a music shop, attracted by their gleaming brass trim. Although Elvis's friends assured her he'd like anything she gave him, she was still nervous when they exchanged gifts on Christmas day, and wasn't fully convinced when he laughingly exclaimed, "Bongos! Just what I always wanted!" when he opened the package. But she was touched by how he prominently displayed them by his guitar, and he made sure they were securely packed as he made preparations to return home from Germany.

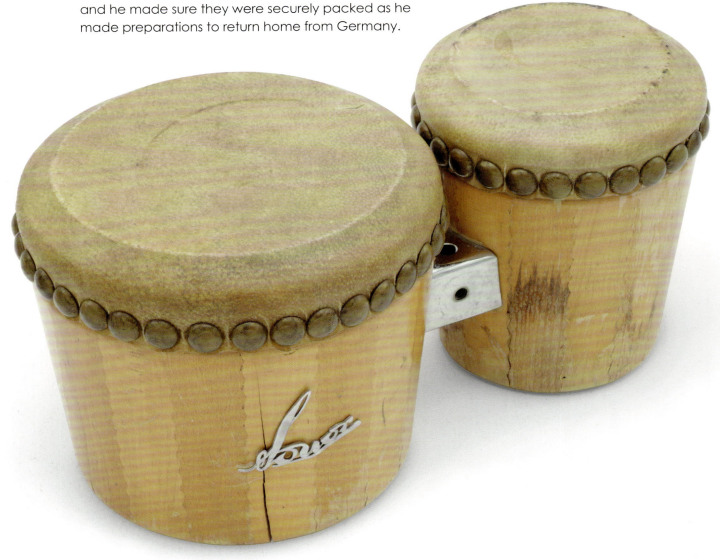

Previous page: Elvis in uniform at Graceland, June 1958.

Above: Elvis and Priscilla in Germany, 1959.

SINATRA TIMEX SHOW PIECES, ARMY DRESS HAT

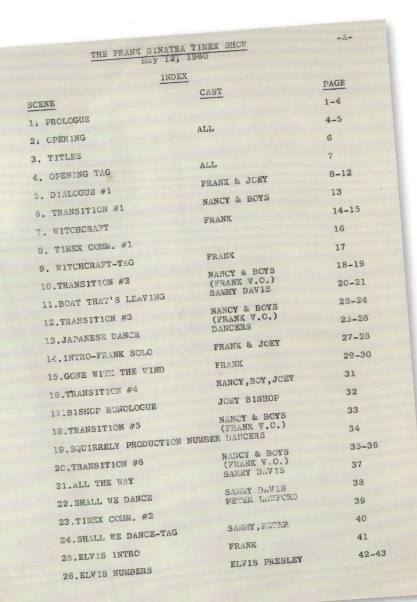

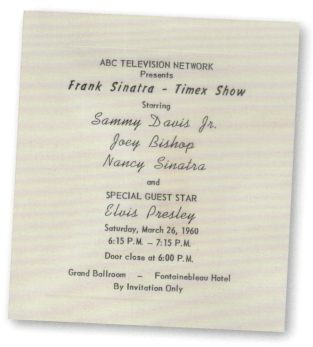

WITH THE CHAIRMAN OF THE BOARD

The Frank Sinatra Timex Special: Welcome Home Elvis was Elvis's first major public appearance after he left the army. Promotion for the show had begun as soon as he stepped onto American soil on March 3, 1960, at Fort Dix, New Jersey, where he was met by Sinatra's daughter Nancy, who presented him with two dress shirts as a gift from her father. Three weeks later, Elvis was in Miami to tape the special (which aired on May 12). The "Index" lists the running order for the show. Elvis appears in the opening number (wearing his dress blues, including this hat), then returns to perform both sides of his just-released single, "Stuck On You"/"Fame and Fortune." Resplendent in a smart tuxedo and a towering pompadour, Elvis is clearly glad to be performing again. Then it's time for a bit of fun. Frank joins Elvis on stage with the suggestion that they sing one of each other's hits, Frank taking "Love Me Tender," while Elvis opts for "Witchcraft." The two playfully spar throughout before harmonizing on the final lines of "Love Me Tender." "Man, that's pretty!" Frank says at one point. Yes, it certainly is.

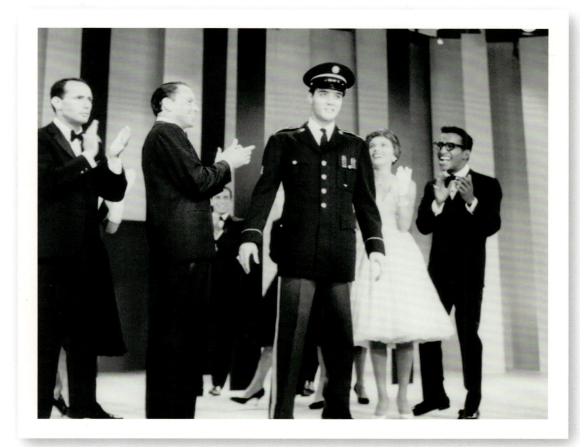

Left: (from left) Joey Bishop, Frank Sinatra, Nancy Sinatra, and Sammy Davis, Jr., give Elvis a warm welcome home on the show.

▼ BLACK VELVET SLIPPER ▼

THE CHARITY SHOW SHOE

It's a single shoe. And you know it's Elvis's because of the personalized "EP" on the buckle. But it's a memento of a very special occasion. Elvis hadn't given a live performance for over three years. Now he was making his first post-army appearances at two shows being held at the Ellis Auditorium in Memphis on February 25, 1961, to benefit local charities. Elvis was nervous, although, as he joked at the day's press conference, he was more nervous when he'd recently performed on the Sinatra television special: "I was petrified, I was scared stiff." But at a pre-show luncheon, he received a diamond-studded watch and a plaque from RCA for having achieved more than 75 million in record sales, and both Tennessee governor Buford Ellington and Memphis mayor Henry Loeb declared it "Elvis Presley Day," which must've given him a boost in confidence. And when he first took the stage for the matinee show, the applause went on for three minutes—Memphis was thrilled to have him back. And Elvis gave them just they wanted, a performance packed with hits old ("Heartbreak Hotel") and new ("It's Now or Never"), a little gospel ("Swing Down, Sweet Chariot"), and a rousing close with "Hound Dog." The shows raised more than $50,000. Maybe one of the shoes got lost in a dance of celebration.

Opposite page: Elvis performing at the Ellis Auditorium in Memphis, 1961.

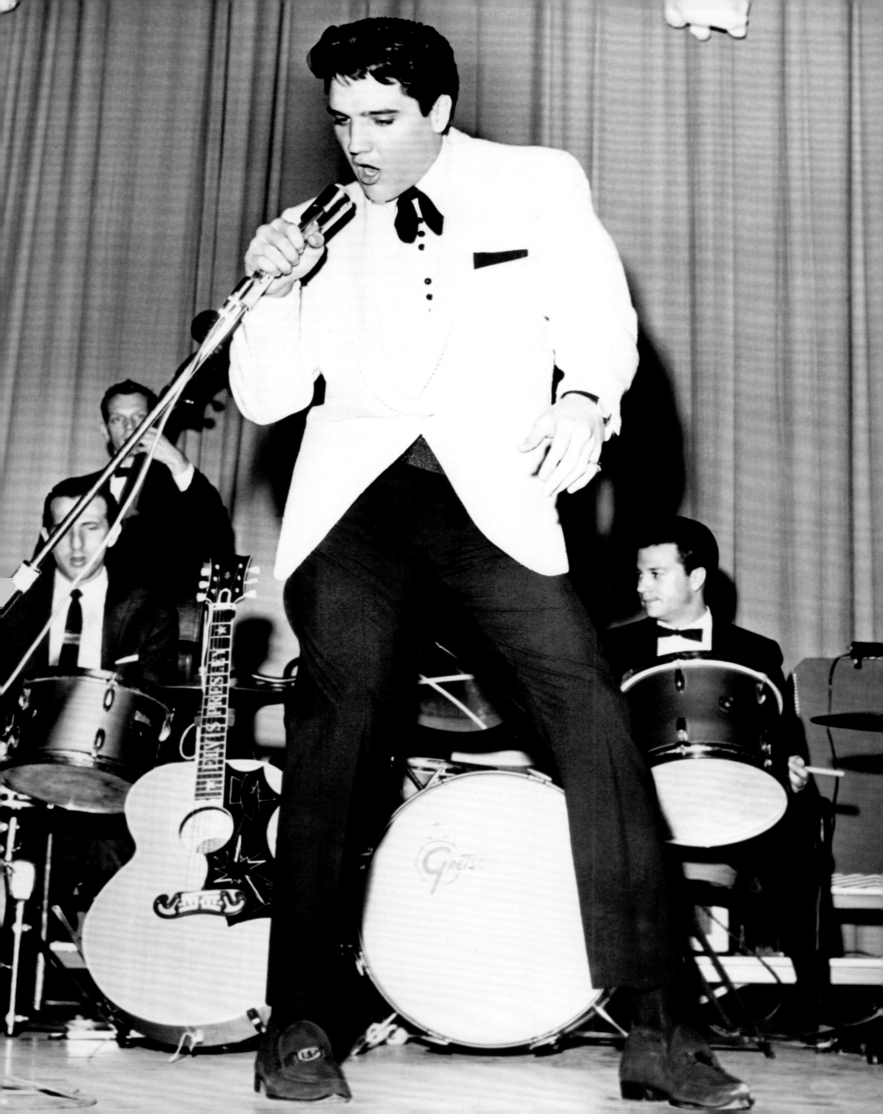

▼ CHARLIE RICH 45 RPM RECORD ▼

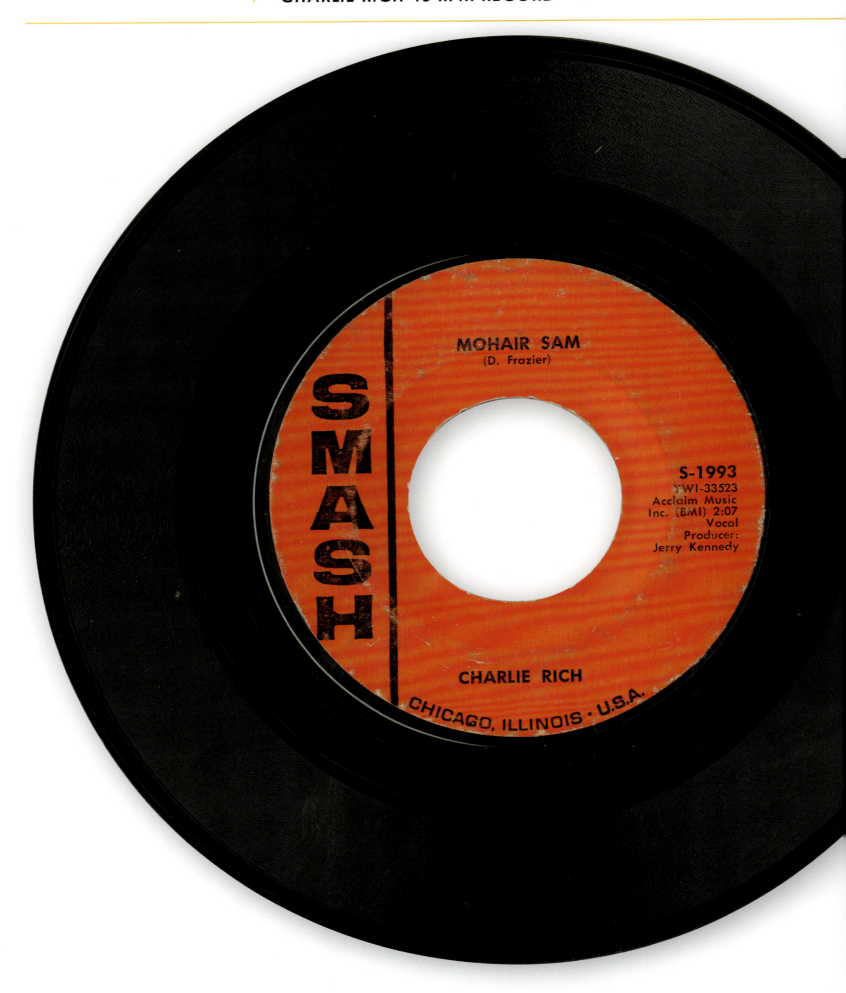

THE FAB FOUR SUMMIT

This record was not just part of Elvis's vast record collection. It was also playing during a very special occasion—the first and only time Elvis met with all four of the Beatles.

Elvis and his manager had sent the "Fab Four" a congratulatory telegram when they made their debut on *The Ed Sullivan Show* in 1964. For their part, the Beatles loved Elvis; John Lennon had famously said "Before Elvis, there was nothing." But it took a while to set up a meeting, which finally happened on August 27, 1965, at Elvis's home in Bel Air, California. As the four were ushered in, the first thing they heard was Charlie Rich's latest record, "Mohair Sam," playing. Then they saw Elvis sitting on the couch, bass in hand, strumming along with the record, which was played over and over again; it was obviously his "record of moment," Paul McCartney recalled. Everyone soon settled in for the evening. Paul (the Beatles' bassist) gave Elvis tips on how to play bass. Ringo Starr shot pool with Elvis's buddies. John entertained everyone by speaking in funny voices. And they all admired Elvis's TV remote control—the first one they'd ever seen. George Harrison later recalled the visit as a high point of the tour. It was a night with their idol they would never forget.

PART 4 ELVIS AT HOME

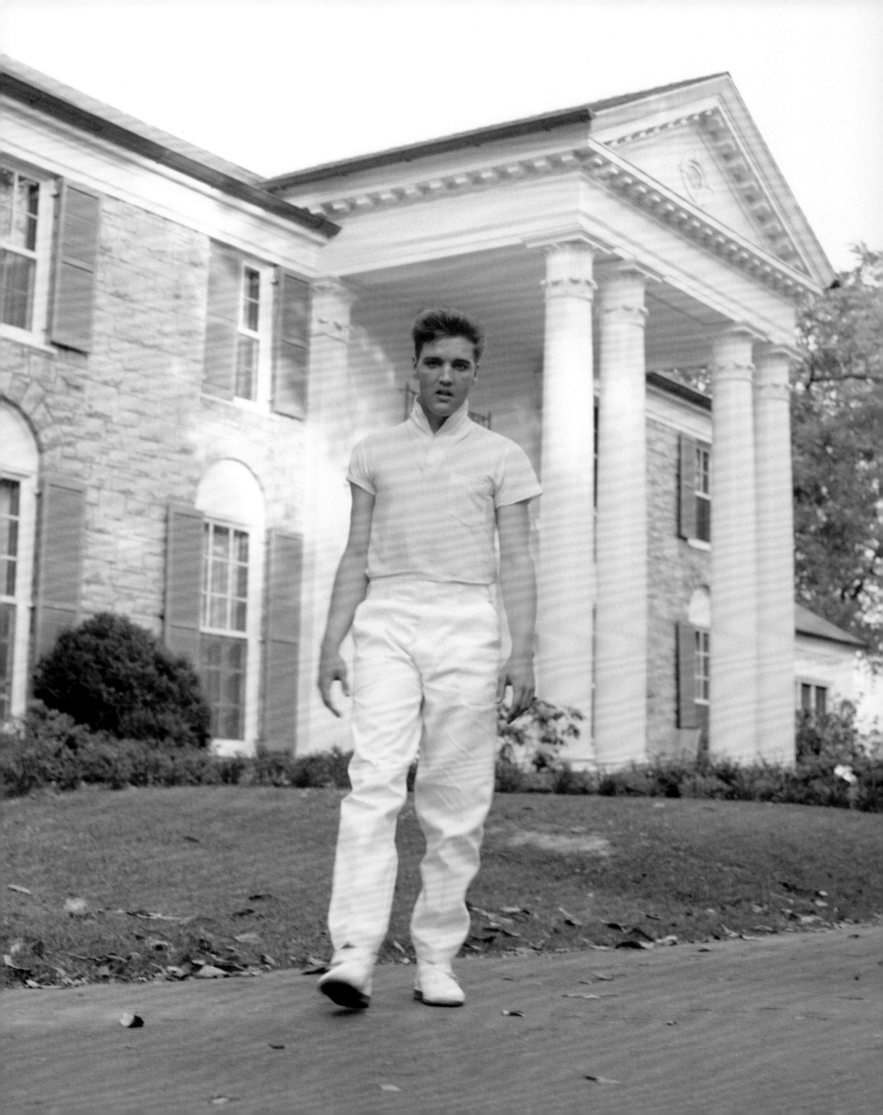

GRACELAND

THE KING'S PALACE

Elvis was finishing up work on his second film, *Loving You*, when his parents called him with exciting news. They'd found a new home that might be just what they were looking for: Graceland. And as soon as Elvis saw the property he knew they were right. The property, close to fourteen acres, was once part of a 500-acre farm owned by Grace Toof. The farm took on the nickname Graceland after its owner. Grace's niece, Ruth, and her husband would build a home on a portion of that farm in 1939, officially naming it Graceland in honor of Aunt Grace. The rural setting meant the family could have plenty of privacy. The home was Elvis's refuge, and, as he once told a friend, "I never feel like I'm really home until I get back to Graceland."

Buying the house for $102,500, Elvis would only end up mortgaging $37,500. The difference between the sale price and the mortgage was Elvis's down payment and money given to him on the trade for his house on Audubon Drive.

The mailbox on the next page has Graceland's original address: 3764 Highway 51. On June 29, 1971, that stretch of road was officially renamed Elvis Presley Boulevard, with the first street sign erected in January 1972.

Upon moving in, Elvis hired interior designer George Golden and his company to decorate his new home. Elvis had seen the marble lions at another home in his previous neighborhood and paid $1,000 for them to be installed at his new home. Over the years, there would be further changes at Graceland, both large and small, and Elvis loved being able to update his home according to his changing tastes.

Previous page: Elvis and Priscilla at the hospital after Lisa Marie's birth, 1968.

Opposite page: Elvis on the front lawn of Graceland, 1958.

Below: Graceland with the marble lions in front.

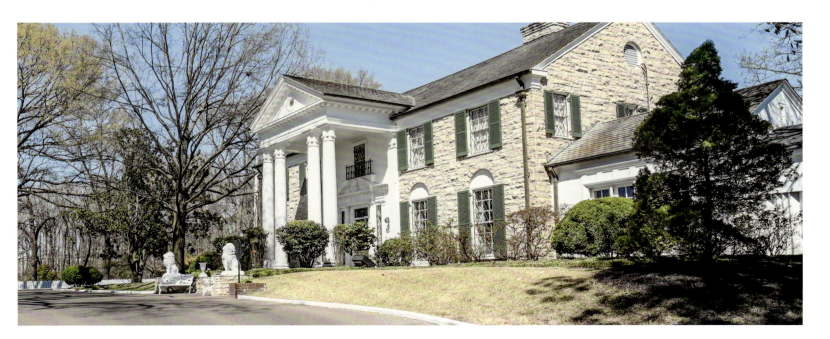

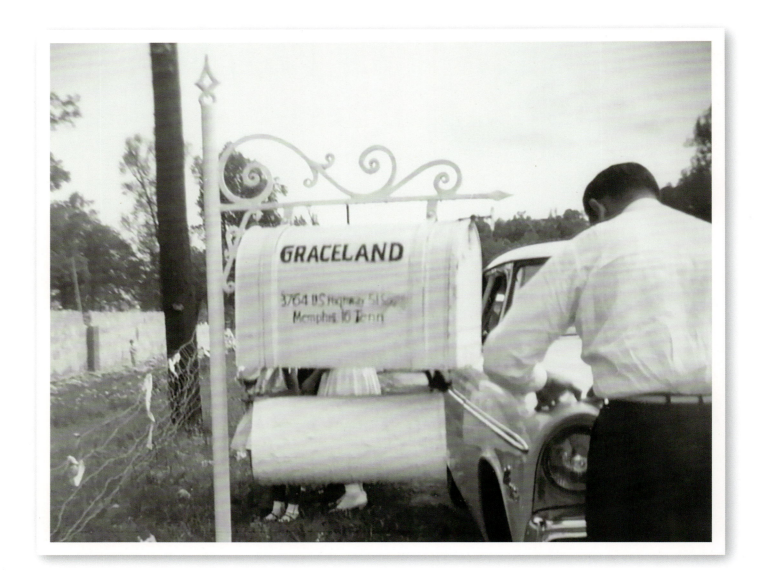

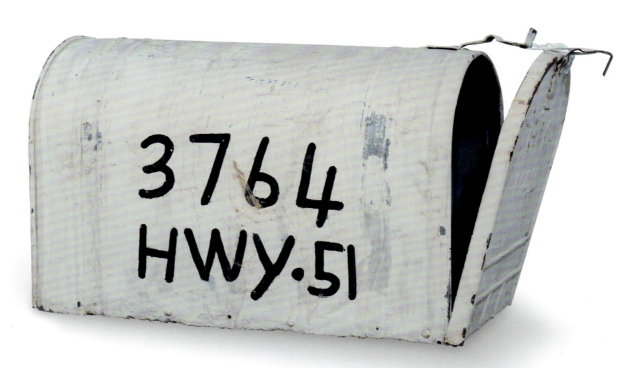

Opposite page: Elvis signing autographs for fans at the gates of Graceland, 1957.

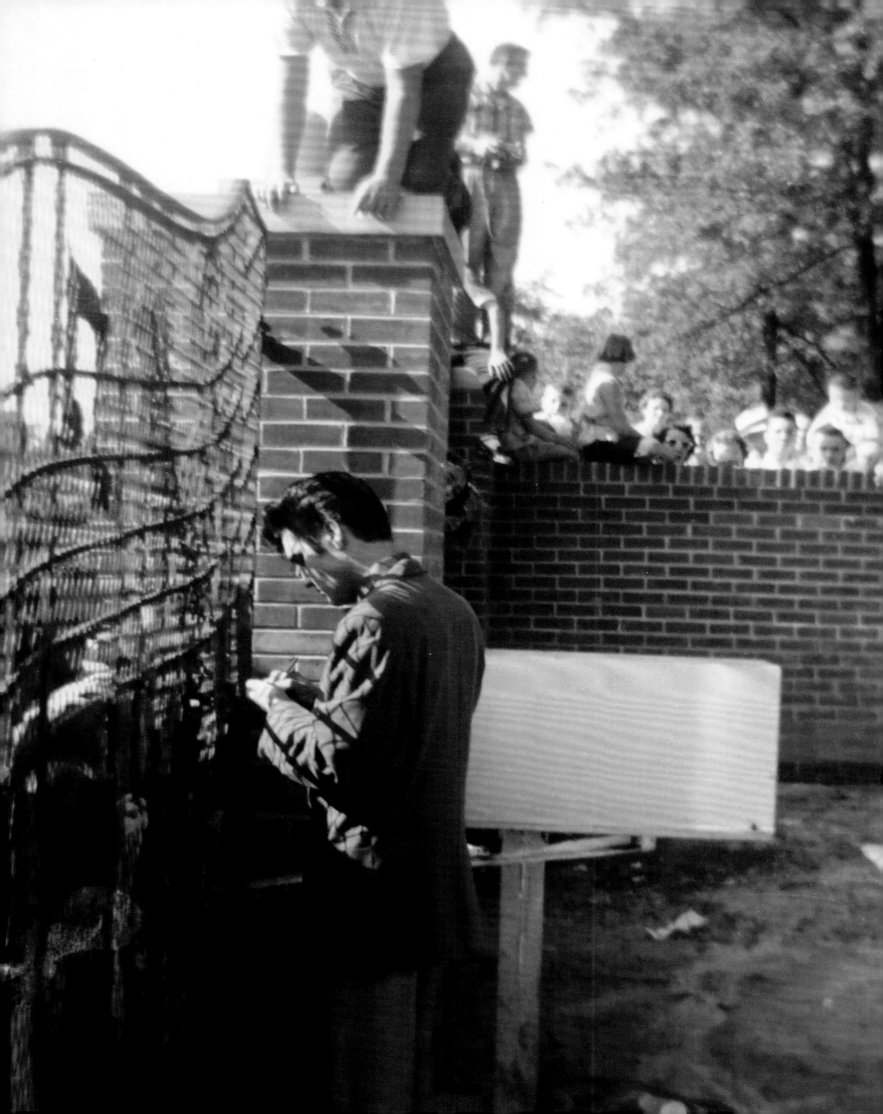

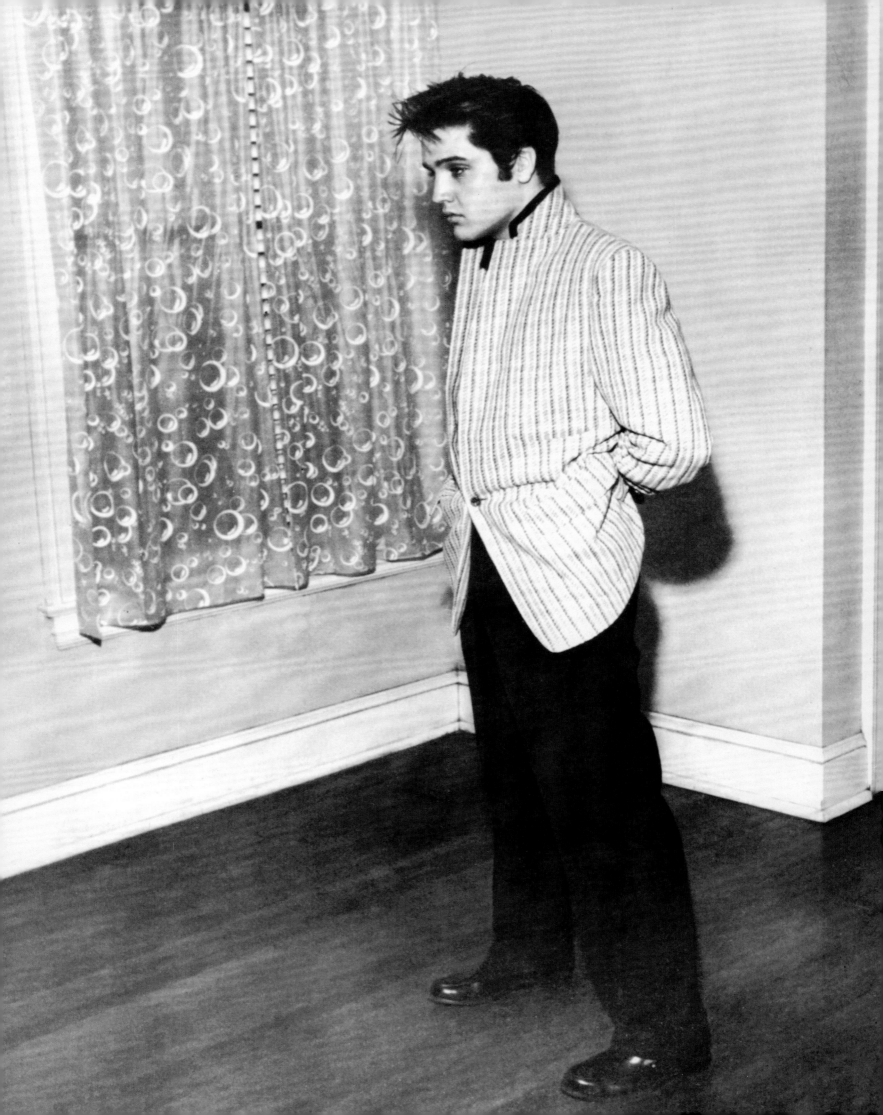

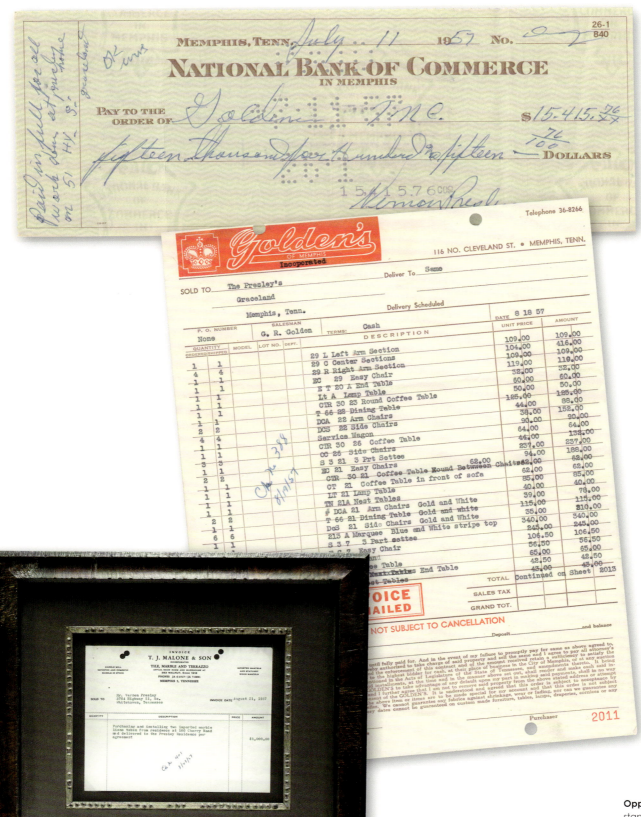

Opposite page: Elvis standing in what would become his bedroom, upstairs at Graceland, 1957.

Above: Invoice and bank check for furniture delivered to Graceland, 1957.

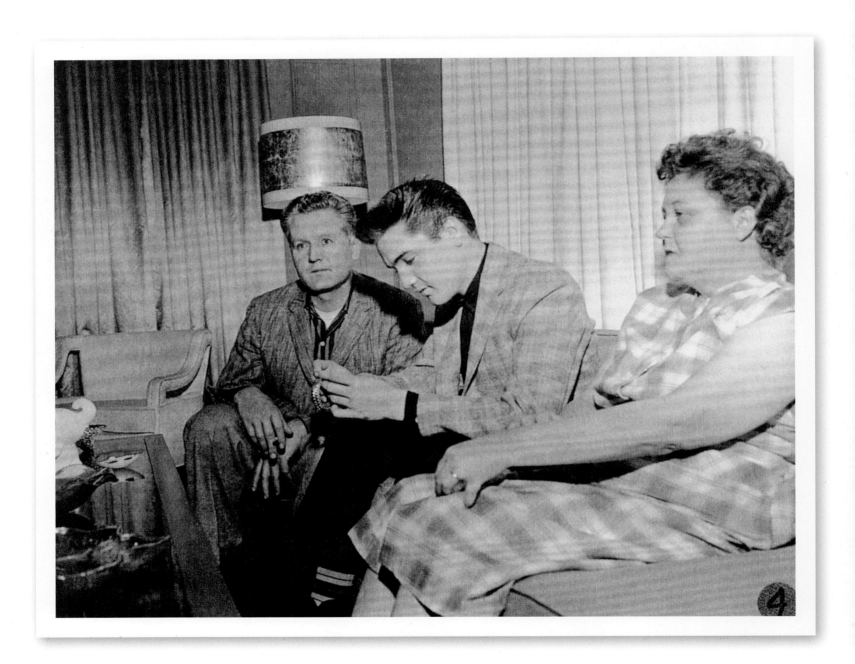

Elvis and his parents relaxing at Graceland.

"*Well, I guess they're just like myself. They're very thankful for it. We've always had a common life. We never had any luxuries, but we were never really hungry, you know, and I guess they're just, you know, they're real proud, just like I am.*"

—Elvis, on his parents' feelings about his success

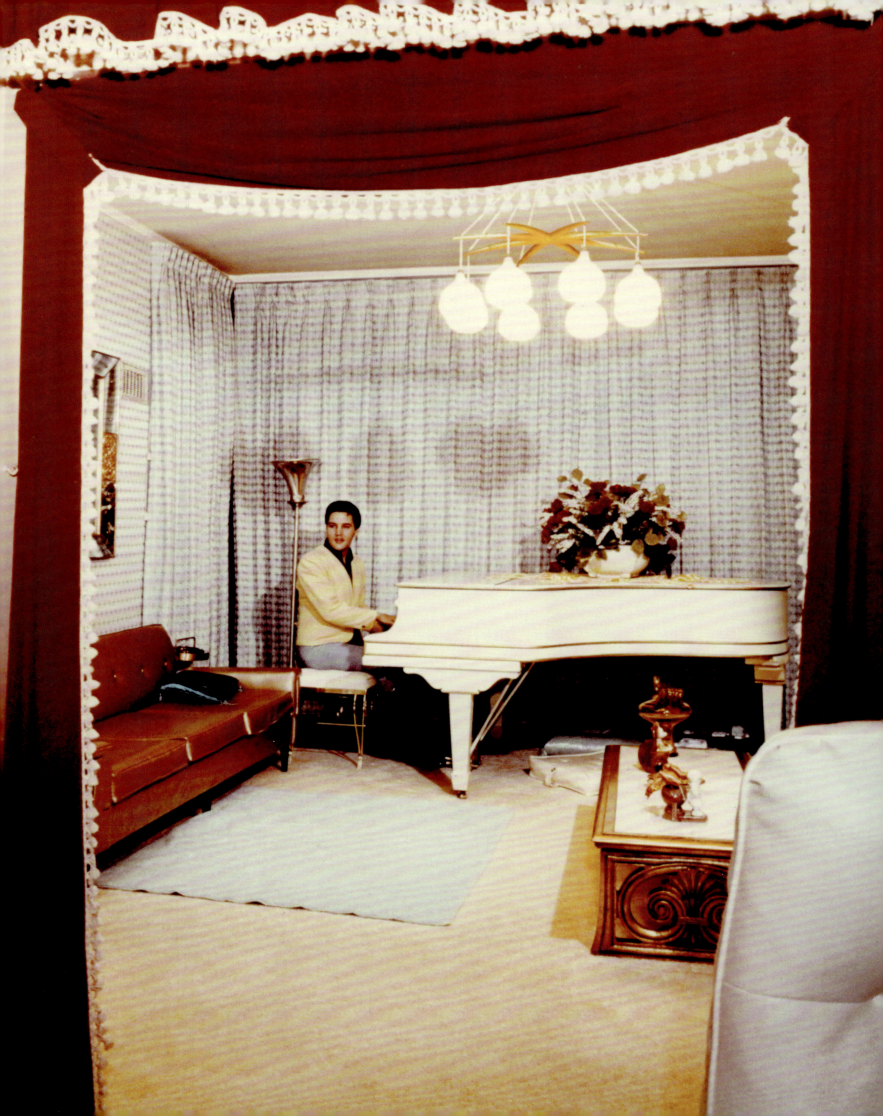

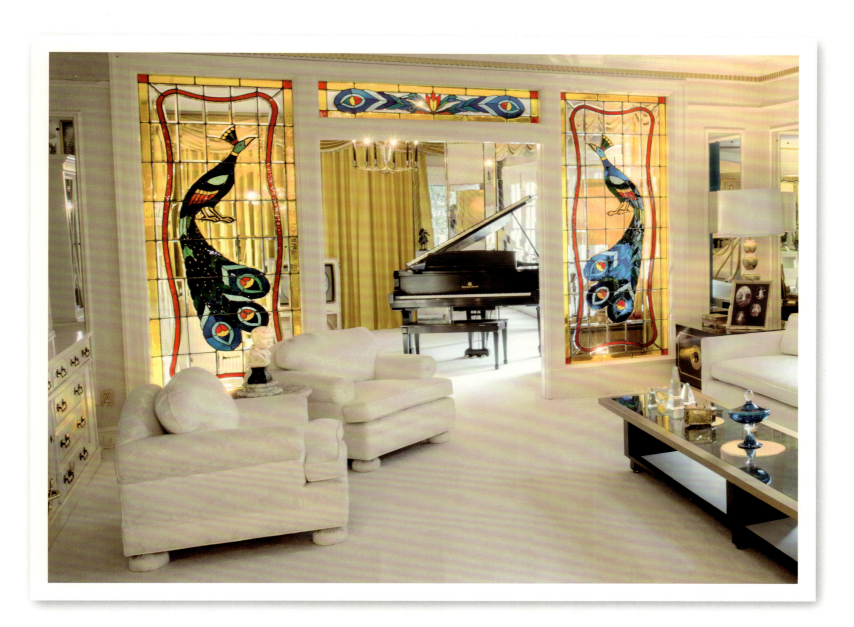

Graceland went through several interior designs during Elvis's lifetime; on the left is the music room in 1966, and on the right is how it looked around the time of Graceland's opening to the public.

▼ THE GOLD PHONE ▼

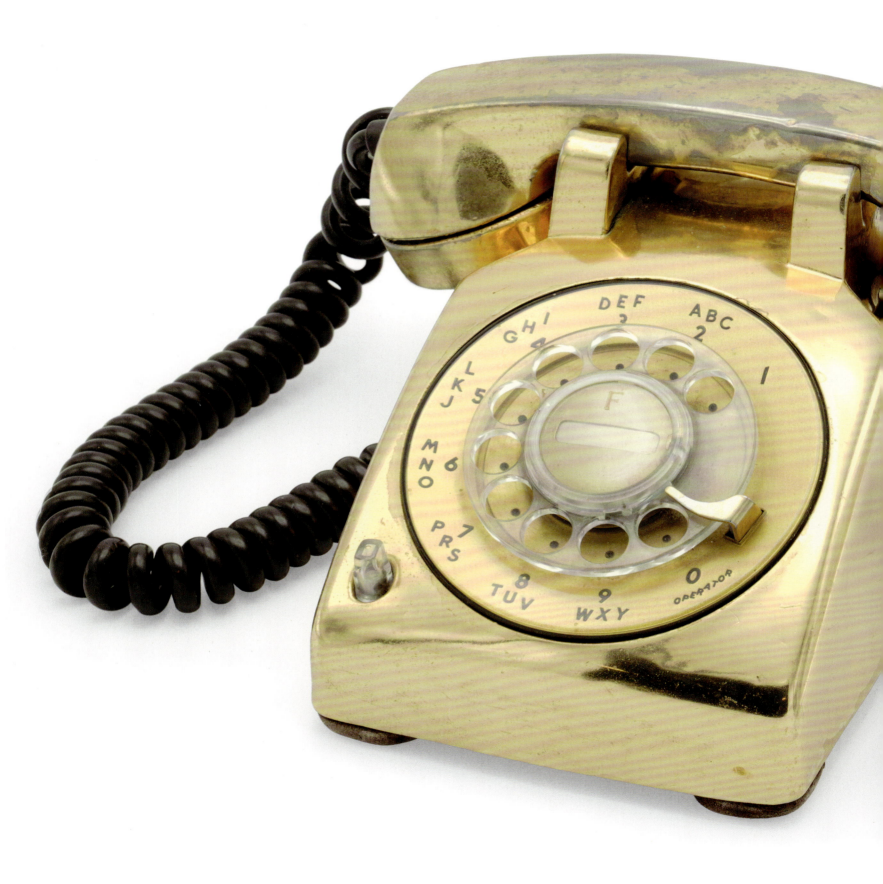

100

THE GOLDEN TOUCH

It's a telephone. An item that's been a standard feature of American homes for decades now. Back then, telephones did just one thing; they made phone calls, and that was it. This telephone also has a hold button, which makes it a bit more upscale. But, in general, a telephone was a very utilitarian device. Still, that didn't mean you had to leave it looking like it was just another appliance in the household. With enough imagination, you could jazz it up a bit. And Elvis loved upgrading and accessorizing his belongings. So, it was no surprise that when he decided to revamp the telephone in his bedroom, he had it gold-plated. Why not? It certainly made it more fun to use. And, given his fondness for gold things—jewelry, the gold-plated buckles on the seat belts on his private plane, the *Lisa Marie*, the gold of the TCB logo—his personal phone couldn't have been any other color but gold.

FIRST AND LAST PIANO

TICKLING THE IVORIES

When Elvis purchased the first piano for Graceland, he bought an instrument that had a pretty interesting history of its own. In fact, he'd seen it many times before, while attending shows at Ellis Auditorium, watching numerous musicians playing on the venue's house piano—a William Knabe & Co. grand piano. In 1957, Elvis had Jack Marshall, who played piano with the Blackwood Brothers and ran Jack Marshall Pianos-Organs, acquire the Knabe for him while Ellis Auditorium was being remodeled. Elvis paid $818.85 for it, and then had it customized, painted white with gold trim, with a matching piano bench featuring a white cushion and gold legs. It was then given pride of place in Elvis's music room, which was just off the living room at Graceland. In addition to guitar, Elvis could also play piano, and whenever he had friends over, he loved to sit and play the instrument, encouraging everyone to sing along; he would most likely play gospel songs. In the 1970s, Elvis purchased the black Storey & Clark piano shown below; it remained in the music room until his death. Recently, the white piano was moved back into the music room, but the black piano is still on view elsewhere at Graceland.

Right: The last piano Elvis bought for Graceland, shown in the music room.

Opposite page: The original white piano in the music room at Graceland today.

Following page: Elvis and friends gathered around the white piano in the music room.

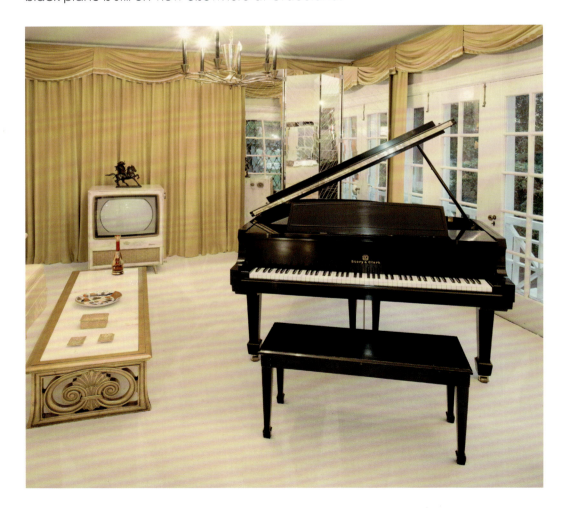

102

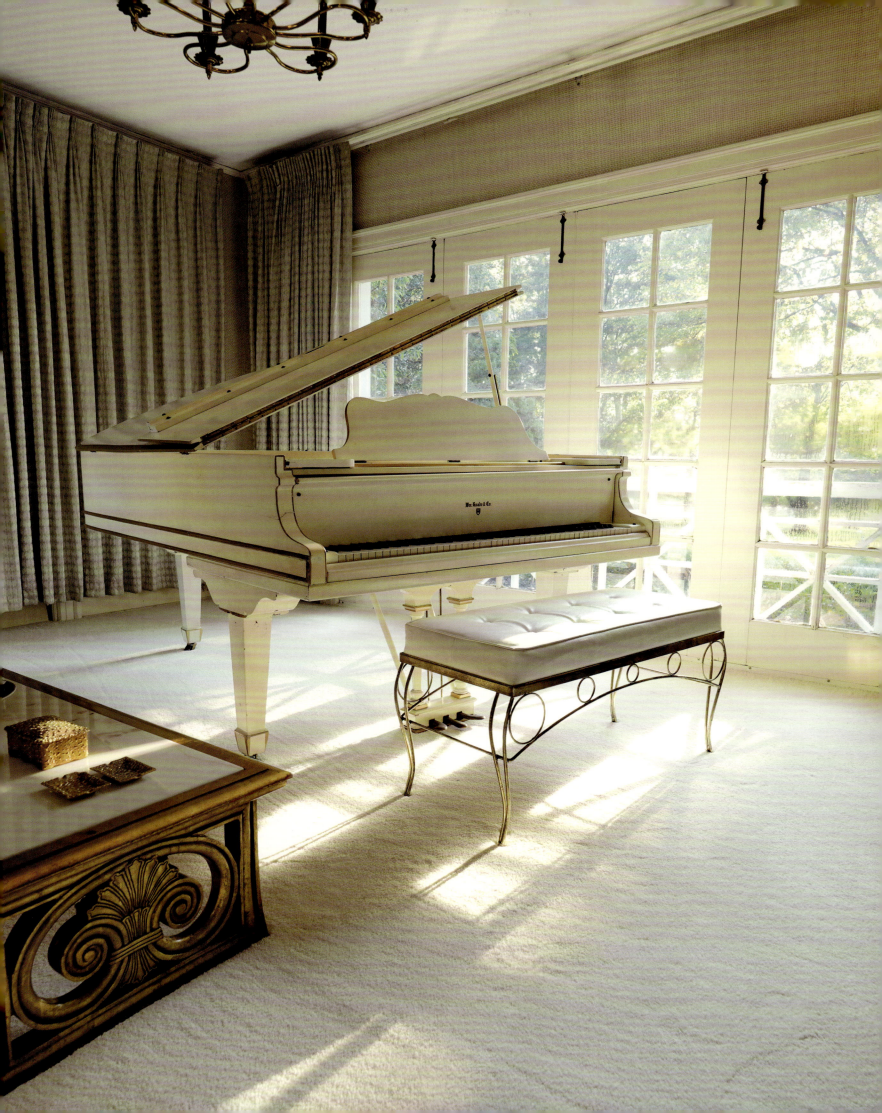

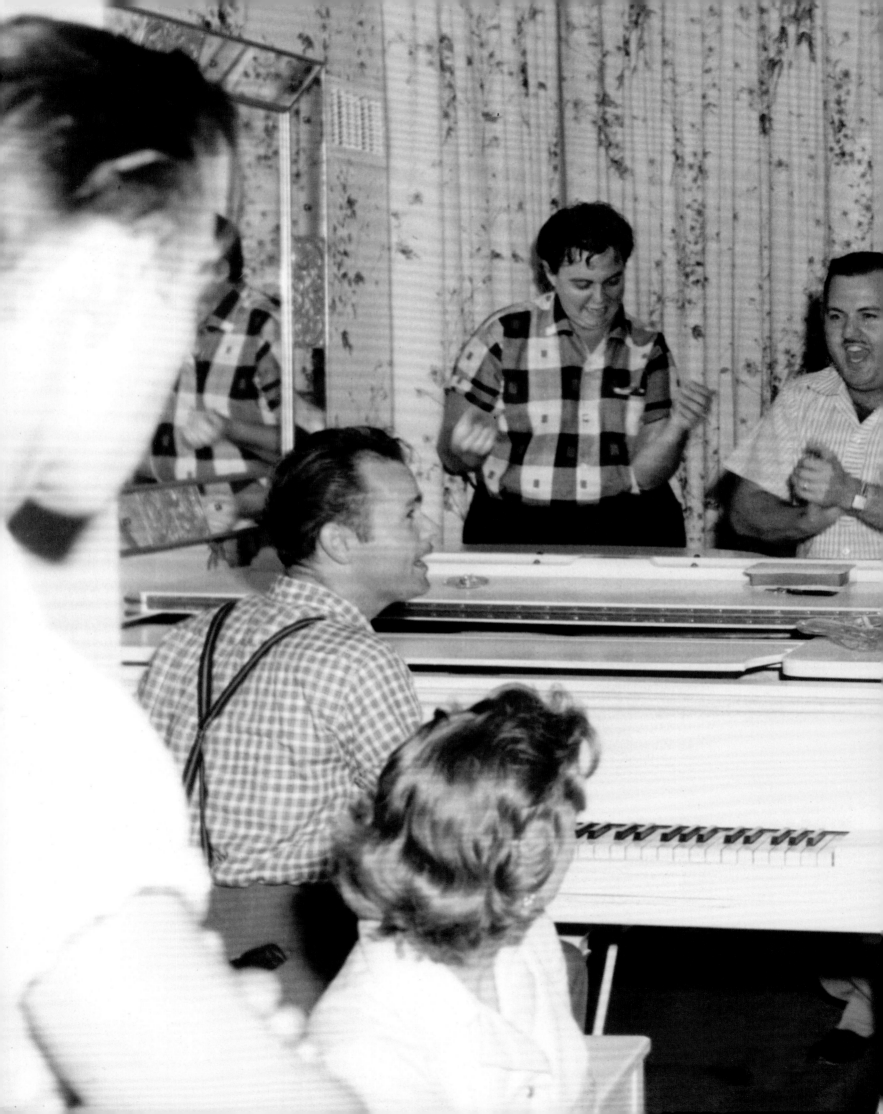

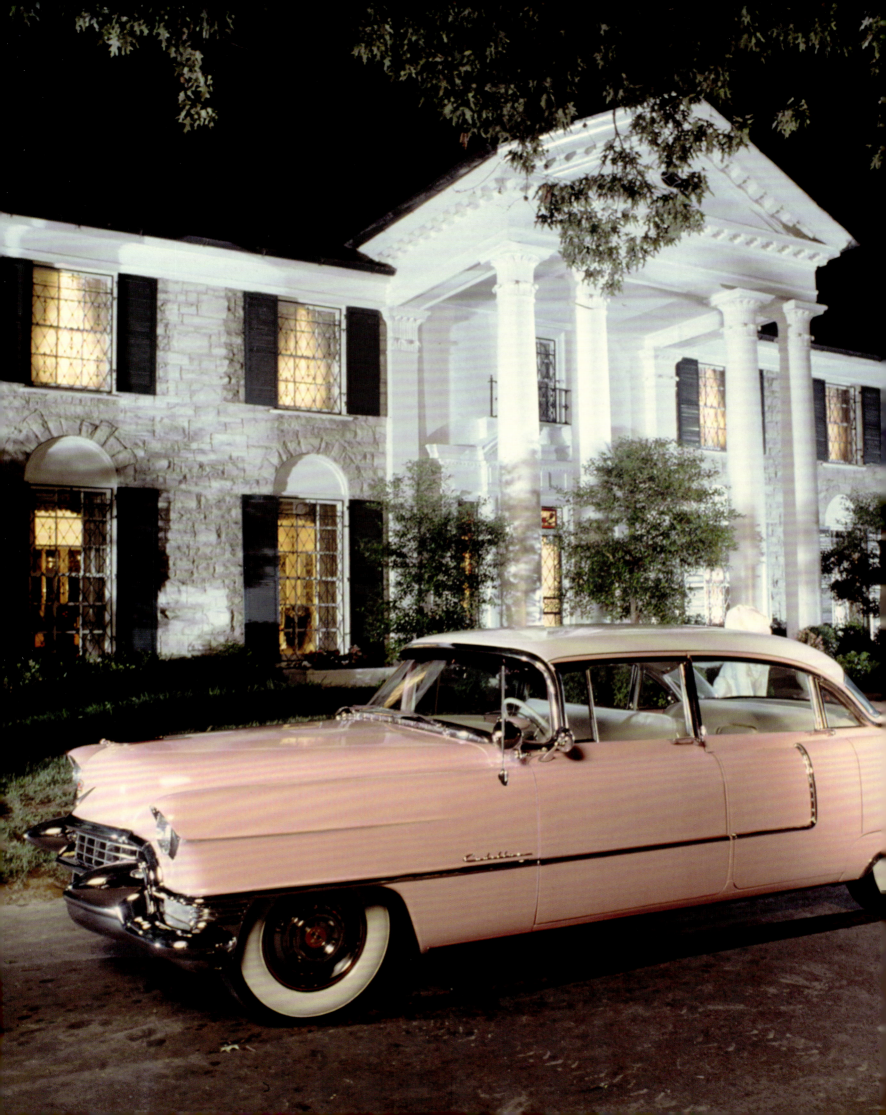

▼ THE PINK CADILLAC REGISTRATION AND THE KEY WALLET ▼

CAR CRAZY

Elvis is well-known for his love of cars, and the car most associated with him is the Cadillac. The first Cadillacs were manufactured in 1902. They were eventually regarded as among the top luxury vehicles in the US; it was the car every driver aspired to own. Elvis's first Caddy was a 1954 Cadillac Fleetwood 60 Special, which he purchased in March 1955. Sadly, while driving to a gig in Texarkana, Arkansas, on June 5, it caught fire and was destroyed; Elvis was heartbroken. But it wasn't long before he was driving another Cadillac, and over the years he would own more than thirty such cars (not to mention the ones he purchased and gave away). His 1960 Cadillac Series 75 Fleetwood limousine was customized with 24-karat gold-plate highlights and trim and featured a telephone, refrigerator, small TV set, and a record player, among other amenities. In the mid Sixties, it was sent out on tour and made it all the way to Australia and New Zealand. The registration form shown here is for his most well-known car, a 1955 Cadillac Fleetwood sedan. Originally having a blue body and black roof, Elvis had the body repainted pink. Eventually he changed the roof to white before gifting the car to his parents. He paid $13.50 to register the vehicle.

Elvis liked to keep his car keys in a wallet, and this wallet features the keys for two Mercedes. There's a German Abus key that was likely for a padlock. But what did the key emblazoned with the initials "EP" open? It remains a mystery.

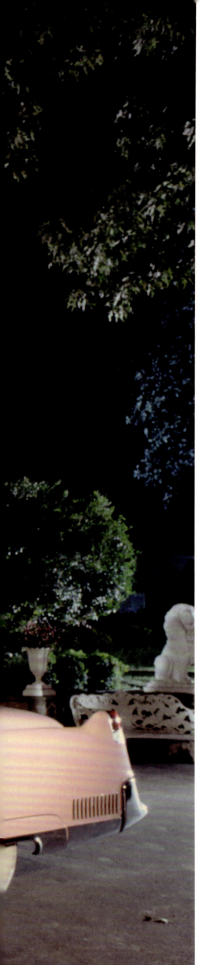

Opposite page: The pink Cadillac parked in front of Graceland.

Following page: Elvis with girlfriend Yvonne Lime. His mother is seated in the Cadillac, 1957.

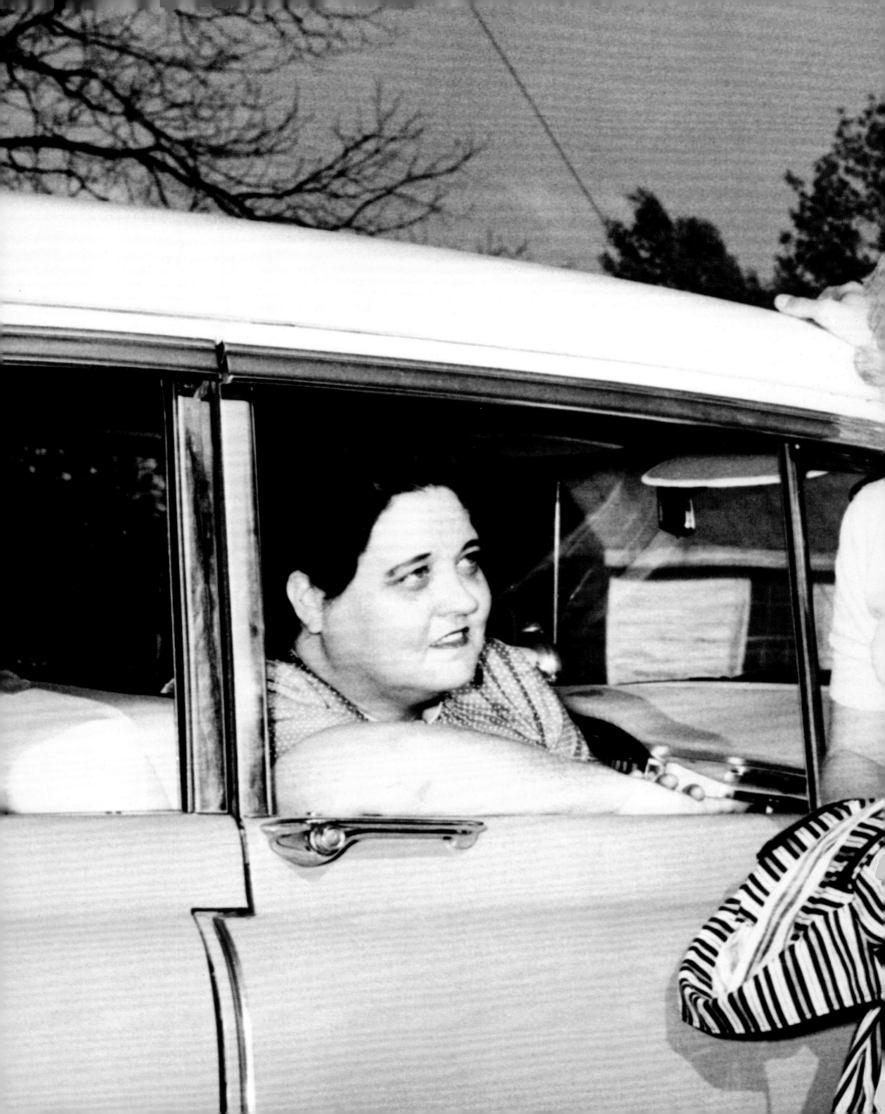

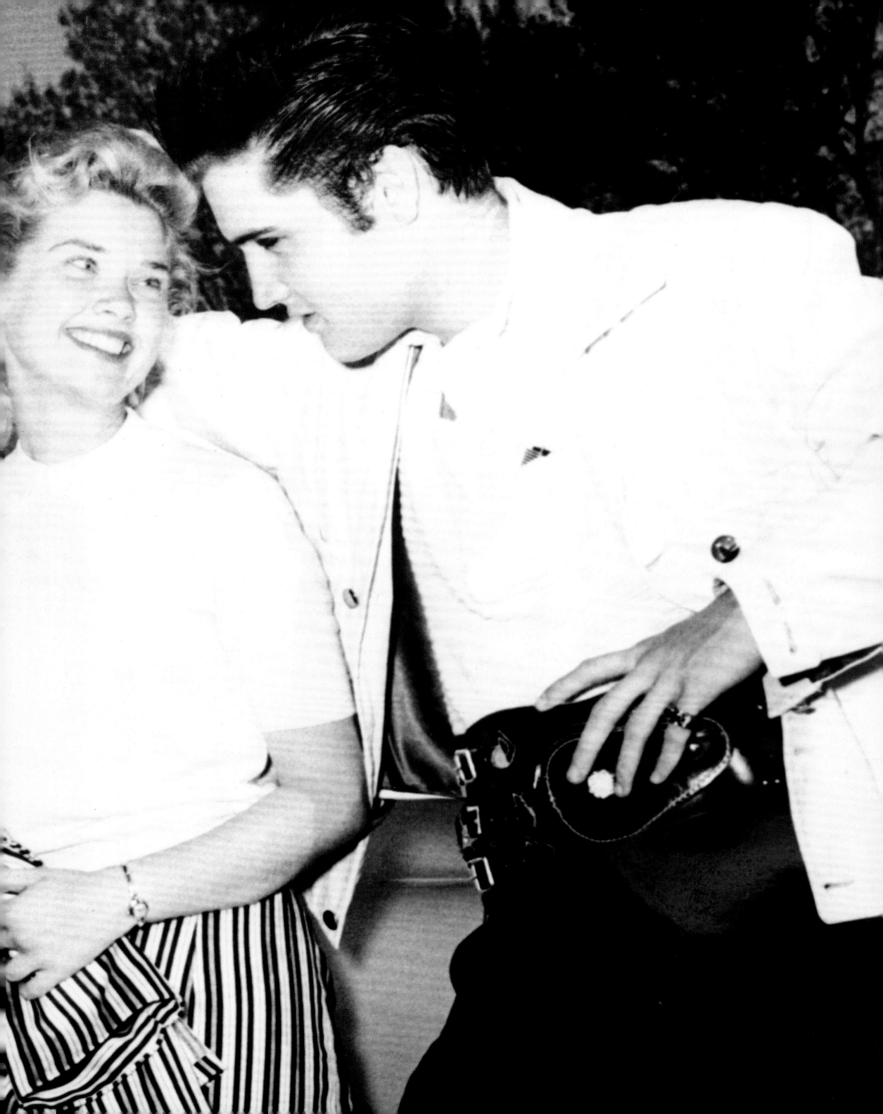

▼ FOOTBALL HELMET, JERSEY, PLAY CARD ▼

GETTING ON THE GRIDIRON

Elvis was a major football fan. His mother wouldn't let him play on his high school football team—as always, she was worried about his safety—but he enjoyed playing touch football with his friends whenever he got the chance. He loved watching games and analyzing the plays, putting himself in the coach's shoes. He later befriended NFL players, such as Cleveland Browns offensive guard Gene Hickerson, who would send Elvis tapes of the games for him to study. The Browns were his favorite team, but he also followed the Pittsburgh Steelers and became friends with their quarterback Terry Bradshaw. He even called Bradshaw one day and invited him to come over and throw a few balls around with him, but Bradshaw's schedule wouldn't allow it (an invitation he still regrets having to turn down). He also formed his own squad, the Elvis Presley Enterprises Football Team, which he outfitted with their own uniforms; the colors were red, white, and blue. Seen here is one of the plays he wrote out for the team, along with a helmet and a team jersey. As he told sportscaster Harold Johnson, "Next to the entertainment thing and music, football is the thing that I enjoy best."

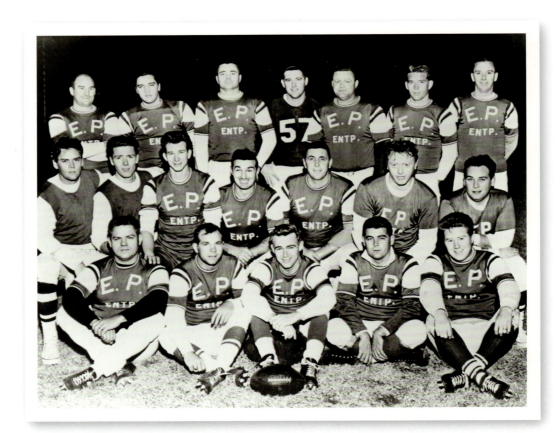

Right: Elvis (top row, second from left) with his team, the E. P. Enterprises.

Opposite page, top: Elvis on the gridiron, 1957.

110

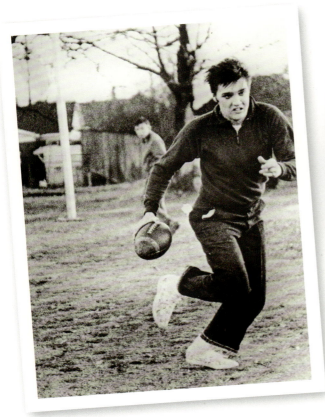
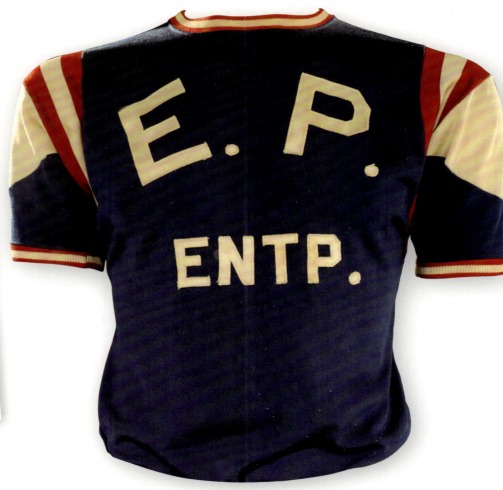
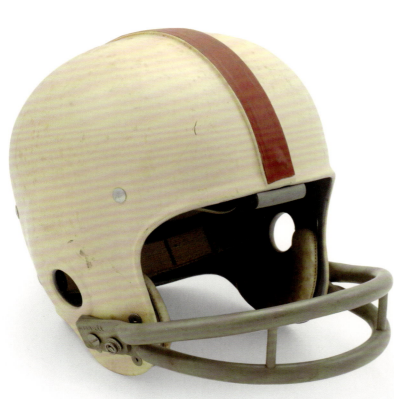
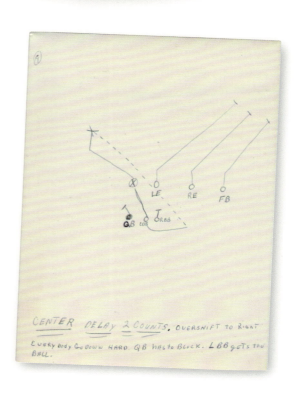

ELVIS'S SADDLE

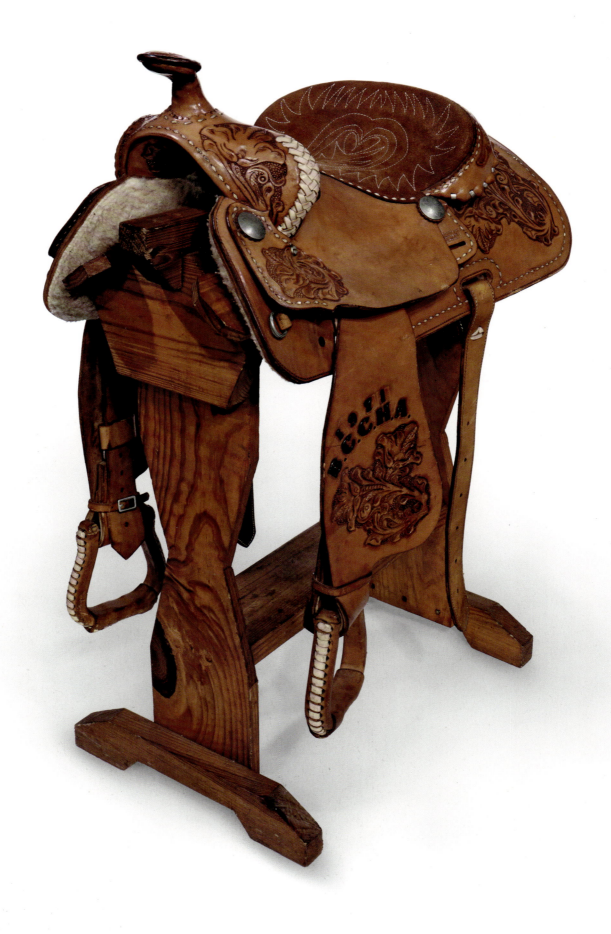

🏛 SADDLE UP!

It all began when Elvis bought a horse for Priscilla as a Christmas present in December 1966. He also purchased a horse for his friend Jerry Schilling's fiancé, Sandy, so Priscilla would have someone to ride with. The two had so much fun with their horses, Elvis bought a horse for himself. And his friends. And their wives and girlfriends. Before he knew it, Elvis had become a gentleman rancher. When Elvis developed a new interest, he went all out with it. A barn at Graceland was quickly remodeled to become a stable; in honor of Elvis's horse, Rising Sun, the barn was jokingly named the "House of Rising Sun" (in reference to the hit song by the British rock group the Animals). And when it became evident that Graceland was too small for his growing herd, he bought a farm in nearby Walls, Mississippi, rechristening it Circle G (later Flying Circle G), the "G" for Graceland. Elvis and his family and friends spent many happy days at Circle G, holding picnics, skeet-shooting, and riding the horses. This is a saddle from that halcyon period.

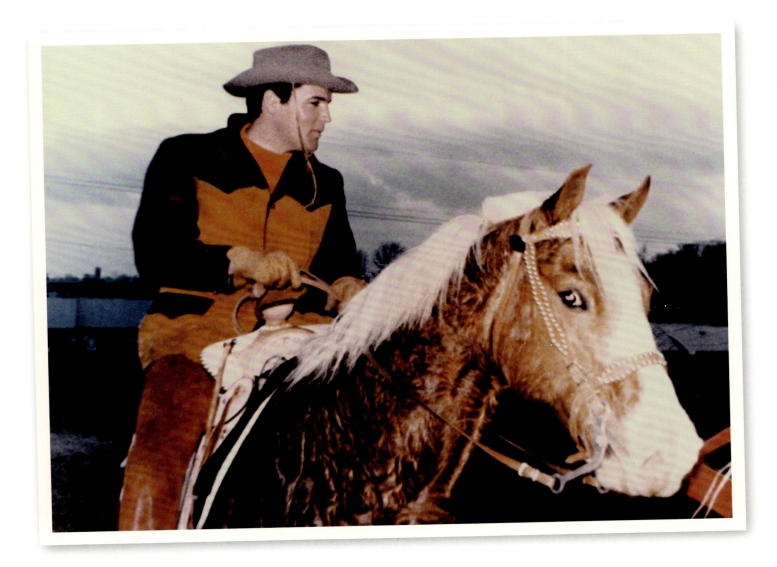

Elvis riding Rising Sun, 1967.

113

WEDDING CHINA AND INVOICE FOR WEDDING PARTY

LOVE AND MARRIAGE

Elvis proposed to his longtime girlfriend, Priscilla Beaulieu, in December of 1966. She happily accepted. Close family and friends were told, but everyone was sworn to secrecy. The date was set for May 1, 1967, just after Elvis had completed work on the film *Clambake*. The couple flew from Palm Springs to Las Vegas on Frank Sinatra's private jet in the early hours of the morning and got their wedding license at the Clark County Courthouse. The ceremony was held at the Aladdin Hotel, in the second floor suite of the hotel's owner, Colonel Parker's friend Milton Prell, at 11:45 am. After a press conference, there was a lavish buffet breakfast, featuring poached candied salmon and eggs Minette, among other treats. The cost was $2,500, not including the wedding cake. Almost as much was spent on champagne—just over $1,600. This china was used at the buffet breakfast and at a reception the couple held later at Graceland. You can still see it today, on the table in Graceland's dining room.

Elvis and Priscilla at their Aladdin Hotel wedding, May 1, 1967.

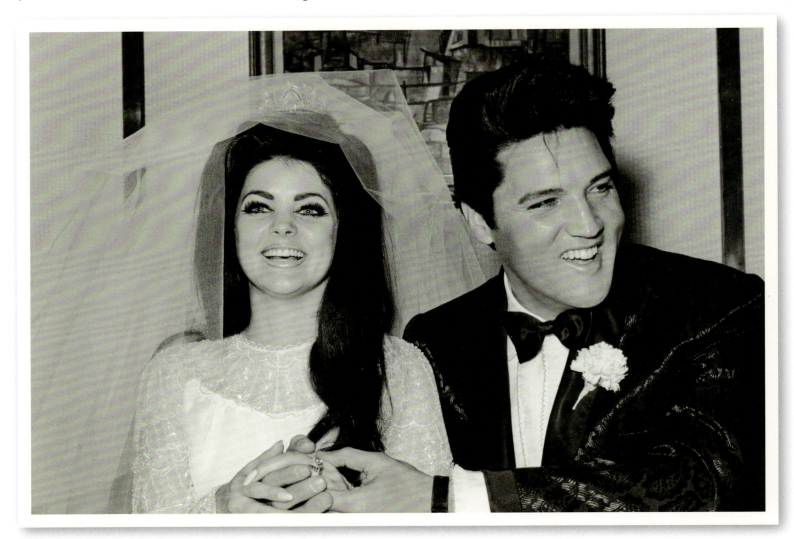

PHONE 736 - 0111

3667 LAS VEGAS BOULEVARD SOUTH
LAS VEGAS, NEVADA 89109

IMPORTANT

William Morris Agency
151 El Camino
Beverly Hills, California

Attn: Lew Goldberg

PLEASE DETACH HEADING AND RETURN WITH
REMITTANCE TO INSURE PROPER CREDIT.

STATEMENT

Copy to: Colonel Thomas Parker, MGM Studios

ITEM	DATE	DEBIT	CREDIT	BALANCE
Re: Elvis Presley Wedding	May 1, 1967			
Plane Charter		1,741.50		
Limousine Service		160.00		
Service to & from airport		86.25		
Musicians		138.60		
Gloves		19.28		
Judge Zenoff (food, lodging, transportation, services & outside expense)		408.17		
Wedding Party (room, food, beverage 2 suites, 21 rooms)		1,860.57		
Floral Arrangements		500.00		
Breakfast Buffet		2,500.00		
Wedding Cake		200.00		
Champagne (rooms, suites & wedding reception)		1,627.00		
Fruit Baskets (to suites & rooms)		80.00		

CHARGES AND CREDITS AFTER THE DATE SHOWN ABOVE WILL APPEAR ON NEXT MONTH'S STATEMENT.

3667 LAS VEGAS BOULEVARD SOUTH
LAS VEGAS, NEVADA 89109

LISA MARIE FOOTPRINT, NEWSPAPER CLIPPING, PHOTO ALBUM

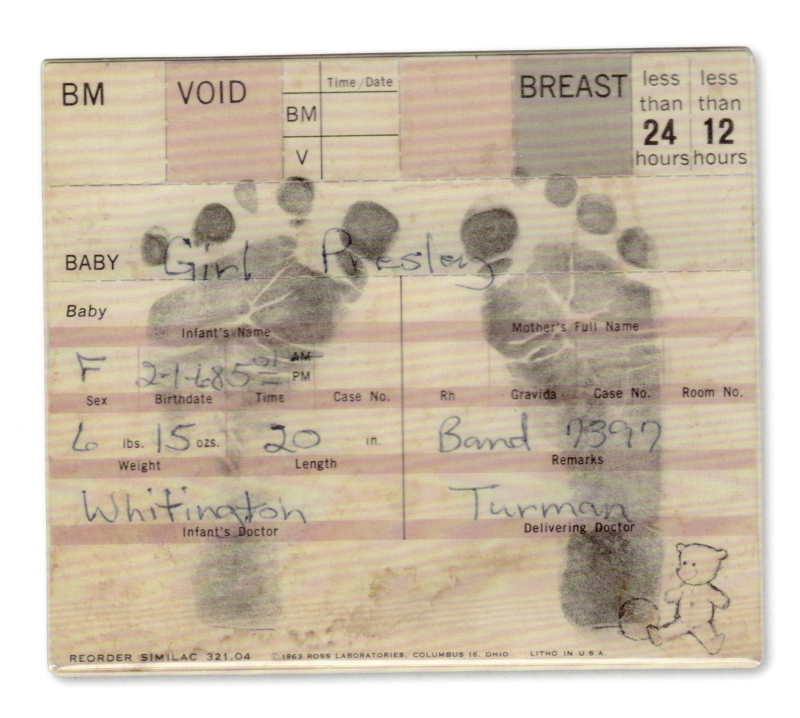

Opposite page, left: Elvis, Priscilla, and Lisa Marie in the Jungle Room at Graceland, 1968.

Opposite page, right: A clipping from the front page of the Memphis paper *The Commercial Appeal*, February 6, 1968.

A PRECIOUS BABY GIRL

When Elvis learned that he and Priscilla were going to become parents he was thrilled. He made the news public while making *Speedway*, announcing, "This is the greatest thing that has ever happened to me," as he passed out cigars to the cast and crew. Preparations were made at Graceland for the new arrival; her bedroom would always be well-stocked with toys. Lisa Marie Presley was born on February 1, 1968, at Baptist Memorial Hospital in Memphis. This form with her footprints notes she weighed just under seven pounds. She made her public debut on February 5, when she was photographed leaving the hospital with her proud parents, Elvis telling his friends "She's a little miracle." A story that ran in the local paper about her birth speculated on whether the newborn already "had a Presley song in her heart," and Lisa Marie would later record three acclaimed albums as an adult. Soon, Elvis and Priscilla were busy filling up photo albums with pictures of their beloved daughter.

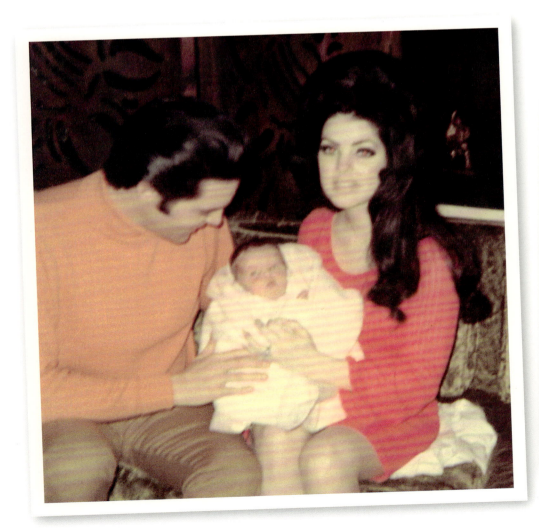

SONG OR A YAWN?—Four-day-old Lisa Marie was either bored to yawns or she had a Presley song in her heart yesterday as her parents, Mr. and Mrs. Elvis Presley, took her home from Baptist Hospital. Born Thursday, the baby weighed 6 pounds, 15 ounces.
—Staff Photo By Robert William

(Color Picture on Page 32; Story on Page 7)

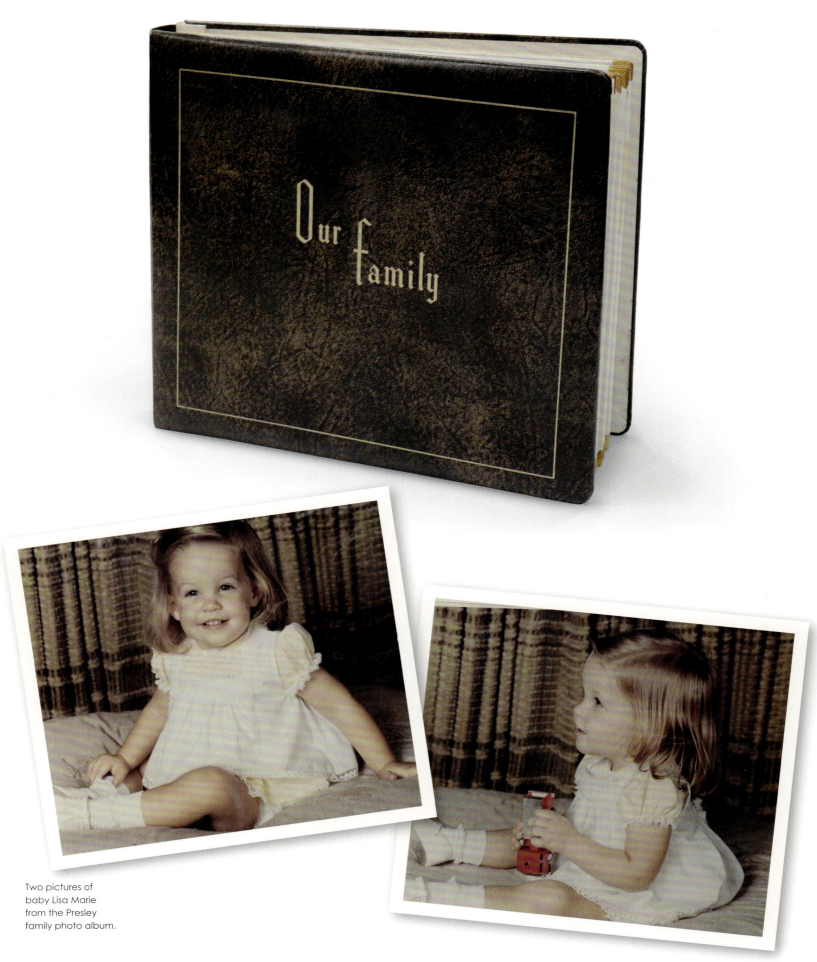

Two pictures of baby Lisa Marie from the Presley family photo album.

> *Becoming a father made me realize a great deal more about life. My favorite memory is when Lisa was born and I first held her, you know? She was so tiny and precious. I know all babies are beautiful to their parents, but she was special, I guess because I realized she was mine to care for. It wasn't just me or Cilla anymore. It was us. They depended on me. I liked it."*

—Elvis

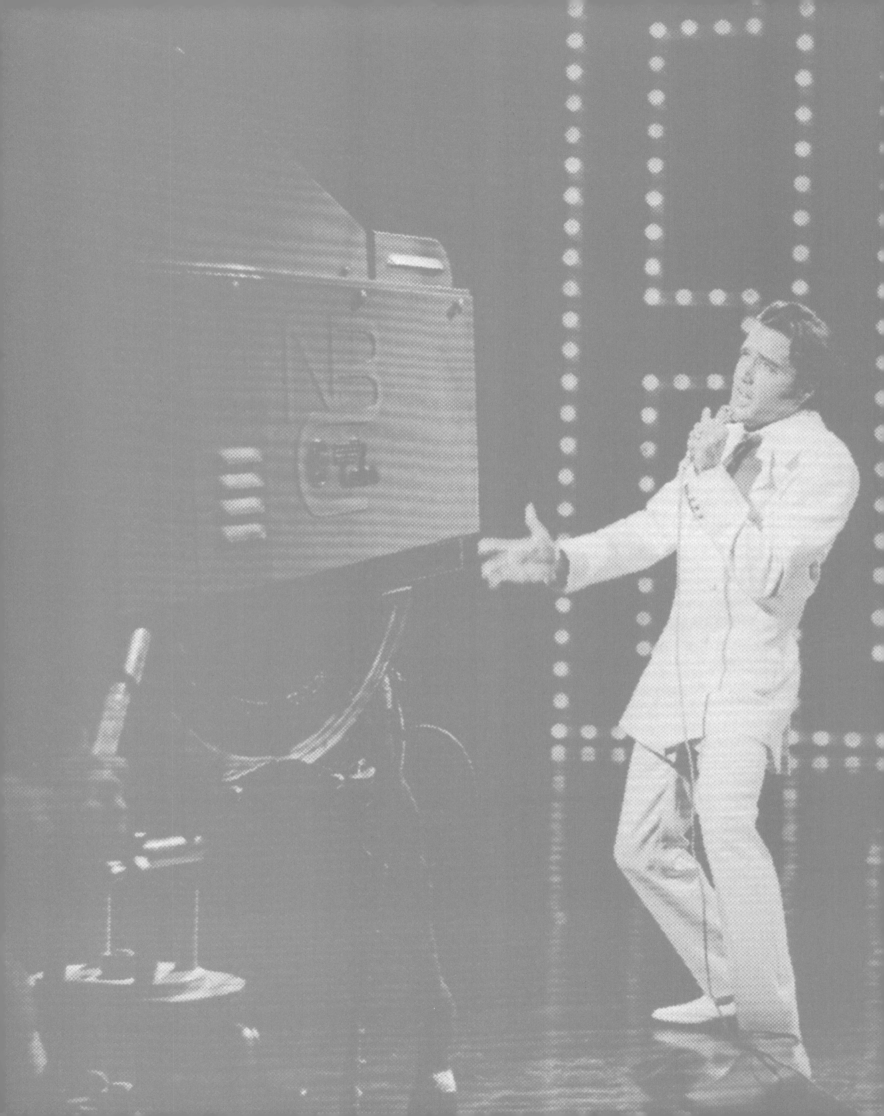

PART 5 BECOMING A LEGEND

▼ **LEATHER WRISTBAND** ▼

 # THE COMEBACK

By 1968, Elvis was itching to get in front of a live audience again. Colonel Parker duly arranged for him to make his first TV appearance since 1960. Steve Binder, who'd directed the rock concert film *The T.A.M.I. Show* and an acclaimed TV special for Petula Clark, was hired to direct what was formally known as *Singer Presents Elvis* (the Singer Corporation being the show's main sponsor). The special had a dynamic opening number, with Elvis singing a medley of "Trouble" (from *King Creole*) and "Guitar Man," ending up between giant red letters spelling out E-L-V-I-S; a gospel segment; a playful sequence that charted his rise to fame; and a stunning closing number, Elvis delivering the powerful song "If I Can Dream." But the heart of the show was the four hour-long performances Elvis gave before studio audiences, memorable not just for the music, but also for his stage wear—a beautiful, form-fitting black leather suit with matching wristbands, which instantly became one of his most iconic outfits. *Elvis* aired on December 3, 1968. Due to its role in reenergizing Elvis's career, it's come to be known as the "Comeback Special."

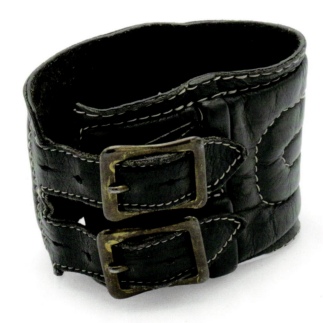
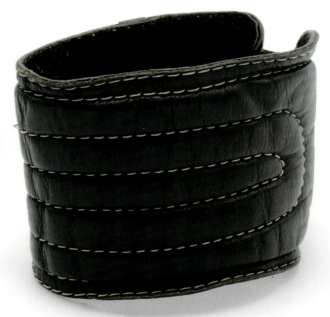

Previous page: Elvis performing "If I Can Dream" during his 1968 television special.

Opposite page: Elvis performing in the iconic leather suit.

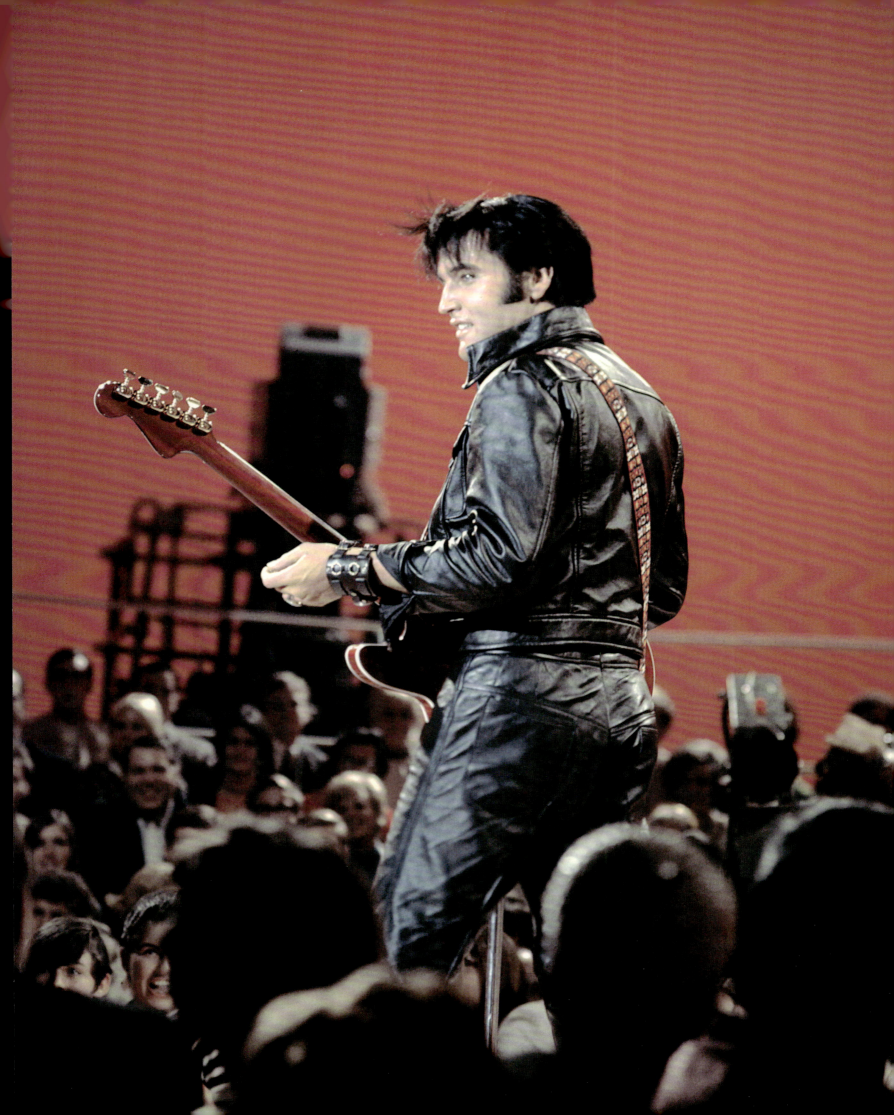

THE INTERNATIONAL HOTEL TABLECLOTH CONTRACT

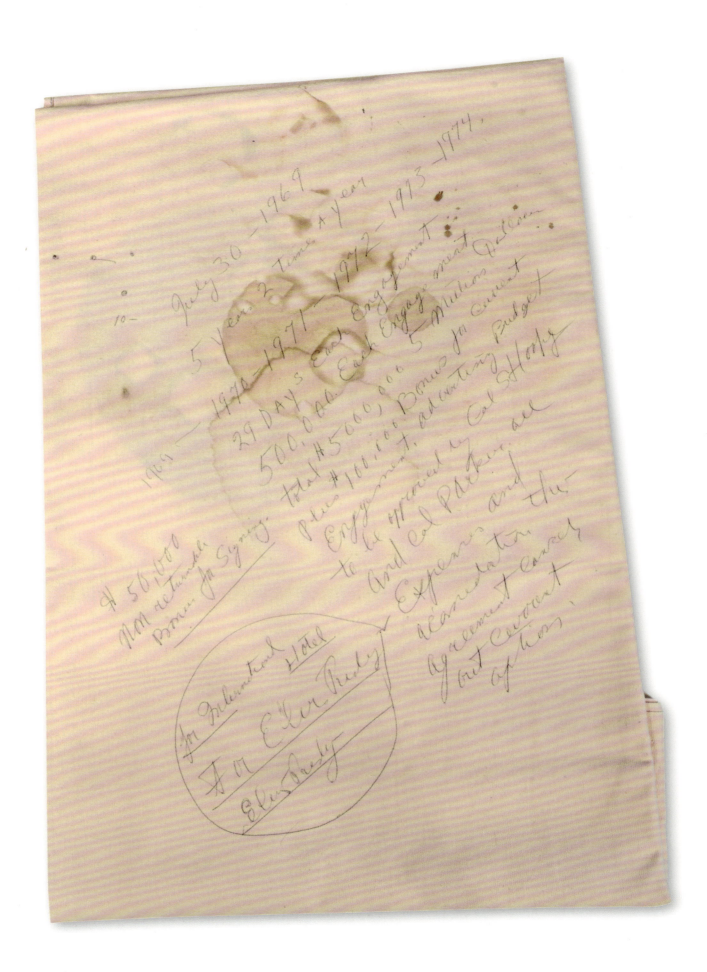

THE IMPROMPTU CONTRACT

The star-studded audience—Fats Domino, Cary Grant, Pat Boone, Shirley Bassey—that turned out to see Elvis on July 31, 1969, at the International Hotel gave him ovation after ovation. Even the reporters at the post-show press conference stood up and cheered when he entered the room. And the management of the International wanted to secure a return engagement as soon as possible. The wheels were set in motion right after the show, when Colonel Parker sat down with the International's president, Alex Shoofey, at the hotel's coffeeshop to draft a rough agreement. Instead of waiting for a pad of paper, Parker made notes on the restaurant's tablecloth, an indication, perhaps, of how eager he was to start negotiations. In the end, the International secured Elvis's services for the next five years, paying one million dollars a year for two four-week engagements, in the winter and summer. This isn't the actual contract Elvis signed; a more conventional paper document was prepared for that.

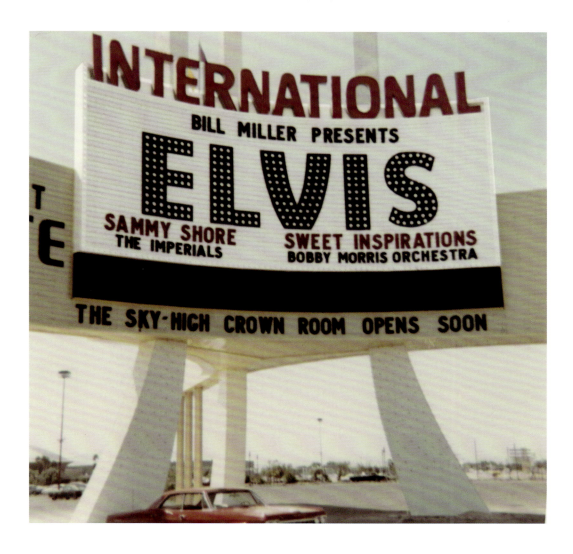

WORLD CHAMPIONSHIP BELT

A CHAMPION FOR ALL SEASONS

At the end of his third, record-breaking season in Las Vegas, the International Hotel's president Alex Shoofey presented Elvis with a commemorative belt after the final performance on September 7, 1970. The belt, similar in style to those given to boxing champions, was cast in silver and gold-plated; the oversized buckle measured 7 inches by 4½ inches. The elaborate buckle features Elvis's name at the top, spelled out in diamonds, above the words "Worlds Championship Attendance Record." The upper corners feature the numbers "19" and "69," indicating when Elvis began performing at the hotel. The International's name and logo are at the bottom of the buckle, and the stars in each corner feature diamonds, sapphires, and rubies. Elvis frequently wore the belt both on and off stage. He's seen wearing it at the press conference for his shows at Madison Square Garden in June 1972. He also wore it when he was granted an audience with President Richard Nixon on December 21, 1970.

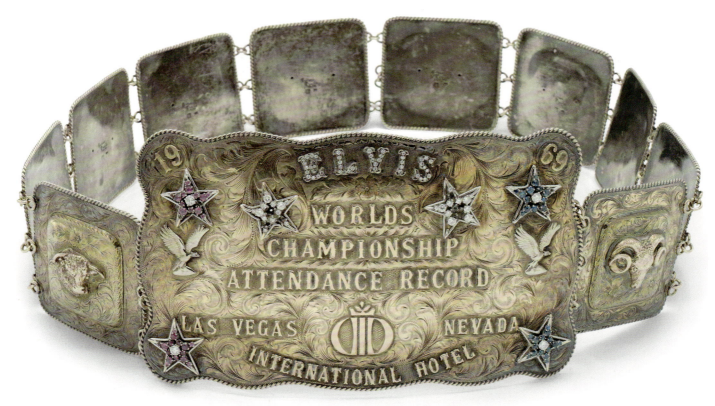

Opposite page: International Hotel president Alex Shoofey presenting Elvis with the belt, 1970.

126

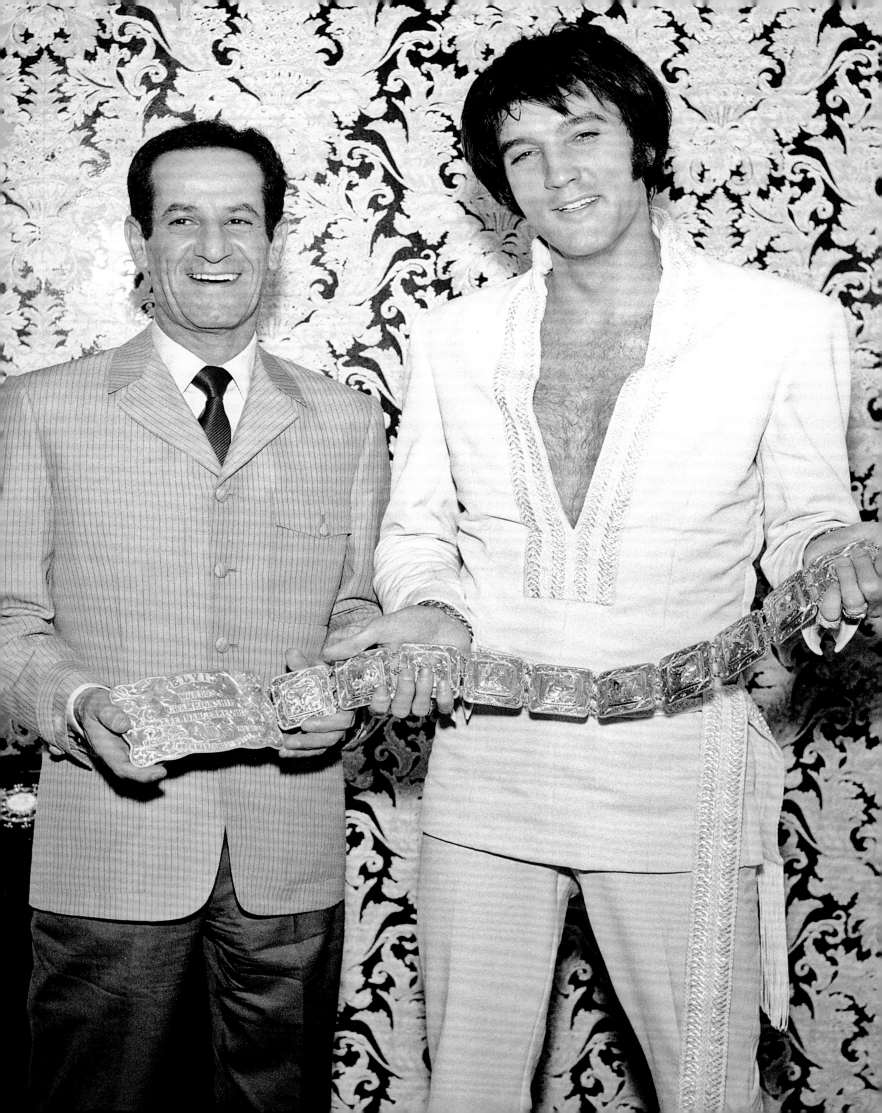

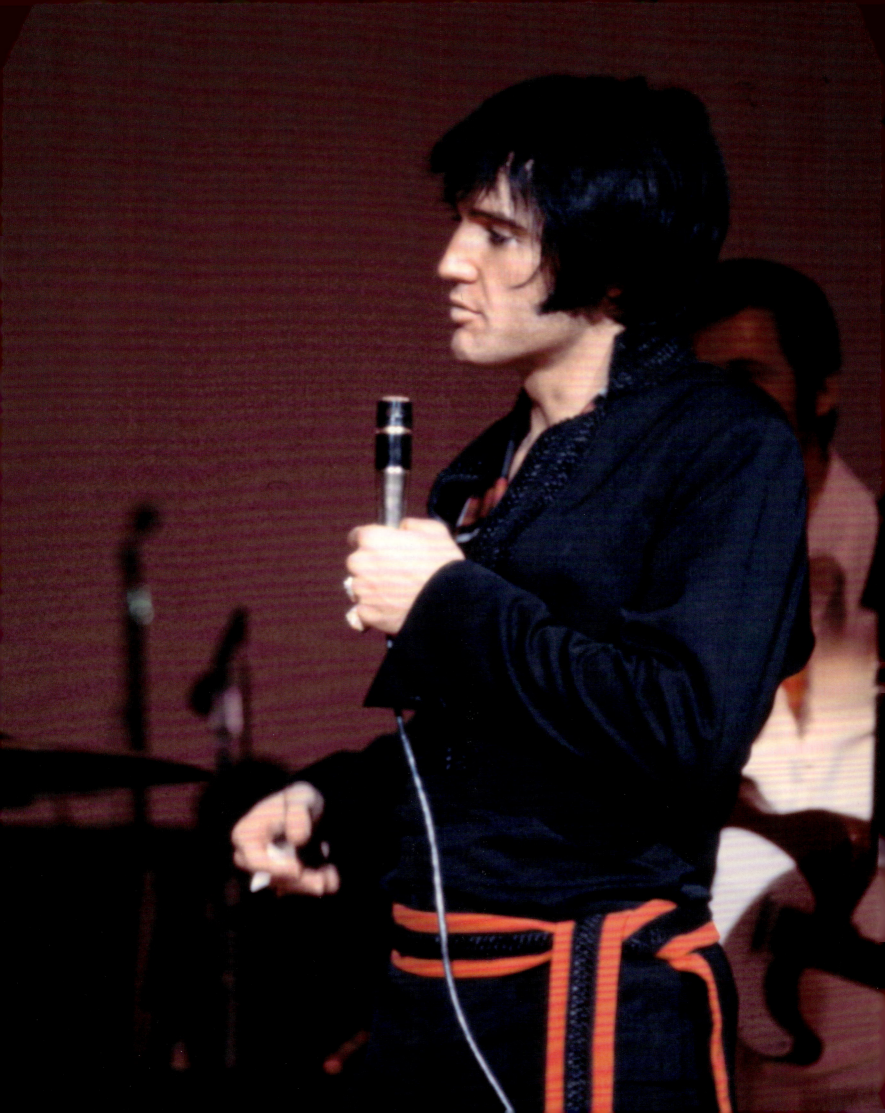

MICROPHONES

THE HIGH-ROLLERS MICROPHONES

After the success of the 1968 *Elvis* special, Elvis was even more eager to get back in front on an audience. He'd spent most of the decade making movies, and, while some of them were quite successful—*G.I. Blues*, *Blue Hawaii*, *Viva Las Vegas*—nothing compared to the excitement of live performance. So, in 1969, he thought carefully about how to put together a show, chose the best musicians he could find, opened in Las Vegas in July 1969, and alternated between Vegas residences and national tours for the rest of his life. A major hotel like Elvis performed at would have its own sound equipment and basic items like microphones. But vocalists tend to have a preferred microphone that they use on stage and in the studio. This gold mic was used during Elvis's first exciting engagement at the International Hotel in Vegas from July 31 to September 28, 1969. The word most commonly used to the describe shows was "electrifying;" Elvis dazzled audiences with high energy renditions of classics like "Jailhouse Rock," and new numbers that showed off the power of his voice, such as "I Can't Stop Loving You." The silver mic, which has "EP 1" etched into it, was used during his subsequent 1970s touring years. For Elvis, a new era in his career had begun.

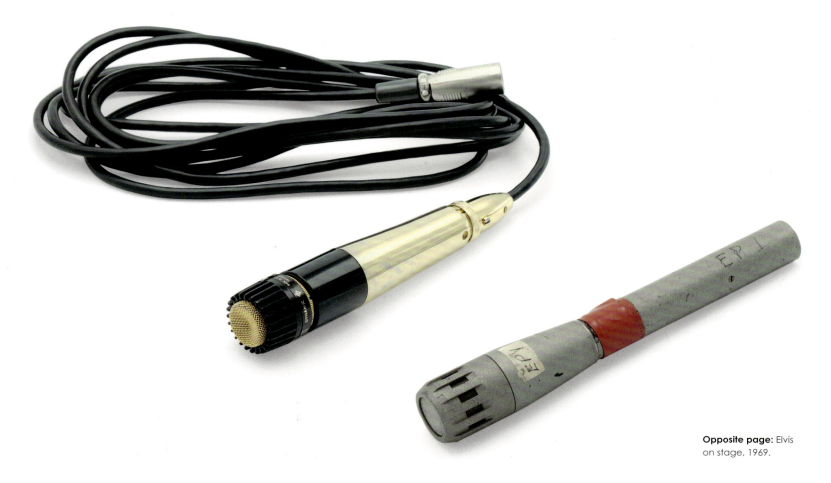

Opposite page: Elvis on stage, 1969.

LIFETIME ACHIEVEMENT GRAMMY

THE LIFETIME GRAMMY

Elvis received three Grammy Awards, all for his religious recordings (see page 133). His music, however, encompassed a much broader range than that one genre. In 1971, the Recording Academy (then known as the National Academy of Recording Arts and Sciences), the organization that oversees the Grammy Awards, decided to honor his accomplishments by giving him the Bing Crosby Lifetime Achievement Award. The award is given to "performers who, during their lifetimes, have made creative contributions of outstanding artistic significance to the field of recording," and was initially named after its first recipient, Bing Crosby, who received the award in 1963. The award was not given on a yearly basis until 1986, meaning that when Elvis was given award for 1971, there were only five previous recipients, including Frank Sinatra, Duke Ellington, Ella Fitzgerald, and Irving Berlin, along with Crosby. Storied company, but one thing immediately becomes apparent; Elvis was the first rock performer to receive the award, making it even more of an achievement. It was an award that acknowledged the monumental impact he'd made on the music industry.

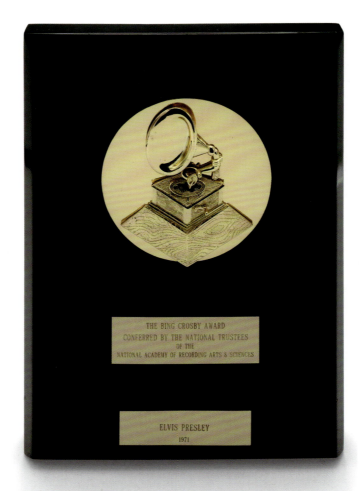

Opposite page: Bing Crosby's nephew Chris (on Elvis's right) and two representatives from the National Academy of Recording Arts and Sciences present Elvis with his Lifetime Achievement Grammy, August 28, 1971.

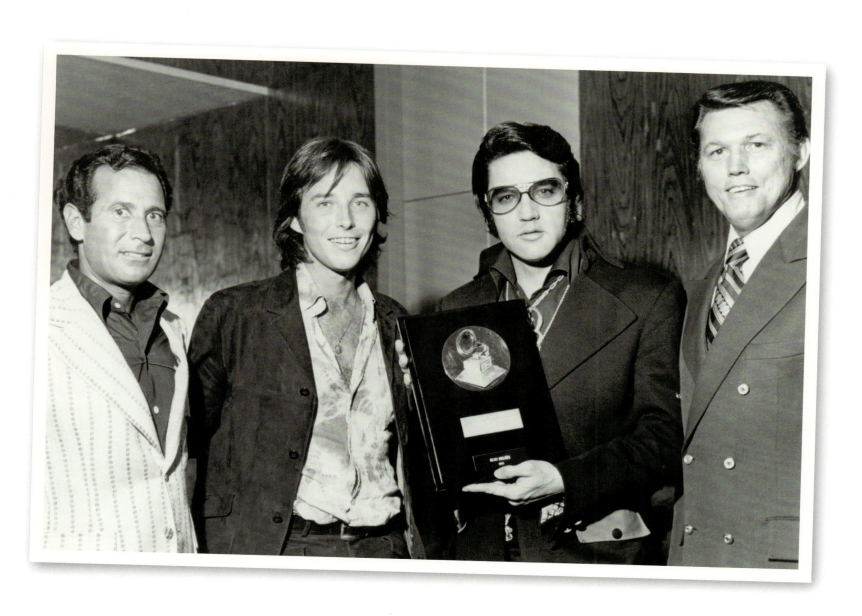

▼ THREE GRAMMYS ▼

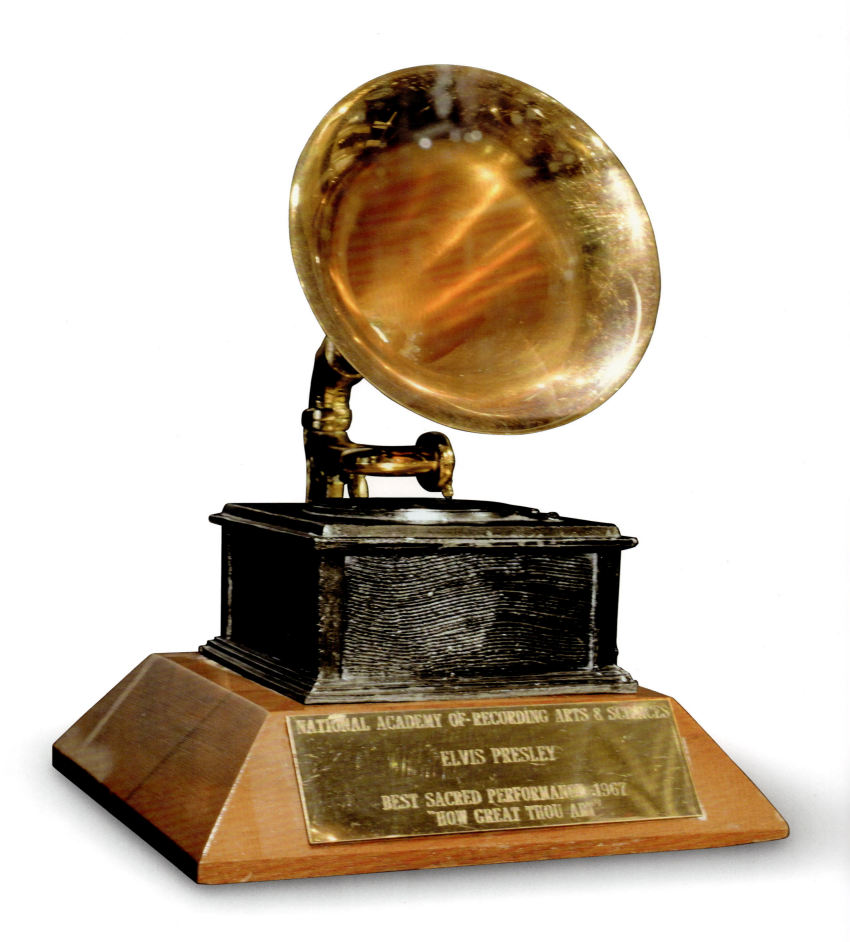

AND THE GRAMMY GOES TO...

It was fitting that Elvis's first Grammy win was for one of his religious recordings, when his 1967 album *How Great Thou Art* received the award for Best Sacred Performance. It was a genre of music that he'd loved all his life, since he first heard hymns being sung in church as a child. One of his favorite ways to warm up at recording sessions was to sing gospel songs, something he'd also do to unwind after a show, sometimes singing in his hotel suite with other performers until the early hours of the morning. As he said to a reporter, "I know practically every religious song that's ever been written." The sessions for *How Great Thou Art* were also his first with producer Felton Jarvis, who would produce Elvis's records for the rest of his career. By the time of his next Grammy win, for his 1972 album *He Touched Me*, the category had become Best Sacred Performance. And there was one more Grammy win, when his live rendition of "How Great Thou Art," taken from his 1974 album *Elvis Recorded Live on Stage in Memphis*, also won Best Inspirational Performance. Behind the Grammys, you can see certificates for other Elvis songs that received Grammy nominations.

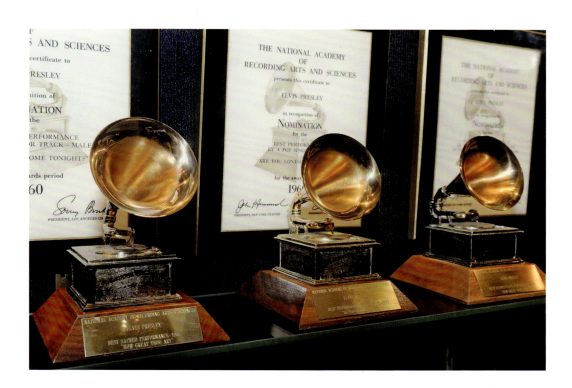

JAYCEES AWARD AND PROGRAM

THE AWARD FOR A DREAMER

On January 9, 1971, it was announced that the Junior Chamber of Commerce—the Jaycees—had named Elvis in its annual list of Ten Outstanding Young Men of the Year for 1970. The honor was given to men of accomplishment who were under 35 years of age, and in Elvis's case, his achievements were not only his outstanding success as an entertainer, but also his extensive charity work. The ceremony was held in Memphis a week later, on January 16. Elvis hosted both a cocktail reception for all the award winners at Graceland and the formal dinner that followed at the Four Flames restaurant. The award ceremony was held at Ellis Auditorium, a venue Elvis was well acquainted with. In his speech accepting the award, Elvis noted that he was a dreamer: "I read comic books, and I was the hero of the comic book. I saw movies, and I was the hero in the movie. So every dream that I ever dreamed has come true a hundred times." Elvis was very proud to receive such a prestigious award, and he often took the statue with him when he traveled.

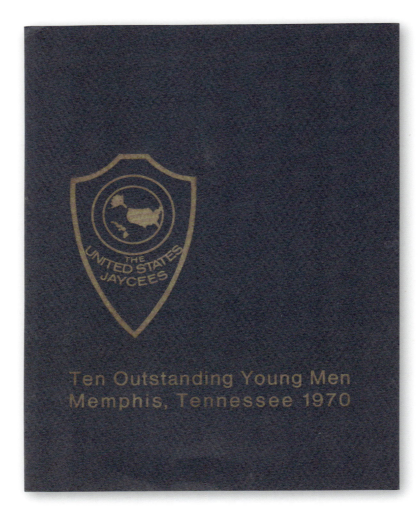

Following page: Elvis giving his acceptance speech.

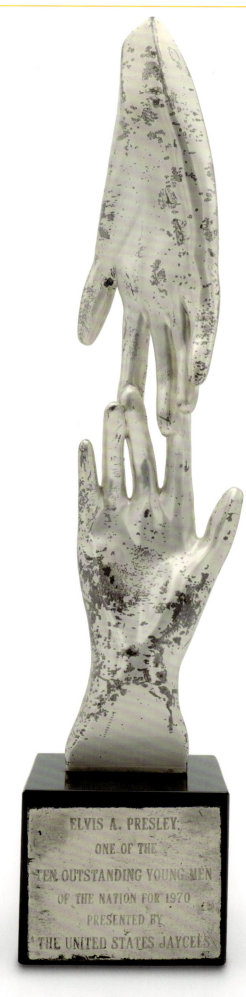

> *When I was a child, ladies and gentlemen, I was a dreamer. I read comic books and I was the hero of the comic book. I saw movies and I was the hero in the movie. So every dream I ever dreamed has come true a hundred times ... I learned very early in life that: 'Without a song, the day would never end; without a song, a man ain't got a friend; without a song, the road would never bend—without a song.' So I keep singing a song."*

—Excerpt from Elvis's acceptance speech for the 1970 Ten Outstanding Young Men of the Nation Award, January 16, 1971

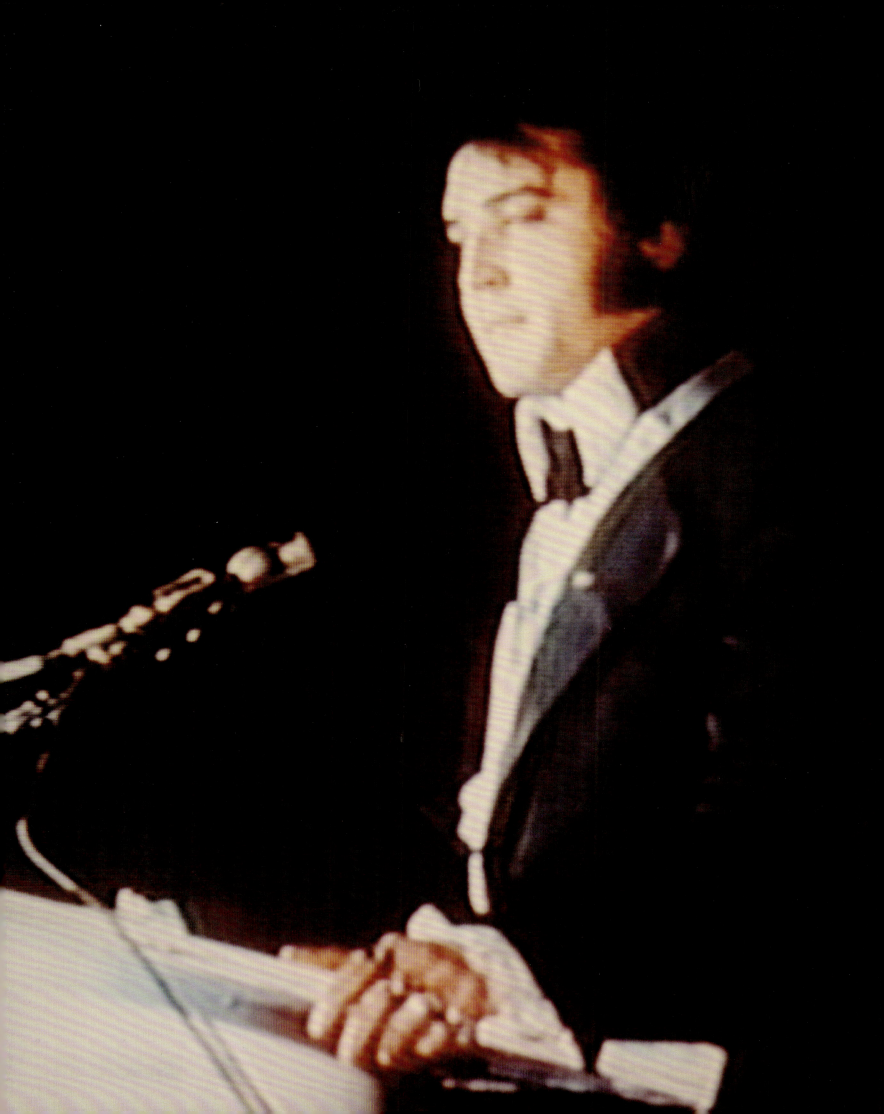

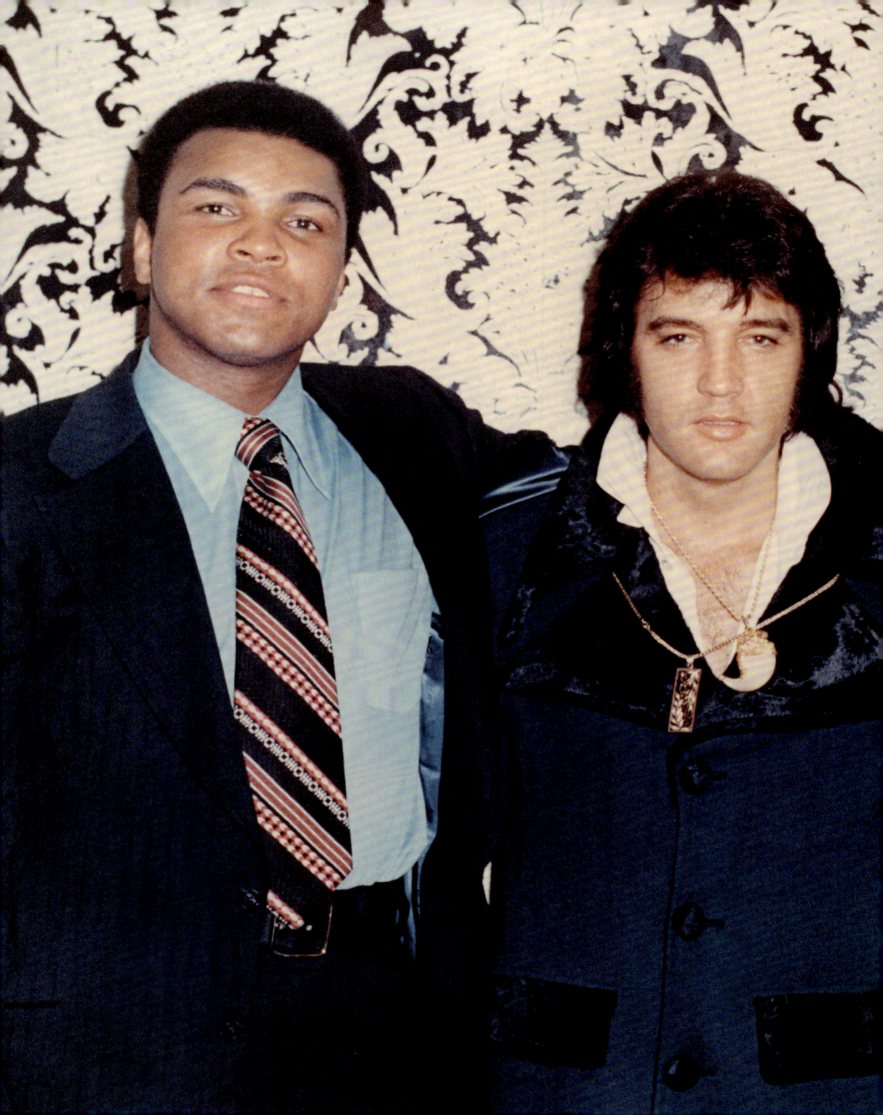

▼ ALOHA FROM HAWAII *CAPE AND PENDANT* ▶

A SHOW IN PARADISE

Colonel Parker had been mulling over the idea of a live broadcast for years; the *Aloha From Hawaii By Satellite* show finally made the idea a reality. There were actually two shows held at the Honolulu International Center (today the Blaisdell Arena): a dress rehearsal on January 12, 1973, and the live broadcast on January 14 at 12:30 a.m. Hawaii time. Elvis commissioned a specially designed outfit for the occasion, a white jumpsuit with matching cape, each emblazoned with large eagles made of red and blue jewels and gold studs. During the January 14 show, Elvis threw the cape into the audience, where it was caught by a *Honolulu Advertiser* sportswriter; it was eventually returned to Graceland. The show was a benefit, raising over $75,000 for the Kui Lee Cancer Fund, and Elvis wore a gold and diamond pendant, with his name spelled in black onyx, which was given to him by the organization as a gift. The show was seen live in Australia and Pacific Rim countries, and later broadcast in more than 10 other countries; the US airdate was April 4, 1973.

Opposite page: Elvis wearing the pendant he received from the Kui Lee Cancer fund at an event in Las Vegas with Muhammad Ali, 1973.

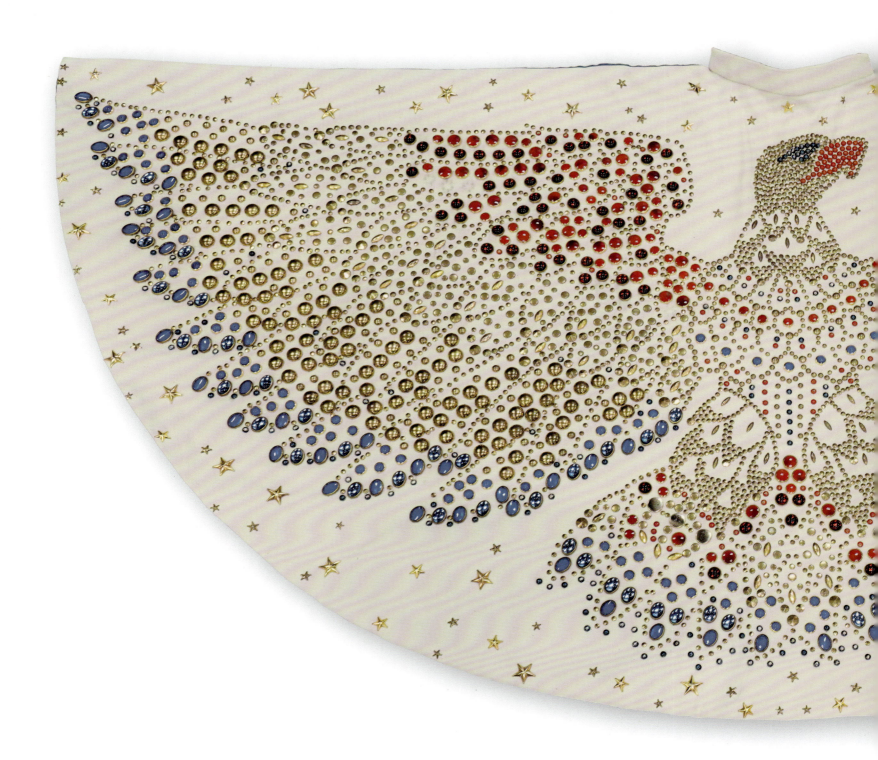

Above: The cape worn onstage during the *Aloha from Hawaii* performance.

Opposite page: Elvis during the performance, 1973.

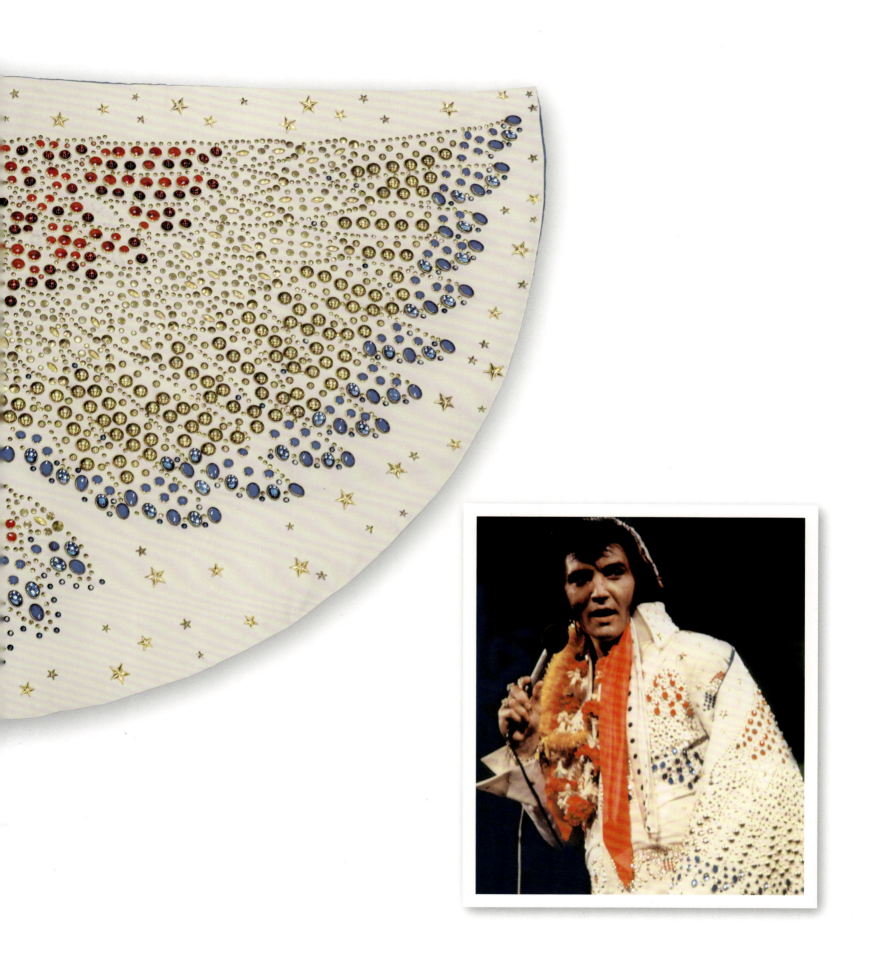

▼ ONSTAGE BOOTS ▼

THE CONCERT BOOTS

These are boots that mean business. When Elvis returned to live performance at the end of the 1960s, his new look extended right down to his feet. Instead of shoes, which he wore for his 1950s performances, Elvis preferred boots when he took to the stage in 1969. There were plenty of practical reasons for this. There were no laces that could come untied during a performance. Being ankle-high in length, they provided a bit of additional leg support. And with two-inch heels, they helped to make Elvis larger than life. They were also made to take some wear and tear; an Elvis performance could be quite a workout. But that didn't mean they couldn't also look good. These boots are enhanced by studs in the shape of a star, a fitting adornment for Elvis. Clearly, these boots were made for doing more than just walking.

Elvis in performance, c. 1973

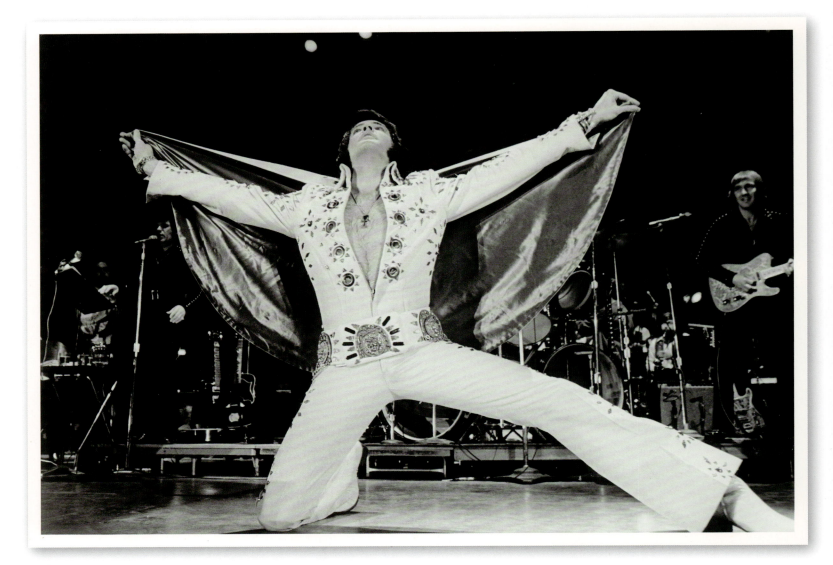

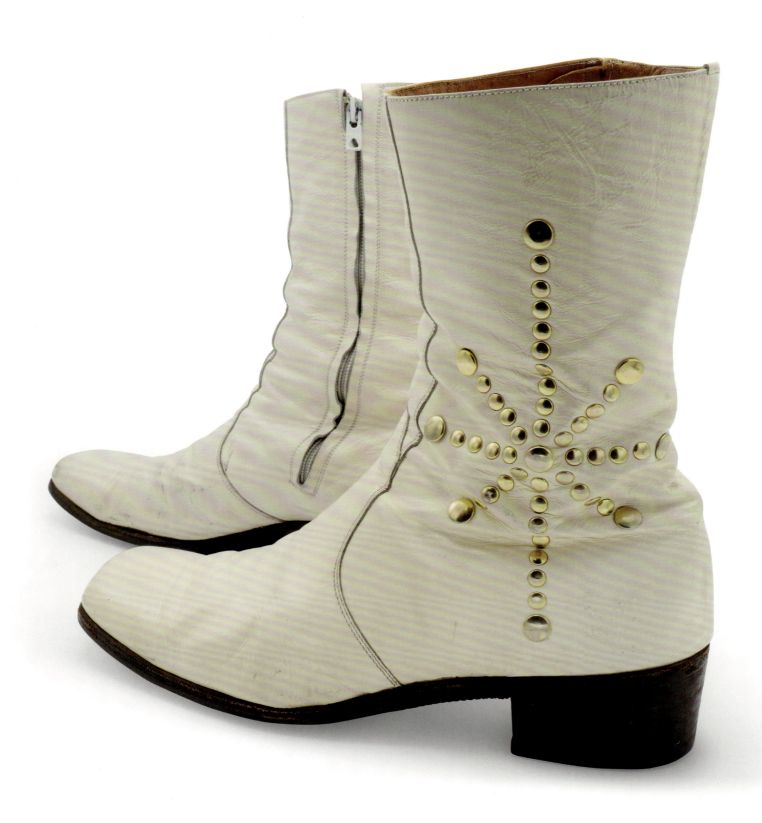

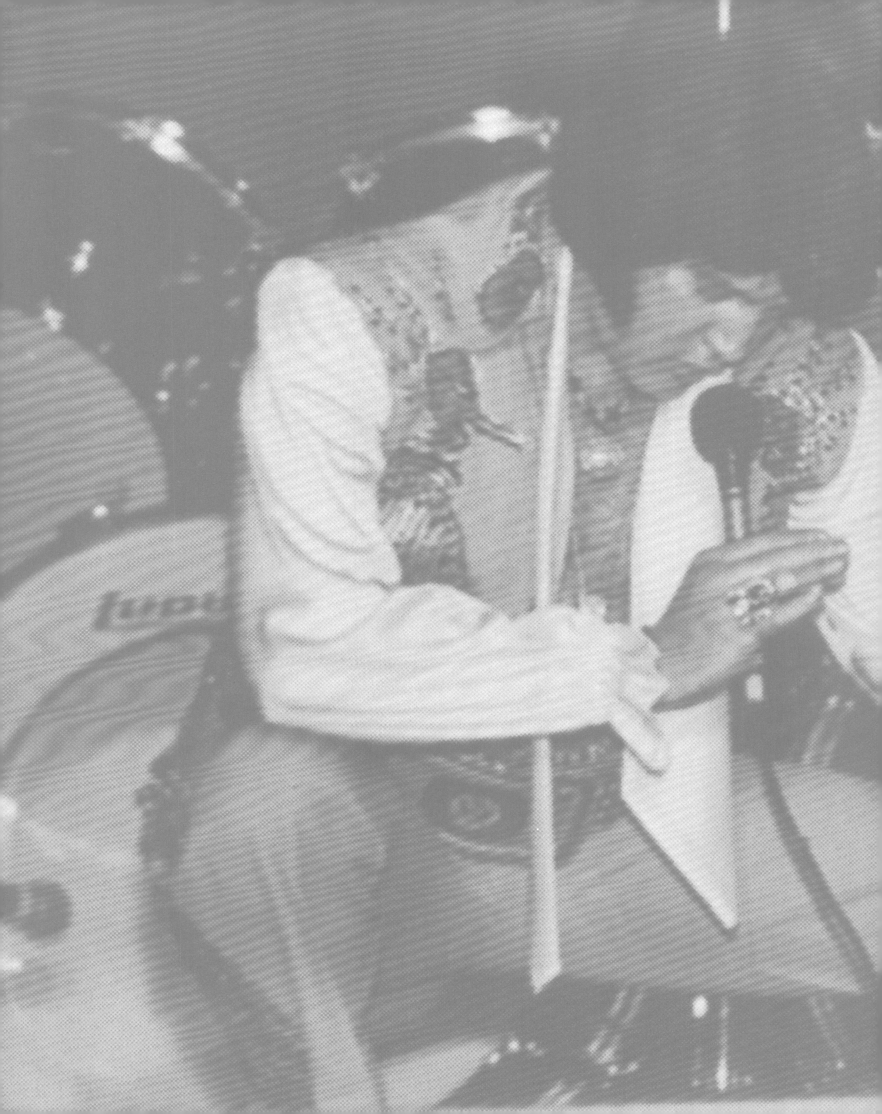

PART 6 THE KING'S PERSONAL STYLE

ELVIS'S SPECTATOR SHOES

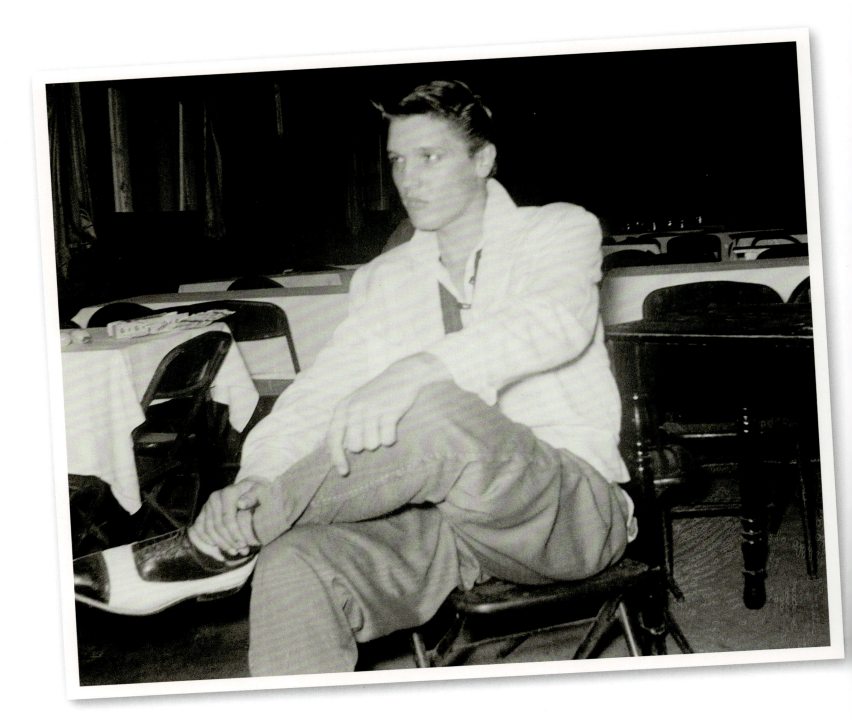

Previous page: Elvis performing in 1976.

Above: Elvis at the Eagle's Nest, a dance hall in Memphis, 1954.

COOL CAT STYLE

When Elvis first started out, his stage clothes weren't much different from the clothes he wore every day. He couldn't wait to change that, of course, and once he picked up these snazzy, two-tone leather shoes, they were often on his feet when he stepped out on the stage during the 1950s. The use of white on the body of the shoes gives them a streamlined look; you could almost imagine them being tap shoes. And they were used for dancing, if of a very different sort, helping to propel Elvis as he gyrated across stage after stage after stage in his rise to stardom. The shoes are now in a decidedly worn condition, evidence that they got a quite a workout during all the years Elvis performed in them.

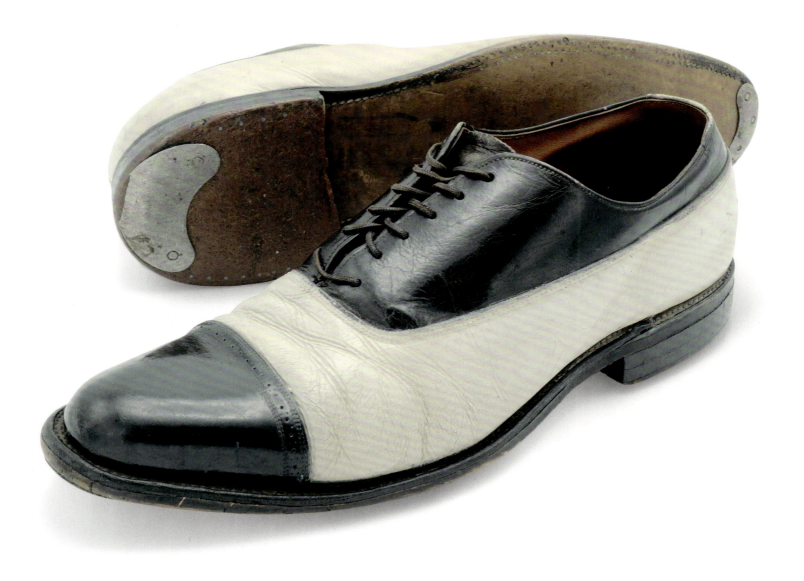

▼ **THE MONOGRAMMED SWEATER** ▼

THE PERSONALIZED TOUCH

One of Elvis's favorite things to do with his clothing and accessories was to personalize them, and this sweater, which he began wearing in the 1950s, was among his first items of clothing to receive such treatment. The sweater has a classic, comfortable look, with an understated color scheme: mostly smoke blue, with gray and cream stripes down the front. The initials "E. P." also in smoke blue, are stitched in a stylish script, a sophisticated touch for what's meant to be casual wear. It's the kind of sweater you pull on when you want to kick back and relax with your friends, looking sharp, but not too formal.

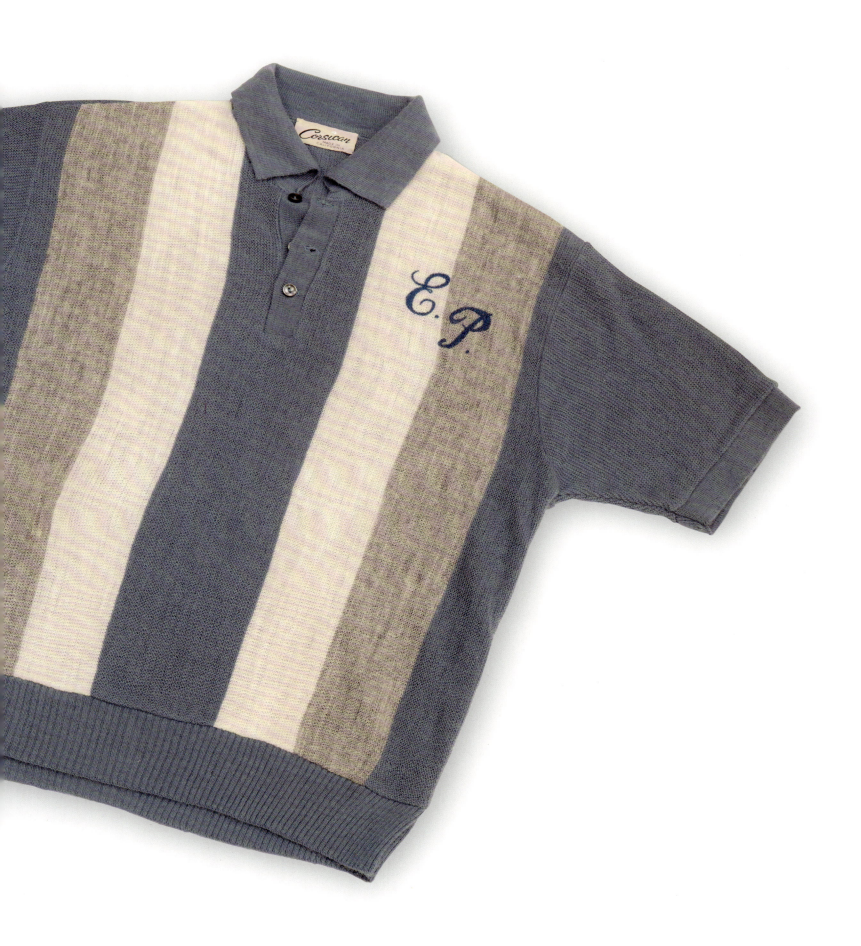

BILL BELEW SKETCHES AND CLOTHES

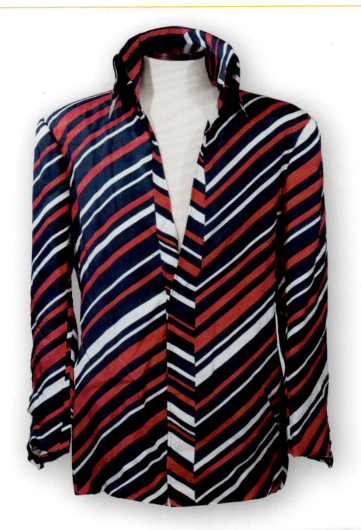
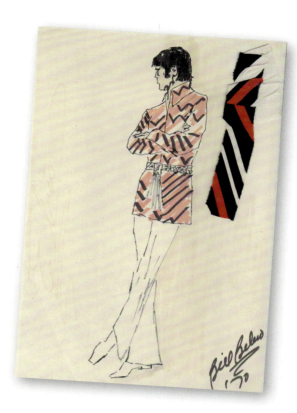
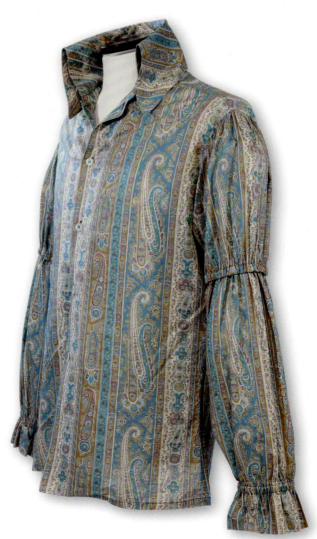

Clockwise from top: A Bill Belew-designed shirt and the original sketch; the paisley Belew shirt Elvis wore in *Elvis: That's the Way It Is*, and a still from the movie.

CLOTHES MAKE THE MAN

Elvis met clothing designer Bill Belew during the making of the "Comeback" special. Belew designed all the costumes Elvis wore in the program, including that famous black leather suit. Elvis liked his work so much that he not only hired Belew to design his stage wear (transitioning from two-piece outfits to increasingly ornate jumpsuits), but his offstage clothing as well.

Elvis wore the blue jacket in a family photo shoot held on December 10, 1970, wearing a light blue shirt underneath. Note the high collar: Belew was a fan of what he called the "Napoleonic look," and felt that a high collar made a good frame for Elvis's face.

Elvis had always liked wearing clothes with stripes. The red, black, and white striped shirt is typical of the kind of vibrant, colorful look he cultivated in 1970s.

The paisley-patterned shirt can be seen in the 1970 documentary *Elvis: That's The Way It Is*, which followed Elvis's 1970 summer residency in Las Vegas. In it, Elvis reads telegrams backstage on opening night, before leaving to change into one of his signature jumpsuits.

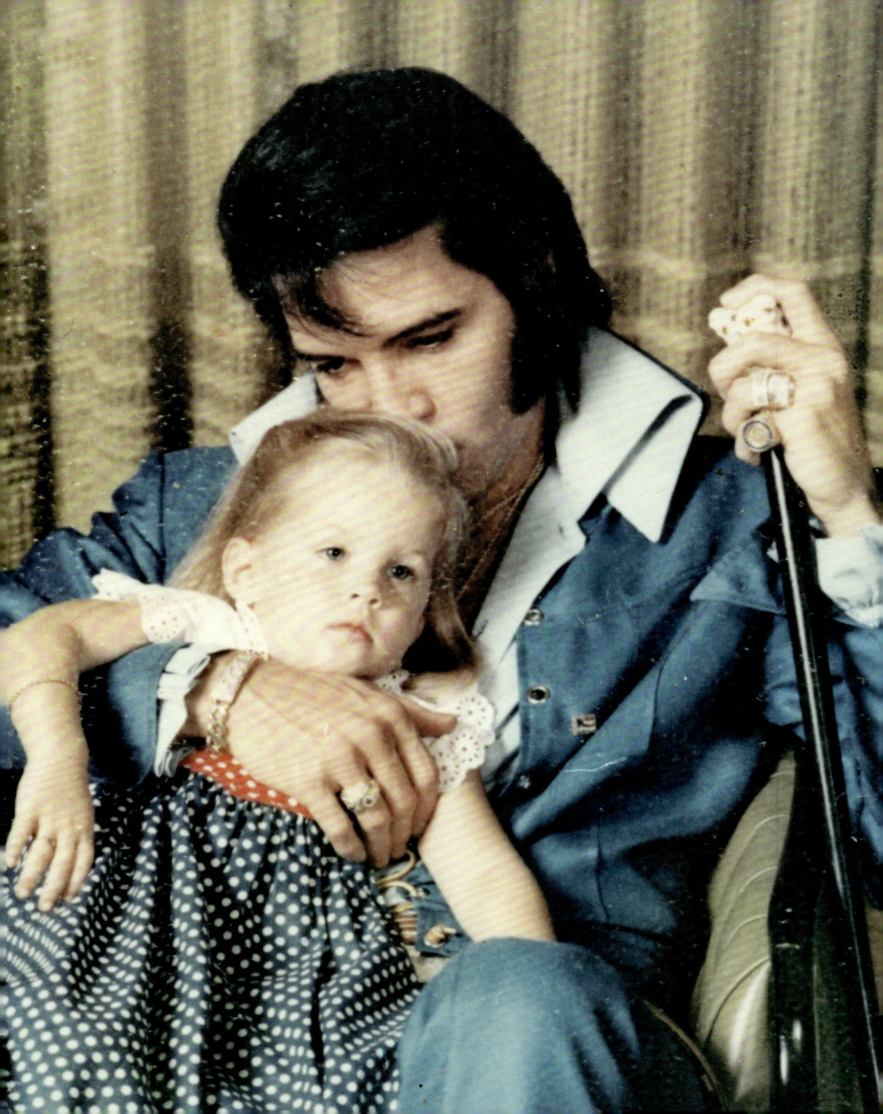

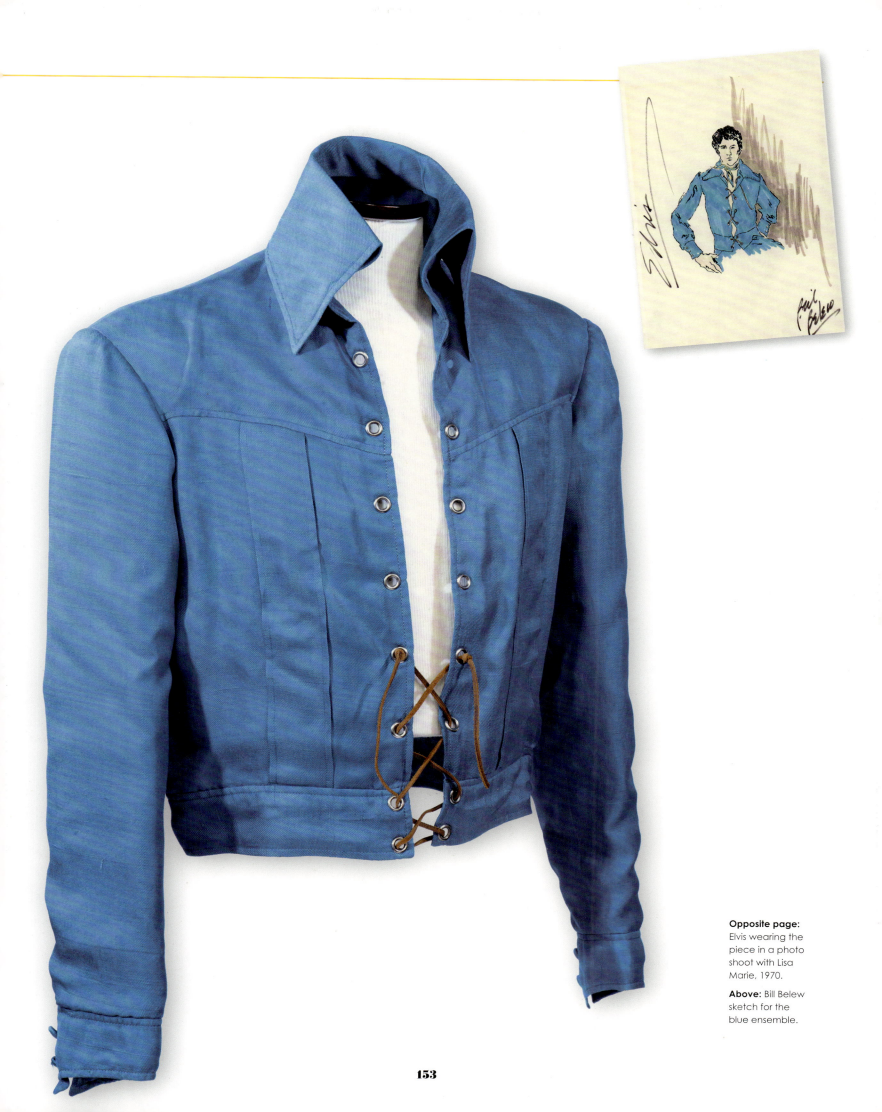

Opposite page: Elvis wearing the piece in a photo shoot with Lisa Marie, 1970.

Above: Bill Belew sketch for the blue ensemble.

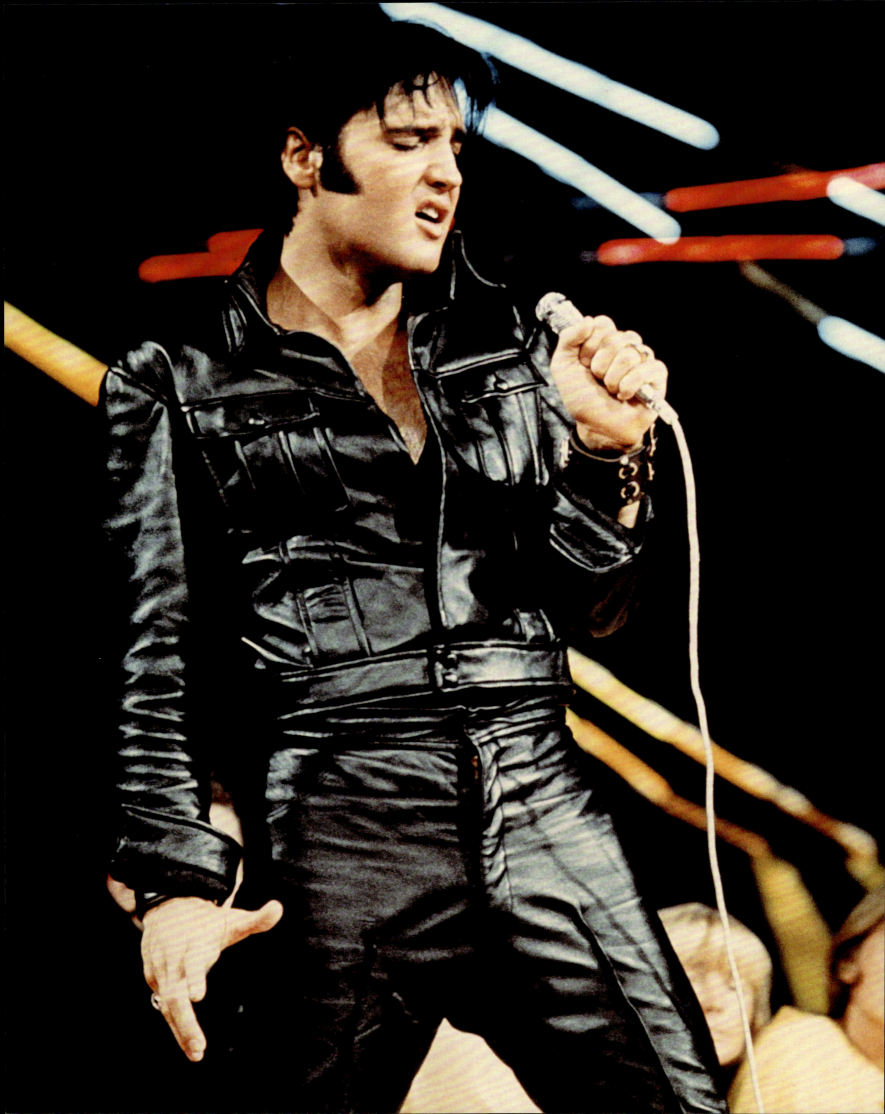

"You could be daring as a designer and put anything on Elvis and he could make it work. The simplest outfits that didn't seem particularly remarkable on the rack transformed into something spectacular when Elvis put them on. He was that beautiful and powerful a presence."

—Bill Belew

COMB, BRUT AFTERSHAVE

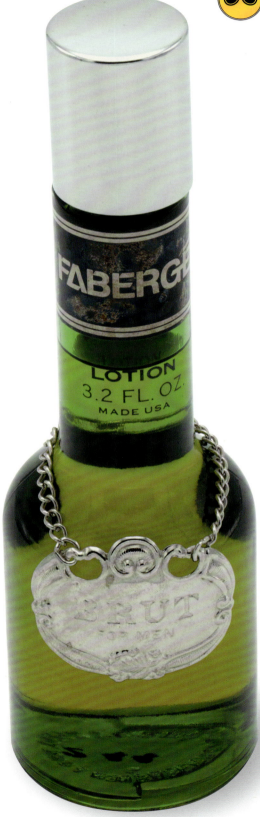

PERSONAL GROOMING

If you're a fan of Brut men's cologne by Fabergé, think of this next time you slap some on after you've had a shave: Elvis used it too. Yes, Elvis was especially partial to this brand, along with millions of other men around the world. Brut is the brand name for a line of men's grooming products, including fragrances and deodorants. In the 1970s, various sports stars, such as Joe Namath and Reggie Jackson, made commercials endorsing the product. In the film *Live and Let Die*, Roger Moore, as James Bond, even used an aerosol can of Brut antiperspirant to make an improvised flamethrower to get rid of a snake that's been placed in his bathroom to kill him. Elvis, a big fan of action movies (and James Bond in particular), undoubtedly got a big kick out of that scene. This bottle of Brut aftershave lotion has the classic Brut design: a slim, green bottle with a silver medallion hanging on the front. And you can't get more back-to-basics than this Ace-brand black comb.

TCB RING AND SUNGLASSES

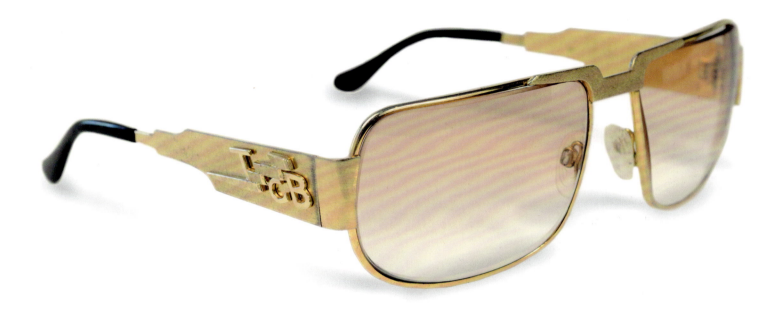

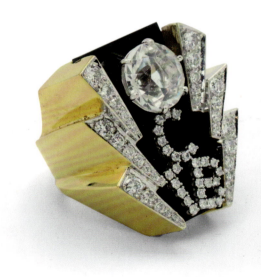

Opposite page: Elvis in concert wearing the TCB ring and the diamond Maltese cross, 1976.

 # THE TCB LOGO

Elvis loved customizing the things he owned. It wasn't enough to have nice jewelry or eyewear; he wanted to make his belongings truly unique. And what better way to make items stand out than by creating your own logo? So it was that in October 1970 the now-famous TCB logo first began appearing on items of jewelry among Elvis's entourage. "TCB" stood for "Taking care of business," a popular expression at the time. Add a lightning bolt to the equation and you get "Taking care of business—in a flash." The first TCB items were necklaces given out to his inner circle. And when Elvis's optometrist saw him wearing one, he suggested putting the logo on the sunglasses he was making for Elvis. Soon, the TCB logo could be seen on other items, from stationery to the tail of the *Lisa Marie* plane. The most bling-ful display of TCB can be found on the ring Elvis had Memphis jeweler Lowell Hays make for him in 1975. The gold creation featured a variation on the elements of the logo, with diamond-studded lightning bolts on either side of the equally diamond-laden TCB, and a solitaire diamond on the top. Truly a feast for the eyes.

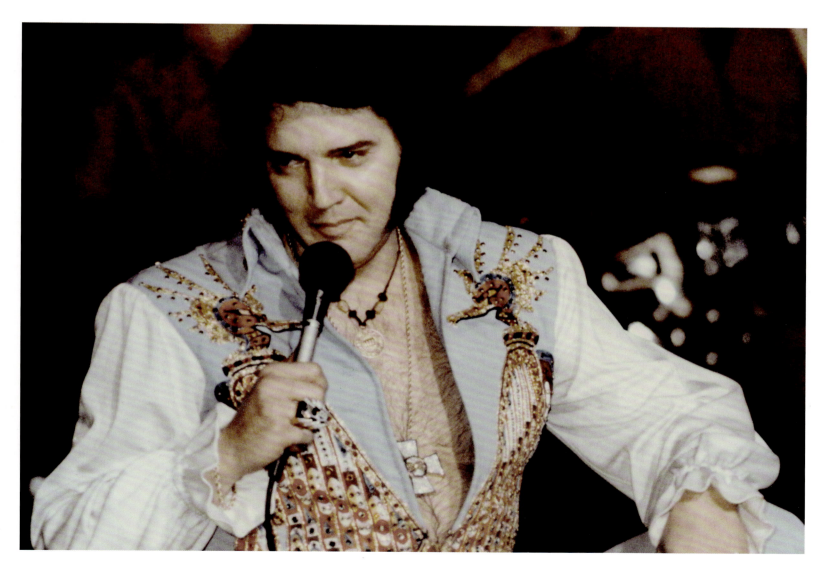

▼ RINGS, BRACELET, PENDANTS ▼

 # THE KING'S BLING

In one way, Elvis was easy to shop for: he was always interested in adding more jewelry to his collection, and if it was custom-designed, that was even better. These pieces shown are especially distinctive, because they feature Elvis's name or initials. The gold "EP" ring (page 163) has a classic look; it's simply the initials, with no extra embellishments, and set together slightly off-center, for a more interesting look. Elvis bought gold ID bracelets for his entourage, and the guys reciprocated by buying him one of his own (below), with his name engraved on the front and the word "Crazy" on the back, their playful nickname for their boss. Priscilla gave Elvis the necklace shown at the top of page 163, which was designed to celebrate the month of his birth. The front side bears his initials, "EAP," with a row of diamonds on each side. The back side features a calendar of the month of January, with a garnet on the 8th—the date Elvis was born—just in case he forgot his birthday.

The ring with a ruby surrounded by diamonds (p. 163 bottom) and the fire opal ring (below) were worn by Elvis both on and off stage. But they are also typical of the kind of jewelry Elvis liked to have on hand to give away. A friend who admired a particular piece might be surprised by Elvis spontaneously offering it to them. He was also known to generously pass out jewelry to his most loyal fans during shows. Even someone he'd just met might be the unexpected recipient of a touch of Elvis's gold, which of course gave Elvis reason enough to go out and buy more. When you're the king, you can never have enough bling.

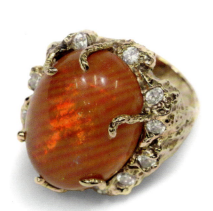

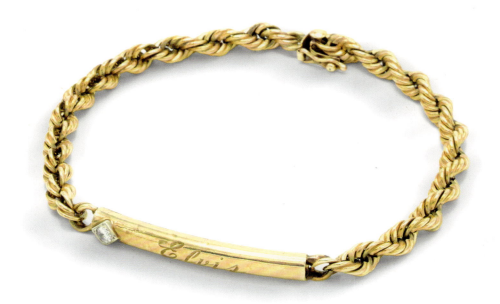

Right: Elvis's fire opal, diamond, and gold ring and his gold "Crazy" bracelet.

Opposite page: Elvis wearing the ruby ring (page 163) during a performance in Las Vegas, 1969.

160

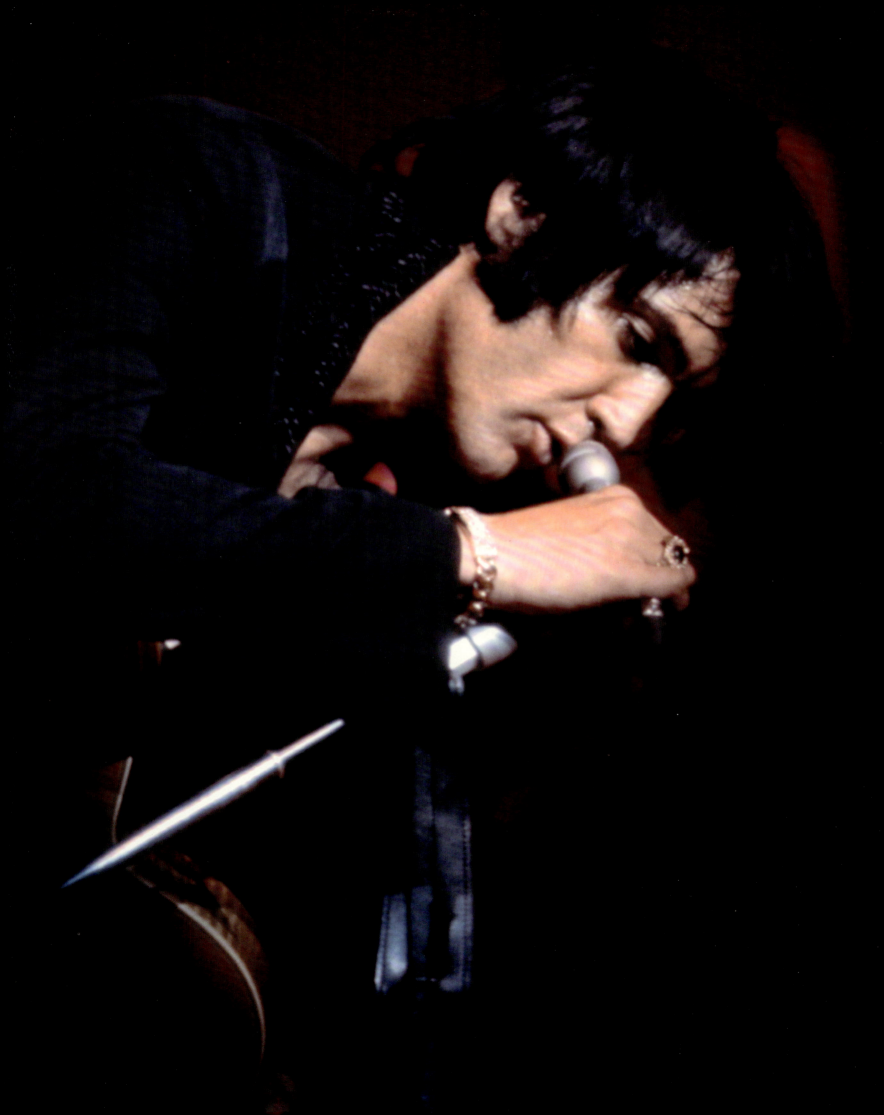

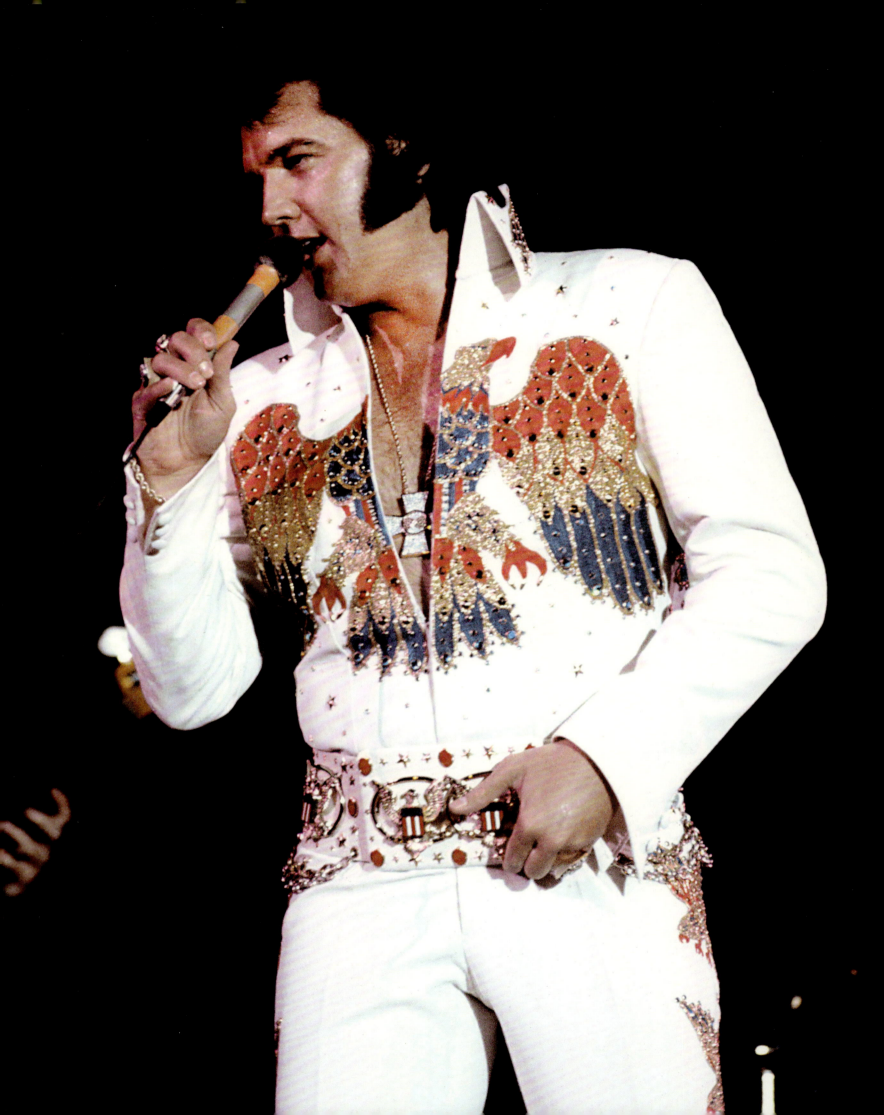

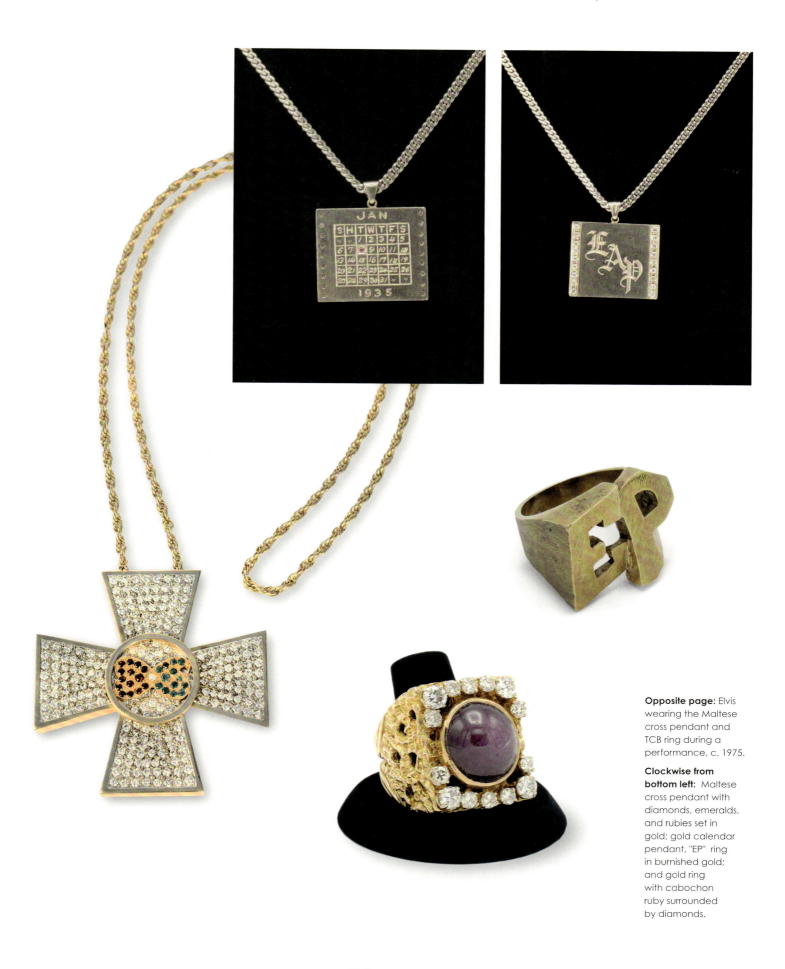

Opposite page: Elvis wearing the Maltese cross pendant and TCB ring during a performance, c. 1975.

Clockwise from bottom left: Maltese cross pendant with diamonds, emeralds, and rubies set in gold; gold calendar pendant, "EP" ring in burnished gold; and gold ring with cabochon ruby surrounded by diamonds.

HAMILTON WATCH

😎 KEEPING TRACK OF TIME

The Hamilton Ventura was the world's first electric watch—reason enough for Elvis to want one. Just think: a watch that didn't have to be wound every day because it ran on a battery! It was designed by Richard Arbib, a car designer who also did illustrations for science-fiction magazines, which perhaps explains the Ventura's futuristic look, shaped like a triangle instead of the usual round face most watches had. The first Ventura was released in 1957, and when Elvis was seen wearing one in his 1961 film *Blue Hawaii*, it caught everybody's attention. Hamilton later released a watch with the Ventura's distinctive triangular design in recognition of the buzz Elvis had generated for the watch: the Ventura Elvis80.

Elvis wearing a version of the Ventura watch (with a leather band) in the film *Blue Hawaii* (1961).

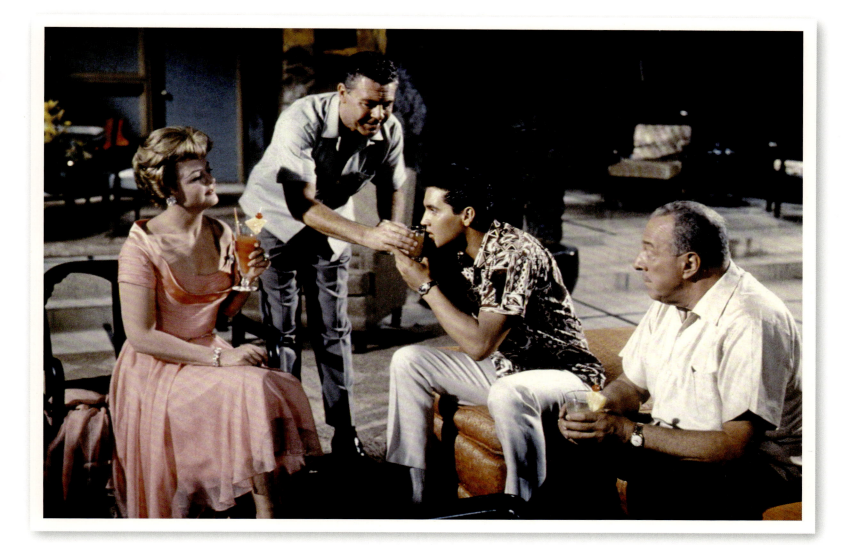

▼ DEA TRACK SUIT ▼

COMFORT WEAR ON THE ROAD

Elvis had loved uniforms, badges, and other insignia since he was a child. So, it was no surprise that when he arrived in Indianapolis on June 26, 1977, for what turned out to be his final concert date, his comfortable track-suit jacket featured an emblem that read "DEA STAFF." No, Elvis wasn't employed by the Drug Enforcement Agency; it was just part of his extensive collection of law enforcement memorabilia. Elvis was wearing the jacket when he received the latest in a string of awards from his record label. RCA executives presented him with a plaque commemorating the company's pressing of his two billionth record, the album *Moody Blue*, which was then being pressed at the company's plant in Indianapolis. That evening, Elvis gave an 80-minute show at the Market Square Arena, which attendees recall as one of the strongest performances of the tour.

Elvis boarding the *Lisa Marie* in his DEA track suit, 1977.

PART 7 ELVIS OFFSTAGE

LETTER FROM JOHNNY CASH

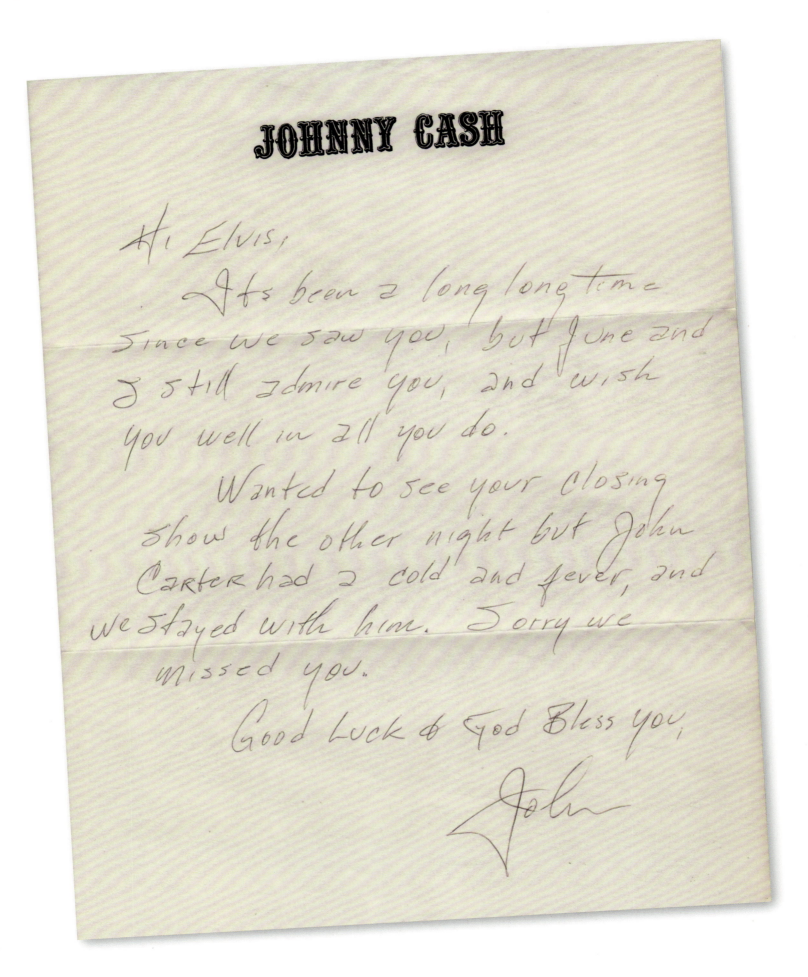

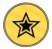 MESSAGE FROM THE MAN IN BLACK

Elvis and Johnny Cash got their start at the same place—Sun Records. Johnny first saw Elvis on September 9, 1954, when Elvis performed on a flatbed truck for the opening of Katz Drug Store in Memphis and was immediately impressed by his charisma (not to mention that he'd attracted a parking lot full of excited teenagers). He followed Elvis's career with interest, and when Elvis dropped by a Carl Perkins recording session (featuring Jerry Lee Lewis on piano) at Sun's studio on December 4, 1956, owner Sam Phillips made sure to put in a call to Johnny so he could come over and join in on all the fun of what came to be called the "Million Dollar Quartet." The two kept in touch over the years, and at some point in the 1970s, Johnny wrote this brief note to Elvis. The reference to a "closing show" makes it sound like it was written at the end of one of Elvis's Las Vegas residencies; and note that Cash's son, John Carter Cash, was born in 1970. Just four short lines convey Johnny's admiration and respect for his fellow performer. And he signs off with a heartfelt "Good Luck & God Bless You, John."

Previous page: Elvis practicing his karate moves, 1973.

Left: Elvis with Johnny Cash in Las Vegas, 1956.

KARATE CLASS CARD, GI

KUNG FU FIGHTING

The art and study of karate was one of Elvis's keenest interests throughout his life. He discovered the martial arts discipline during his years in the army. This card records three classes he attended in December 1959, taught by Jurgen Seydel, the "father of German karate." Elvis was so devoted to his studies that when he went to Paris the following month while on leave, he not only took Seydel with him on the trip but he also arranged to take classes with instructor Tetsuji Murakami, then based in France. Soon after leaving the army, Elvis met Kenpo master Ed Parker, who would in turn introduce him to many martial arts instructors and competitors.

Elvis showed off his skills in the karate-inspired fight sequences in his 1960s movies, as well as in his live shows in the 1970s. His drummer, Ronnie Tutt, even studied karate himself so he could provide just the right percussive accents for Elvis's movements. Also seen here is his karate gi, the uniform worn in practice and competition. In the 1970s, Elvis considered making a karate-influenced film, either a feature-length action movie or a documentary. His love of the discipline can be seen in every high kick he did in concert.

Opposite page, top: Elvis with his karate classmates.

Opposite page, bottom: Elvis practicing karate at the Kang Rhee Institute in Memphis, 1973.

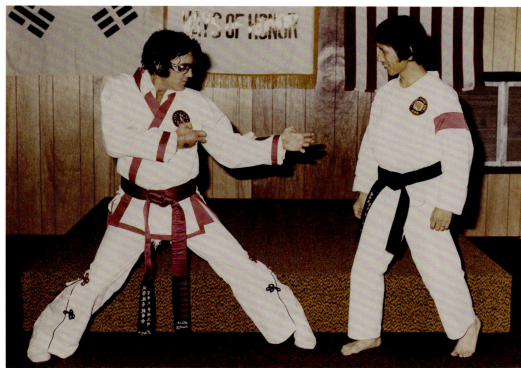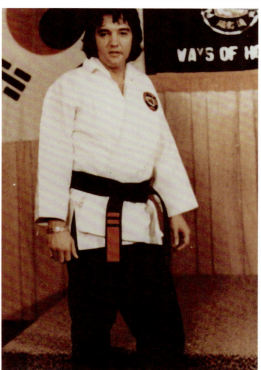

173

WALLET, BADGES, MEMBERSHIP CARDS

WEARING THE SHIELD

Elvis often said that if he hadn't been an entertainer he might have gone into law enforcement, and he always loved spending time with police officers and hearing about their profession. The treasured pieces on the next few pages show that love.

This wallet from 1957 shows some of Elvis's earliest insignia, including his membership card for the Detective Sergeants & Detectives Association from from the city of Buffalo, New York, and a card from the state of Louisiana certifying him as a Colonel "on the staff of Earl K. Long," the state's governor. There's also a card for a service a detective could make use of: a Bell System's telephone credit card.

Elvis began collecting police badges in 1957, when a young fan gave him a Special Officer police badge from the Memphis Police Department. In the 1970s, as he began touring more widely, he collected badges from the cities he visited and eventually developed a very impressive collection, which can be seen in the framed display on the next page.

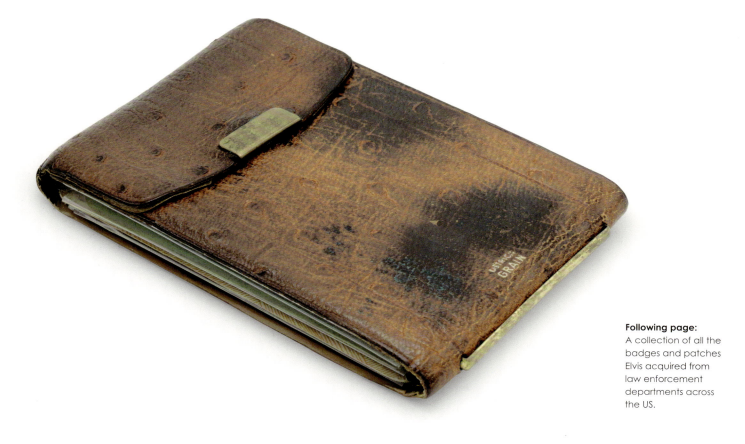

Following page:
A collection of all the badges and patches Elvis acquired from law enforcement departments across the US.

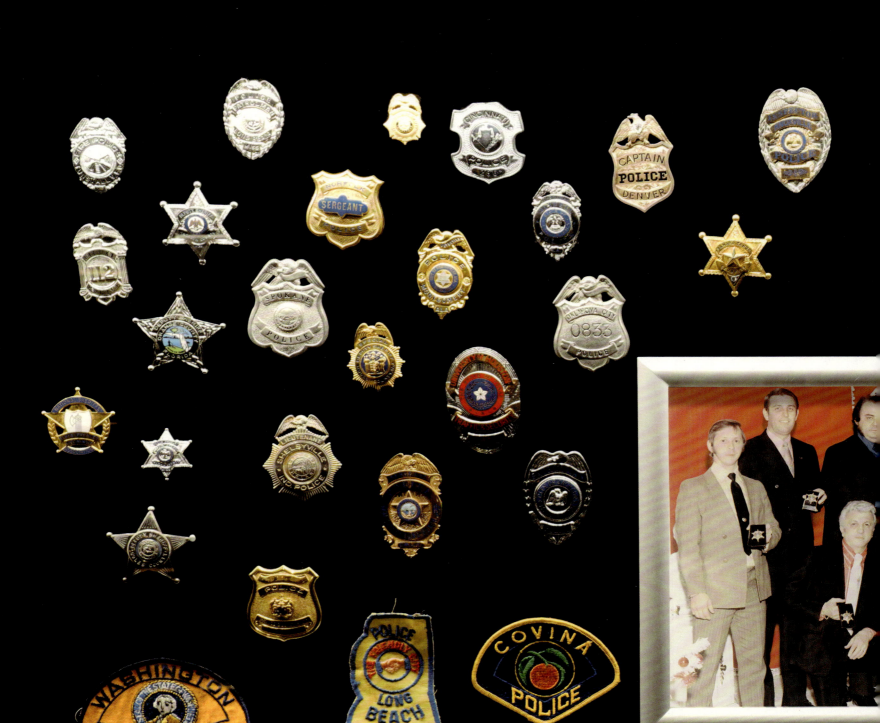

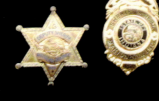

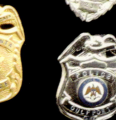
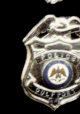
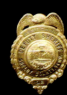

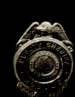
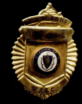

Below: Elvis and his entourage pose in the living room at Graceland with the police badges they received from Shelby County Sheriff Nixon. Standing (left to right): Billy Smith, Bill Morris, Lamar Fike, Jerry Schilling, Sheriff Roy Nixon, Vernon Presley, Charlie Hodge, Sonny West, George Klein, Marty Lacker. Front (left to right): Dr. George Nichopolos, Elvis, Red West, December 28, 1970.

Elvis was especially close to the police in his hometown, and proudly carried his Reserve Captain badge from the Memphis PD, along with an accompanying ID card, in a special wallet (opposite page). He was also made a Deputy Sheriff of Shelby County (where Memphis is located) and received this star-shaped badge a week after his historic meeting with President Nixon.

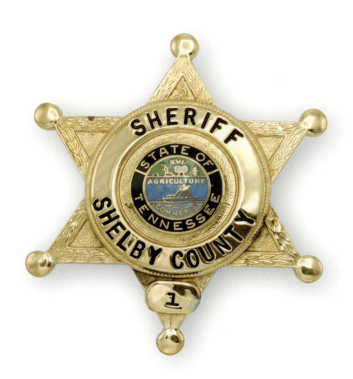

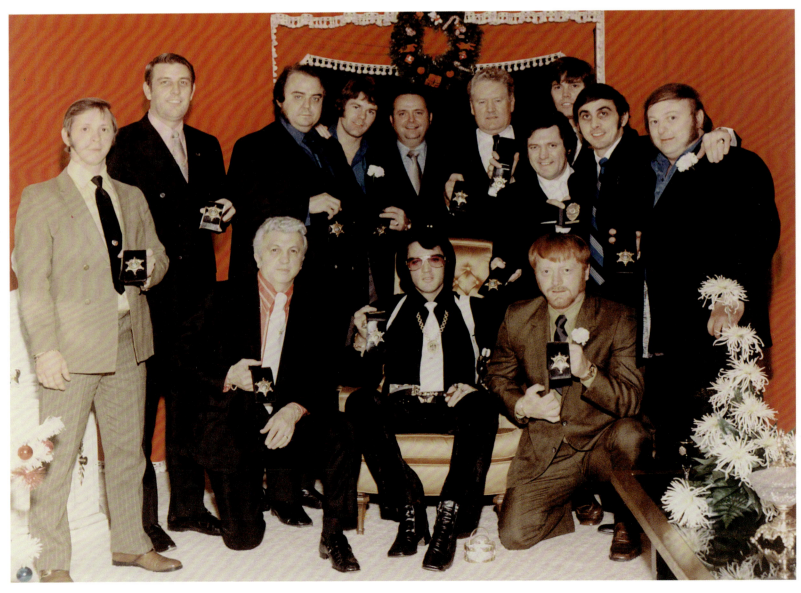

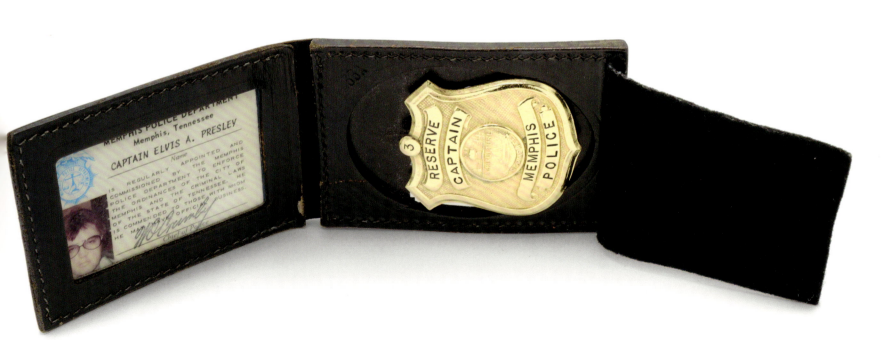

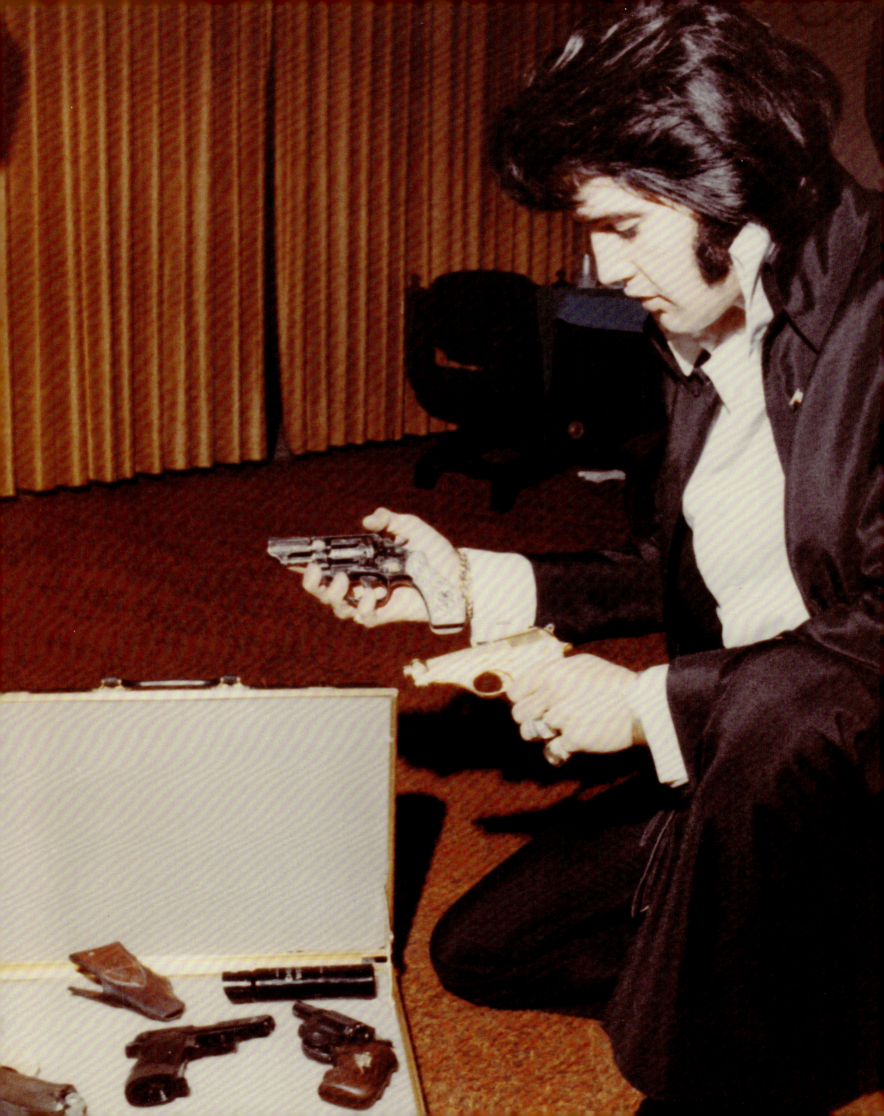

THE GOLD BERETTA

THE MAN WITH THE GOLD GUN

There's more than one photo of Elvis brandishing a toy gun as a child, so it's no surprise that his interest carried over into adulthood, when he was able to buy the real thing. Elvis owned numerous guns, both handguns and rifles, some for his personal use, others as collector's items. This Pietro Beretta Gardone VT handgun is gold-plated, and also features a mother-of-pearl handle. "Gardone VT" stands for "Gardone Val Trompia," and is the name of the town in northern Italy where the firearm was made. This gun was a favorite of Elvis's, and he was frequently photographed with it.

Opposite page: Elvis showing off his firearms collection (the Beretta is in his left hand), 1973.

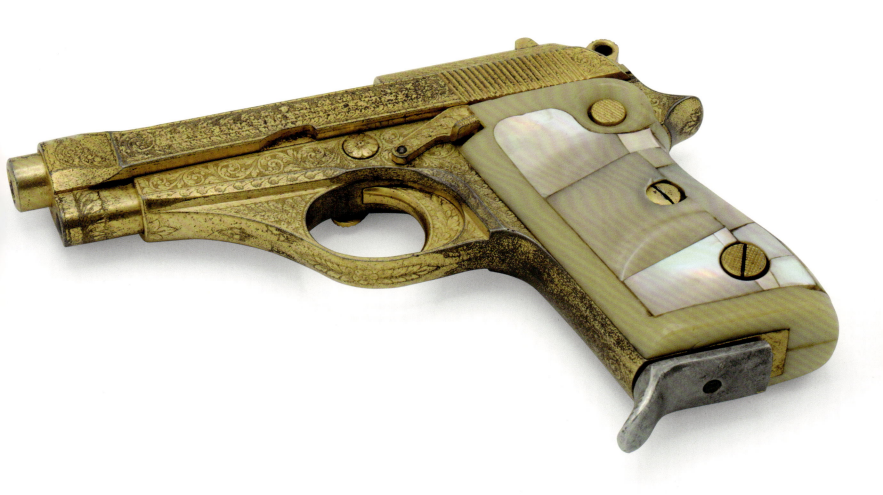

▼ *PRESIDENTIAL CUFFLINKS, SUIT, NARCOTICS BADGE* ▼

THE PRESIDENT WILL SEE MR. PRESLEY

December 21, 1970, was one of the most remarkable days in Elvis's life, when a spur of the moment letter led to his getting a private audience with President Richard Nixon. Elvis was flying to Washington, D.C., and during the flight he struck up a conversation with Senator George Murphy. Afterward, feeling inspired, Elvis wrote a letter to President Nixon, offering his services to help bring the country together, dropping the letter off at the White House gates when he arrived in D.C.

The letter went up the chain of command, and Elvis was invited to meet with the president later that day. When talking about how Elvis could speak to young people about the dangers of drugs, Elvis said he'd be interested in acquiring a badge from the Bureau of Narcotics and Dangerous Drugs. Nixon agreed to get him one. Elvis was so happy, he hugged the president, to Nixon's surprise. He then introduced the president to two friends he had with him, Jerry Schilling and Sonny West, all of whom were given various souvenirs with the presidential seal on them—including these cufflinks. The BNDD badge became one of Elvis's most prized possessions.

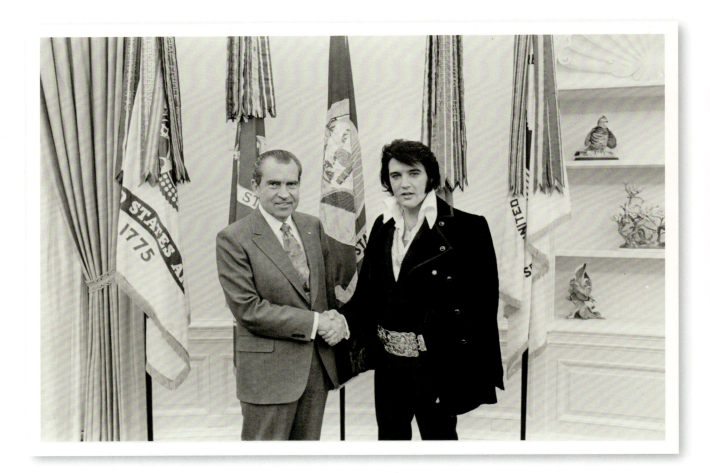

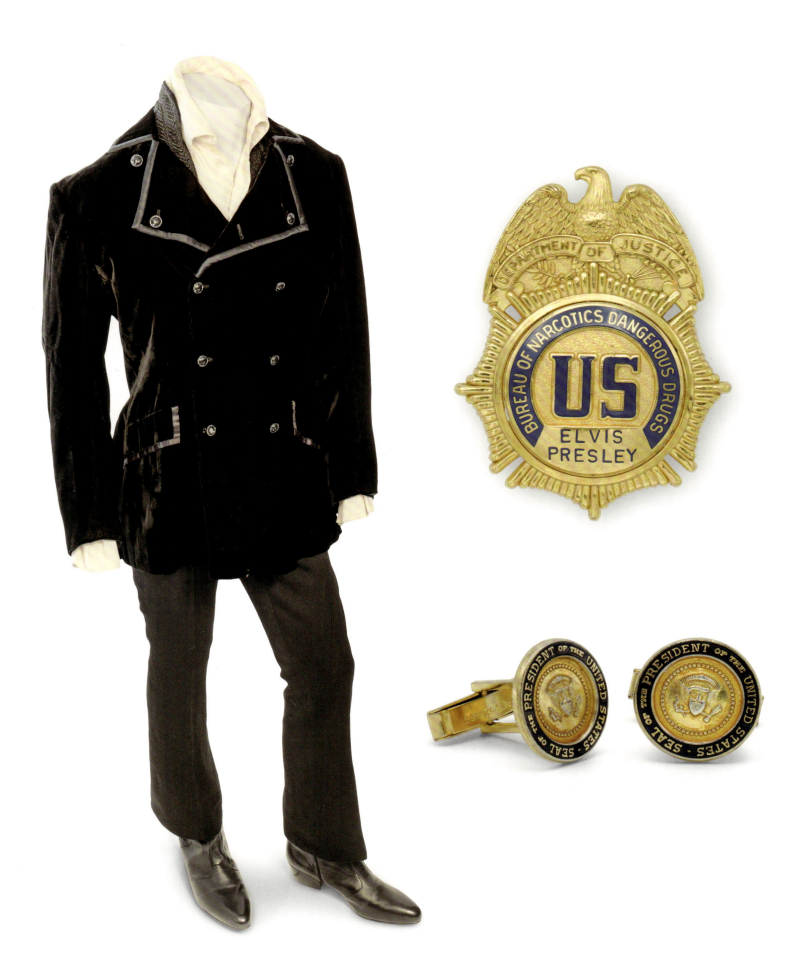

ELVIS'S BOOKS

⭐ DEDICATED READER

Two books from Elvis's extensive library show the range of subjects he was interested in. *The Prophet* is a collection of prose poetry by Kahlil Gibran, and it discusses the different facets of the human condition: the nature of relationships, the joys of existence, the importance of self-knowledge. First published in 1923, it's since been translated into more than 100 languages and is one of the best-selling books of all time, selling more than nine million copies in the US alone. It was one of Elvis's favorite books, and he underlined several passages in his copy and made notations in the margins. *To Seek a Newer World* was Senator Robert F. Kennedy's 1967 book in which he discussed his views on the issues of the day: racial injustice, nuclear power, the war in Vietnam. On June 4, 1968, Elvis was in Steve Binder's office working on the Comeback Special when the news came on the television that Kennedy had been shot (he died on June 6). The event struck an emotional chord in Elvis, who accompanied himself on guitar as he shared stories about his life with Binder and the show's writers. It was an illuminating moment for them, and they vowed to have the special explore Elvis's personal side, something especially in evidence during the concert sequences.

To: Elvis,
from Robert Kennedy

TO SEEK A NEWER WORLD

▼ BOOK BOX ▼

⭐ THE PORTABLE LIBRARY

Elvis always had a book on hand to read. He was the kind of reader who not only enjoyed reading, he also liked sharing his latest interest with his friends, telling them what he was currently reading and regularly giving out copies of his favorite books. And it was no different when he traveled. This personalized case was used to take his books from place to place while he was on tour, flying on the *Lisa Marie*. Elvis had purchased the plane, a Convair 880 that was previously part of Delta Airlines' fleet, on April 17, 1975. The purchase price was a quarter of a million dollars, and he spent another half million dollars on redesign and refurbishments, using the same company that customized Air Force One. He endeavored to turn the aircraft into a "flying Graceland," and the carrying case was designed to match the plush surroundings. The case is covered with metallic gold vinyl, with Elvis's initials stenciled on the front; a classy container for one's personal library. The case was last used on Elvis's final concert tour.

Right: A collection of Elvis's books, showing his wide range of reading interests.

Opposite page: The *Lisa Marie*, now on view at Graceland.

186

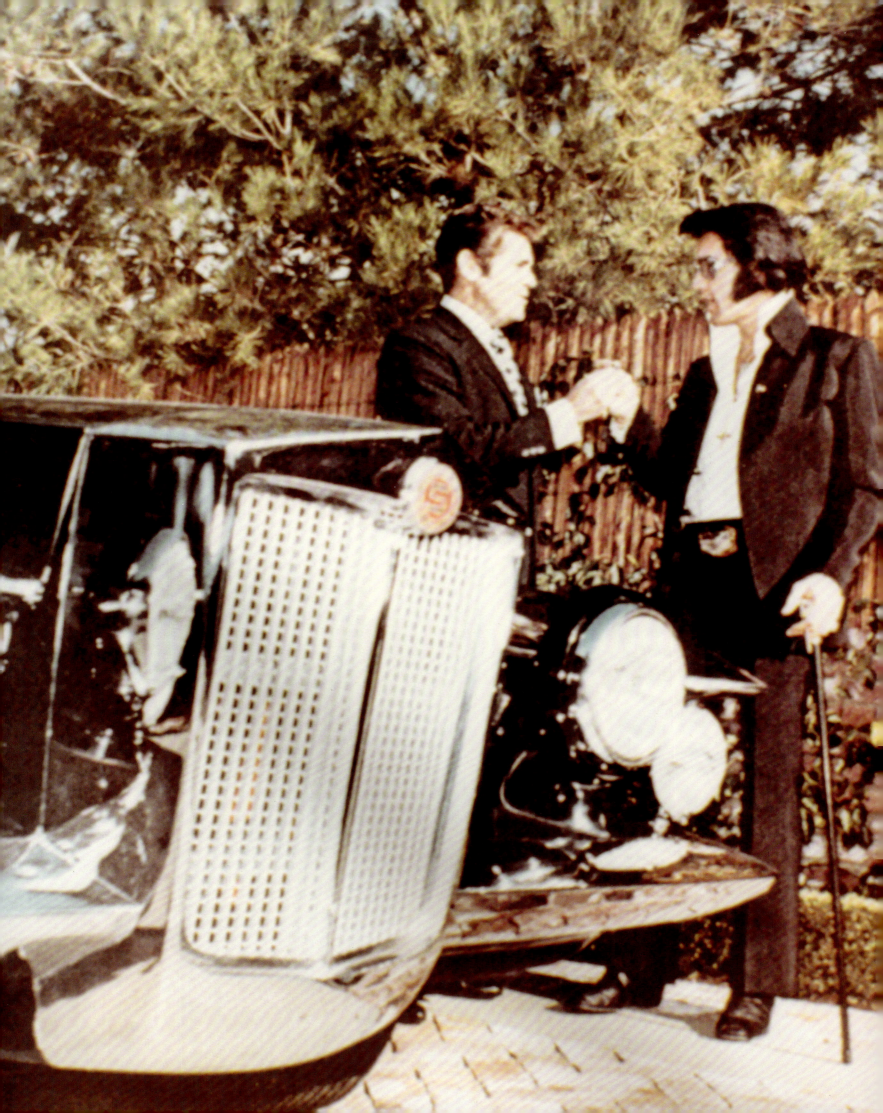

KEY TO THE STUTZ

BLACKHAWK RISING

This is the key to a very special automobile, for the Stutz Blackhawk is one of the world's most valuable luxury cars. No more than 600 were ever manufactured—and Elvis owned four of them. When Stutz dealer Jules Meyers visited Elvis in the fall of 1970 with a second prototype model of the car, Elvis was so taken with the vehicle he offered to buy it on the spot. Meyers explained it was only a prototype, but Elvis was insistent. Frank Sinatra was also interested in the car, but he wouldn't agree to Meyers' additional conditions; the car was scheduled to be shown at a few car shows, and the company also wanted pictures of Sinatra with the car. But Elvis readily agreed to both conditions and purchased the Stutz on October 9, 1970, for $26,500. The prototype car has a larger rear window than other Stutzs and can be seen at Graceland today. Elvis bought three more Stutzs, his favorite being a 1973 Stutz Blackhawk III, which he initially leased and ended up purchasing on September 6, 1974. This Stutz had a red leather interior and gold-plated trim. In the last known picture of Elvis, he's seen sitting behind the wheel of the Blackhawk III, driving through Graceland's gates in the early morning hours of August 16, 1977.

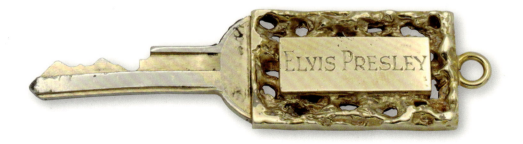

Opposite page: Elvis posing with Jules Meyers from the Pontiac dealership following the purchase of his 1971 Stutz Blackhawk, October 9, 1970.

BRIEFCASE CAR PHONE

A CALL FROM THE PRE-CELL PHONE AGE

Elvis never played James Bond in a movie, although he did follow his exploits on the silver screen (and he would later enter the realm of espionage himself in the animated series *Agent Elvis*). One element that always fascinated him was the range of gadgets used in a Bond film: a miniature rocket inside a cigarette (*You Only Live Twice*), a side mirror on a car that fires a poison dart (*Live and Let Die*), and, of course, a jetpack (*Thunderball*). A simpler device caught his eye when he saw *From Russia With Love*, where Bond makes a telephone call from his car. A phone that wasn't tethered to the kitchen wall or bedside table—what a concept! One of Elvis's Cadillacs was outfitted with a phone, but the days of portable telephones still lay in the future. That didn't stop him from looking, and, finally, in 1976, the Canyon Mark 900 portable briefcase phone was released. It wasn't exactly lightweight; together, the case and phone weighed almost 17 pounds. And you didn't just pick up the receiver and dial; Elvis wrote out precise instructions on how to use the device (below). But, being able to take your phone with you and make a call from wherever you were was a decided thrill in the days before cell phones.

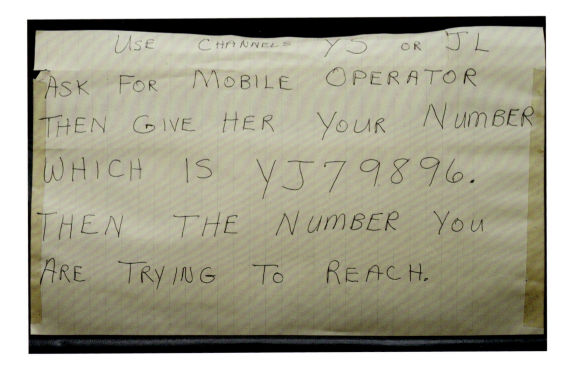

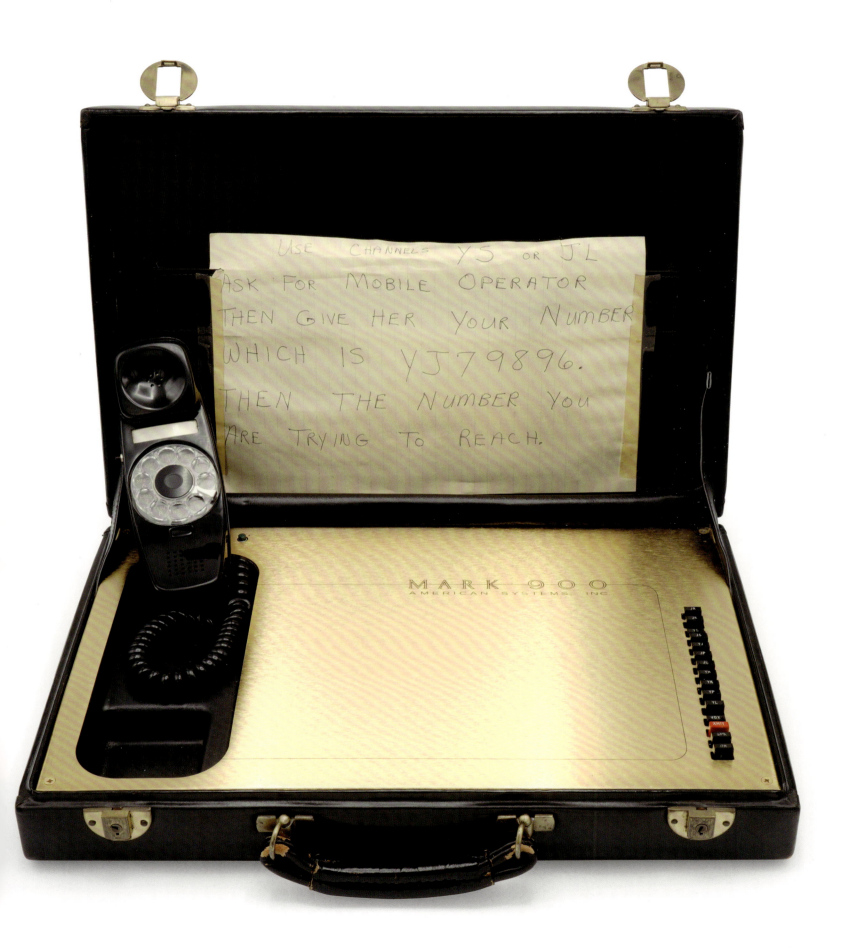

TURNTABLE AND RECORD

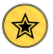

SWEET, SWEET SPIRIT

There was more than one record player at Graceland. Elvis always wanted to make sure there was a player close by so he could hear music wherever he was in the house. And this turntable, manufactured by United Audio, still has the last record Elvis ever played on it: an album by J. D. Sumner and the Stamps. J. D. Sumner was a gospel singer who got his start with the Sunny South Quartet in 1945. He joined the Blackwood Brothers in 1954, which is when he met Elvis, sometimes letting him in backstage to the group's shows when Elvis had no money to pay for a ticket. He later joked that after Elvis became famous, he returned the favor, letting Sumner in backstage to his shows. Sumner later managed the Stamps Quartet, joining the group in 1965, which then became J. D. Sumner and the Stamps. In 1971, Elvis hired the group to be his male backing singers on stage and in the studio. Elvis loved having Sumner step out for a solo spot during performances, demonstrating just how low a note he could sing. The record on the turntable is an acetate, without its final label, but it's likely to be the Stamps' 1977 album *Street Corner Preacher*.

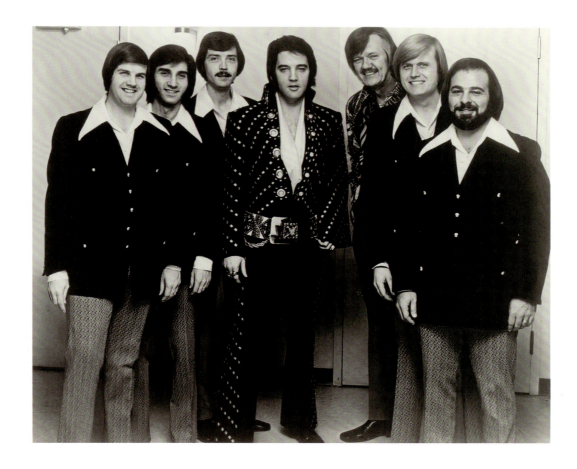

Elvis with J. D. Sumner and the Stamps Quartet, c. 1973.

▼ ELVIS'S LAST WALLET ▼

⭐ CLOSE TO HIS HEART

Wallets serve a practical purpose—they're a handy way to carry around your ID, credit cards, and cash. But they can also hold personal items: small souvenirs, mementos, and photos of loved ones. This wallet, which was the last that Elvis carried, has the kind of things you might find in anyone's wallet, such as a BankAmericard and a Blue Cross insurance card. There are also a few items specific to Elvis, namely, his American Guild of Variety Artists card and a police ID card. But the most personal items are the photos, and the only photos in this wallet are two pictures of Lisa Marie, one on her own, and the other of her being held in her father's arms. Nothing made Elvis happier than being able to spend time with his daughter, and when she wasn't with him, looking at her picture could always bring a smile to his face.

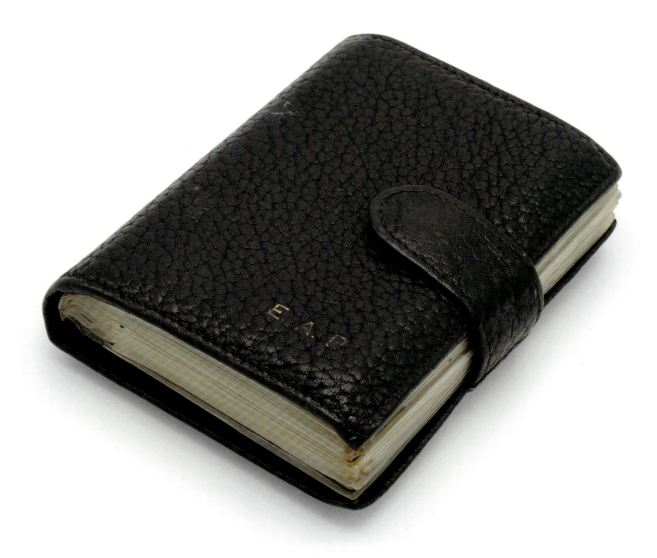

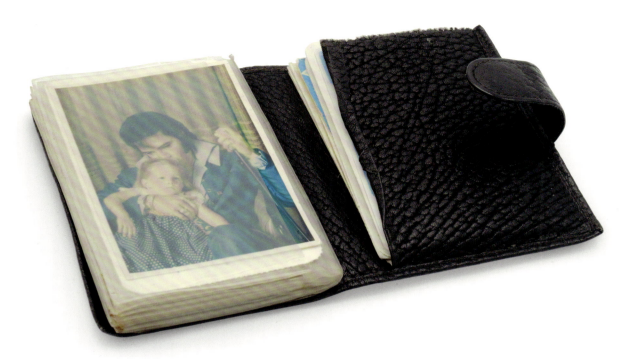
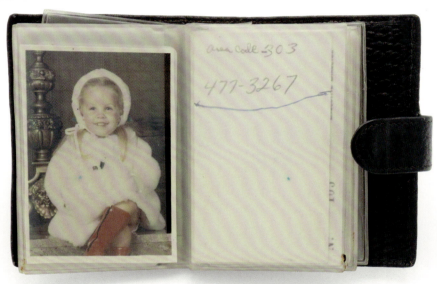
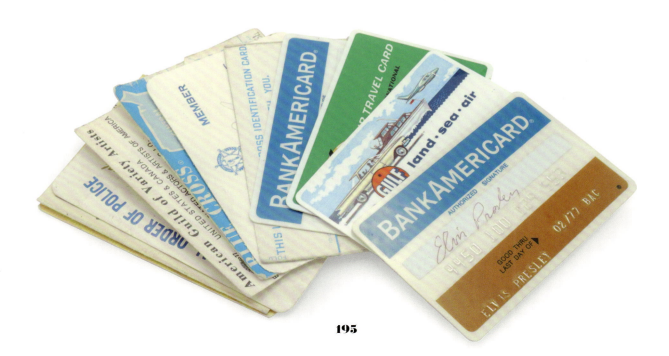

195

PART 8 HONORING THE KING

▼ MEMORIAL BOOK ▼

🎵 IN TRIBUTE

Elvis died at his beloved home, Graceland, on August 16, 1977; the cause was heart failure. He was 42 years old. His death was sudden and unexpected, and the world mourned his passing. "Elvis Presley's death deprives our country of a part of itself," President Jimmy Carter said in a public statement. "He was a symbol to people the world over of the vitality, rebelliousness, and good humor of his country." The service was held on August 18 at Graceland, after which Elvis was interred at the Forest Hill Cemetery. Elvis and his mother would later be moved to Graceland's Meditation Garden. This book of Memorial Tributes features signatures from visiting guests during that sad time, including Joe Moscheo of the gospel group the Imperials, who toured and recorded with Elvis in the 1970s; Master Kang Rhee, one of Elvis's karate instructors; Bitsy Mott, Colonel Parker's brother-in-law, who provided security for Elvis; and Caroline Kennedy, the daughter of President John F. Kennedy.

Previous page: Elvis's star on the Hollywood Walk of Fame in Los Angeles, California.

Below: Flowers placed by fans at Elvis's funeral, August 18, 1977.

199

GOSPEL HALL OF FAME AWARD

In 2001, the Gospel Music Association (GMA) inducted Elvis into its Gospel Music Hall of Fame. The GMA was founded in 1964 "to foster an appreciation for the historical development of gospel music and its impact on our culture," as its website puts it. And inducting Elvis into the Hall of Fame was meant to highlight his great love of gospel. The first sacred recording he released was the *Peace in the Valley* EP (1957), and over the course of his career, he recorded more than 50 sacred numbers. Most such songs appeared on the albums *His Hand in Mine* (1960), *How Great Thou Art* (1967), and *He Touched Me* (1972). But sacred material also appeared in his movies ("Swing Down Sweet Chariot" from *The Trouble With Girls [And How to Get Into It]*), the gospel segment in the "Comeback Special," and in a sequence where he's seen singing gospel numbers with J. D. Sumner and the Stamps in the documentary *Elvis On Tour*. Gospel music was Elvis's first love, and being inducted into the Gospel Hall of Fame was an honor he richly deserved.

> " If Elvis was alive and here getting this honor, I would anticipate doing some gospel singing after the show that would last until Thursday or Friday."
>
> —Ed Enoch of the gospel quartet The Stamps, one of three gospel quartets who inducted Elvis into the Hall of Fame

▼ COUNTRY MUSIC HALL OF FAME AWARD ▼

SMALL TOWN SOUTHERN MAN

Though he's the King of Rock 'n' Roll, Elvis's first hits were as a country artist. His first success came when his Sun Records singles "Baby Let's Play House" and "I Forgot to Remember to Forget" reached the Top 20 on *Billboard*'s country charts. It's where Elvis's releases always found a warm welcome throughout his career, with "There Goes My Everything," "I've Got a Thing About You Baby," *From Elvis in Memphis*, and, of course, *Elvis Country* all hitting the Top 10 on the country charts. Elvis's roots were in country music. When he first started performing in the 1950s, he gave younger country fans something new to listen to; even Bill Monroe stated he liked Elvis's uptempo cover of Monroe's "Blue Moon of Kentucky," which appeared on Elvis's first single (on the flipside of "That's All Right"). And he paved the way for those who followed as well. As the Country Music Hall of Fame's website puts it, "Presley opened the door for younger country singers, such as Marty Robbins, Sonny James, and Johnny Cash to reach a wider market." Elvis was inducted into the Country Music Hall of Fame in 1998.

ROCK AND ROLL HALL OF FAME AWARD

When the first inductees into the Rock and Roll Hall of Fame were announced in 1985, it was no surprise that Elvis was among them; one could even say there wouldn't have been a "Rock Hall" without his accomplishments. The Rock and Roll Hall of Fame Foundation was established in 1983 by Atlantic Records founder Ahmet Ertegun, who then put together a team of industry professionals, dedicated to preserving and promoting the legacy of rock music. The first induction ceremony was held on January 23, 1986, at the Waldorf-Astoria in New York City. Elvis was inducted by John Lennon's sons Julian and Sean, Julian speaking about how much his father had loved Elvis's music. The award was accepted on behalf of the family by George Klein, the Memphis DJ and television presenter who'd gone to high school with Elvis, and Jack Soden, President and CEO of Elvis Presley Enterprises. The Rock and Roll Hall of Fame museum opened in Cleveland in 1995, and it features the largest public collection of Elvis artifacts outside of Graceland.

> " Elvis Presley wasn't a star— he was a damned galaxy!"
>
> —Elvis's oldest and dearest friend, George Klein, in his speech inducting Elvis into the Rock and Roll Hall of Fame

Following page: Elvis in the music room of Graceland.

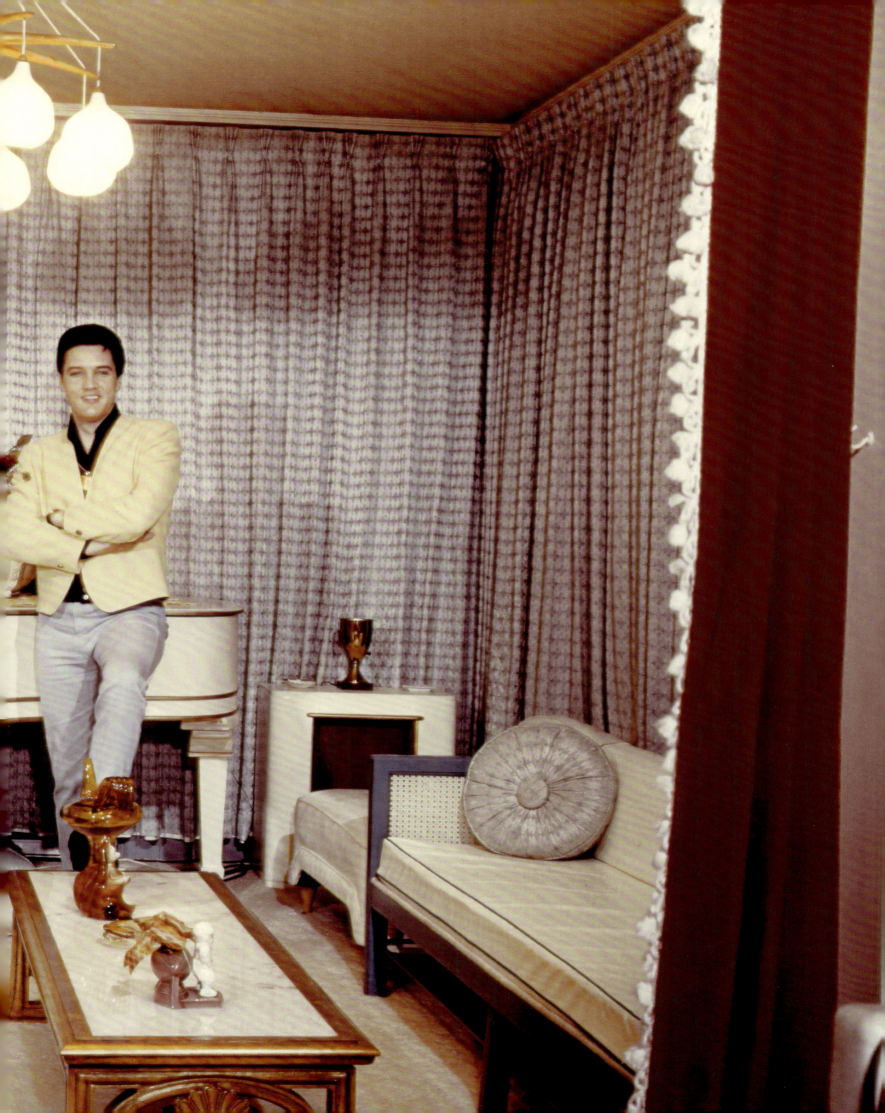

THE ELVIS CHRONOLOGY
A TIMELINE OF ELVIS'S LIFE AND LEGACY

JANUARY 8, 1935
Elvis Aaron Presley is born to Vernon and Gladys Presley in Tupelo, Mississippi.

OCTOBER 3, 1945
Elvis gives his first performance at the age of 10 at the Mississippi-Alabama Fair and Dairy Show.

1946
Elvis buys his first guitar for just $7.90.

1947
Radio host "Mississippi Slim" invites Elvis to sing on the air.

1948
The Presley family relocates to Memphis.

1950
Under the tutelage of neighbor Lee Denson, Elvis forms a rockabilly group with brothers Dorsey and Johnny Burnette.

1953
Elvis graduates high school.

1953
Elvis records "My Happiness" and "That's When Your Heartaches Begin" as a gift for his mother at Memphis Recording Service.

JULY 5, 1954
Elvis meets Sam Phillips at Memphis Recording Service (later Sun Records) and records "That's All Right" and "Blue Moon of Kentucky," his first single.

JULY 17, 1954
Elvis, with Scotty Moore and Bill Black, give their first performance at the Bon Air club.

1940 — 1950

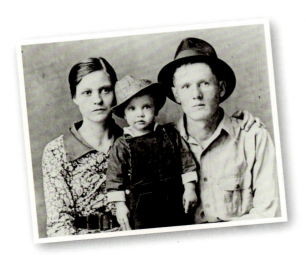

1955
Elvis meets Colonel Tom Parker, who would become his manager until his death.

OCTOBER 2, 1954
Elvis performs at the Grand Ole Opry.

MARCH 3, 1955
Elvis makes his first television appearance, on KSLA-TV.

NOVEMBER 21, 1955
Elvis signs with RCA Victor, which acquired his Sun contract for $40,000.

JANUARY 27, 1956
"Heartbreak Hotel," Elvis's first single for RCA, is released.

MARCH 23, 1956
RCA Victor releases Elvis's debut album, *Elvis Presley*.

MAY 1956
Elvis Presley becomes first Rock 'n' Roll album to top the *Billboard* chart, holding that position for 10 weeks.

NOVEMBER 1954
Elvis appears on the *Louisiana Hayride* for the first time.

1955
Elvis signs a management contract with Hank Snow Productions; Colonel Tom books Elvis for Hank Snow's February tour.

AUGUST 1955
Elvis appoints Colonel Parker his "special adviser."

JANUARY 28, 1956
Elvis appears on CBS's *Stage Show*.

APRIL 3, 1956
Elvis appears on NBC's *The Milton Berle Show*.

MAY 1956
Elvis signs a seven-year contract with Paramount Pictures.

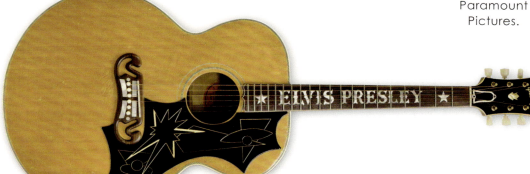

209

AUGUST 18, 1956
Single containing "Hound Dog" and "Don't Be Cruel" first tops the charts and holds that position for 11 weeks, a record that wouldn't be broken for 36 years.

DECEMBER 4, 1956
Elvis visits Sam Phillips at Sun studios and records an impromptu session with Johnny Cash, Carl Perkins, and Jerry Lee Lewis, who were dubbed the "Million Dollar Quartet." The recording wouldn't be released for 25 years.

MARCH 24, 1958
Elvis is drafted into the Army and is stationed at Fort Hood, Texas, before being deployed to Friedberg, Germany.

JUNE 1956
"Heartbreak Hotel" becomes Elvis's first Number 1 hit.

MARCH 19, 1957
Elvis purchases Graceland.

AUGUST 14, 1958
Gladys Presley dies of heart failure at the age of 46.

AUGUST 1956
A judge in Jackson, Florida, orders Elvis to tame his act.

SEPTEMBER 9, 1956
Elvis appears on *The Ed Sullivan Show*, breaking the record for the highest viewing audience (60 million viewers, about 82.6 percent of the viewing audience).

OCTOBER 15, 1957
Elvis' Christmas Album is released, which would become the highest-selling Christmas album ever in the US.

SEPTEMBER 13, 1959
While stationed in Germany, Elvis meets Priscilla Beaulieu at a party.

JULY 2, 1958
The movie *King Creole* is released and is a Top 5 film at the box office. It will come to be known as one of Elvis's best movies.

NOVEMBER 15, 1956
Elvis makes his film debut in *Love Me Tender*.

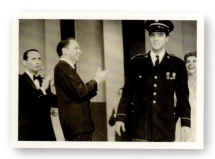

MARCH 5, 1960
Elvis is honorably discharged from the Army.

DECEMBER 1966
Elvis proposes to Priscilla.

DECEMBER 3, 1968
The television special *Elvis* airs on NBC. It is one of the biggest hits of the year, receiving 40 percent of the viewing audience. (The show is later called the '68 Comeback Special). It is his first performance before a live audience since 1961.

FEBRUARY 1961
RCA Victor presents Elvis with a plaque certifying worldwide sales of more than 75 million records.

MAY 1, 1967
Elvis marries Priscilla in Las Vegas.

JULY 31, 1969
Elvis begins a 4-week, 57-show engagement at the International Hotel in Las Vegas. It breaks all Las Vegas attendance records and Elvis receives rave reviews. He would go on to give 636 sold-out performances at the hotel from 1969 to 1977.

1960

MAY 12, 1960
Elvis appears as a guest on *The Frank Sinatra Timex Show*, also known as "Welcome Home Elvis."

1967
Elvis wins his first Grammy Award for Best Sacred Performance for the album *How Great Thou Art*.

JUNE 1969
From Elvis in Memphis is released, Elvis's first non-soundtrack album in eight years.

FEBRUARY 1, 1968
Lisa Marie Presley is born.

MARCH 25, 1961
Elvis performs a benefit concert for a Pearl Harbor memorial, which would be his last live performance for seven years.

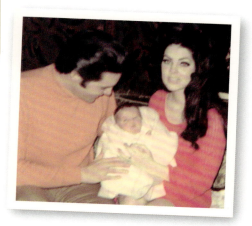

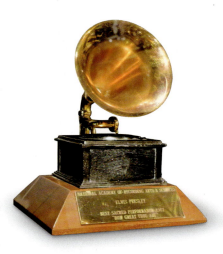

1970

NOVEMBER 11, 1969
Elvis's thirty-first film, *Change of Habit*, is released. It is his last acting role in a major motion picture.

SEPTEMBER 7, 1970
Elvis embarks on a week-long concert tour, largely of the South, his first since 1958.

1971
Elvis becomes the first rock and roll singer to be awarded the Grammy Lifetime Achievement Award (then known as the Bing Crosby Award).

APRIL 1972
The gospel album *He Touched Me* earns Elvis his second Grammy Award for Best Inspirational Performance.

FEBRUARY 23, 1972
Elvis and Priscilla separate.

AUGUST 1969
"Suspicious Minds" is released and becomes Elvis's first US Number 1 hit in more than seven years. It would be his last.

FEBRUARY 1970
Elvis performs six attendance-record–breaking shows at the Houston Astrodome.

DECEMBER 21, 1970
Elvis meets with President Richard Nixon at the White House, to request that he be made a "Federal Agent-at-Large" in the Bureau of Narcotics and Dangerous Drugs.

JANUARY 1971
The city of Memphis names the stretch of Highway 51 South on which Graceland is located "Elvis Presley Boulevard."

1972
"Burning Love" is released. It would be Elvis's last Top 10 hit in the US.

1973
Elvis performs 168 concerts, his busiest year.

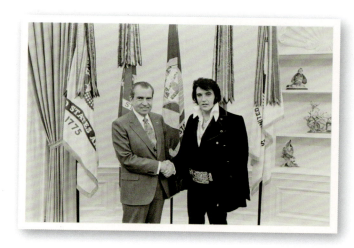

JANUARY 14, 1973
"Elvis: Aloha from Hawaii—Via Satellite" makes television history as the first concert by a solo artist to be televised globally. Airing of it in the US is delayed until April because it conflicted with the Super Bowl, but when aired, it is viewed by 57 percent of households, more than watched the moon landing. The special ultimately will be seen by 1.5 billion people.

JUNE 6, 1977
"Way Down," the last single to come out during Elvis's life, is released.

MARCH 1, 1975
"How Great Thou Art" wins Elvis his third competitive Grammy, for Best Inspirational Performance.

JUNE 26, 1979
Vernon Presley dies in Memphis.

OCTOBER 9, 1973
Elvis and Priscilla divorce.

AUGUST 16, 1977
Elvis dies at Graceland at the age of 42.

FEBRUARY 1973
The double album *Aloha from Hawaii* goes to Number 1 in the US and sells more than 5 million copies. It is Elvis's last US Number 1 pop album released during his lifetime.

APRIL 1975
Elvis purchases a Convair 880 jet and names it the "Lisa Marie."

OCTOBER 2, 1977
Elvis's and his mother's bodies are interred at Graceland.

JUNE 26, 1977
Elvis performs his last concert in Indianapolis, Indiana.

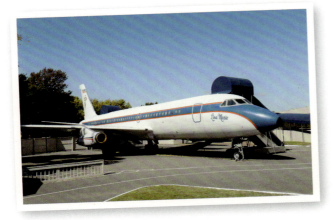

213

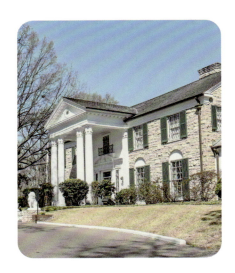

JANUARY 8, 1993
The US Postal Service releases the now-iconic Elvis postage stamps.

NOVEMBER 6, 2001
Elvis is inducted into the Gospel Music Hall of Fame.

JUNE 7, 1982
Graceland is opened to the public.

1998
Elvis is inducted into the Country Music Hall of Fame.

2006
Elvis is inducted into the Grammy Hall of Fame.

1980 1990 2000

1984
Elvis's record sales top 1 billion worldwide.

1997
Elvis is inducted into the Rockabilly Hall of Fame.

MARCH 27, 2006
Graceland is named a National Historic Landmark.

JANUARY 23, 1986
Elvis is the first person inducted into the Rock & Roll Hall of Fame.

2015
Elvis is inducted into the National Rhythm & Blues Hall of Fame.

214

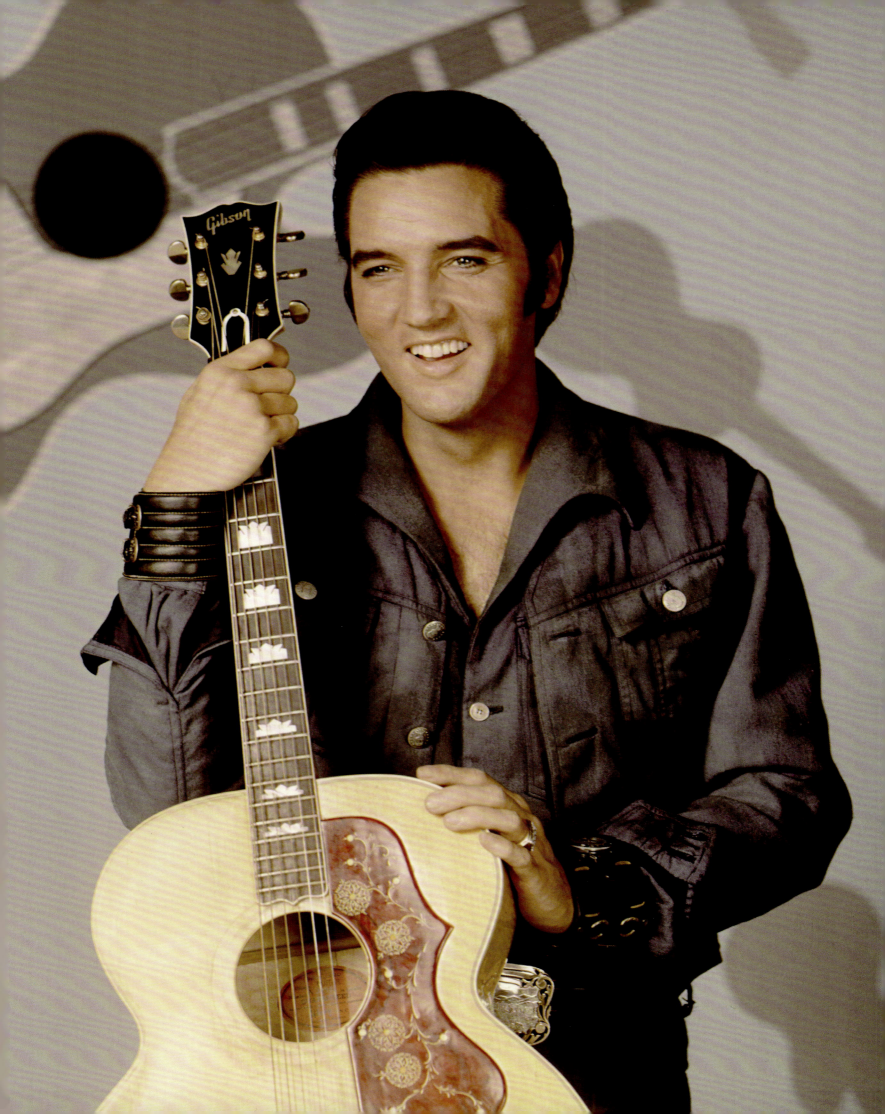

DISCOGRAPHY

1954

SINGLES
That's All Right
Blue Moon of Kentucky
July 19 / Sun

Good Rockin' Tonight
I Don't Care If the Sun Don't Shine
September 25 / Sun
CERTIFICATION: GOLD

1955

SINGLES
Milkcow Blues Boogie
You're a Heartbreaker
January 8 / Sun

Baby, Let's Play House
I'm Left, You're Right, She's Gone
April 10 / Sun

I Forgot to Remember to Forget
Mystery Train
August 20 / Sun

1956

ALBUMS

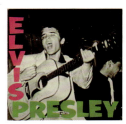

ELVIS PRESLEY
(Studio Album)
March 23 / RCA Victor
CERTIFICATION: PLATINUM

ELVIS PRESLEY (DOUBLE EP)
(EP Album)
March 23 / RCA Victor

ELVIS PRESLEY
(EP Album)
April 20 / RCA Victor
CERTIFICATION: GOLD

HEARTBREAK HOTEL
(EP Album)
April 20 / RCA Victor
CERTIFICATION: GOLD

ELVIS PRESLEY
(EP Album)
June 8 / RCA Victor
CERTIFICATION: GOLD

THE REAL ELVIS
(EP Album)
August 17 / RCA Victor
CERTIFICATION: PLATINUM

ANY WAY YOU WANT ME
(EP Album)
September 5 / RCA Victor

ELVIS
(Studio Album)
October 19 / RCA Victor
CERTIFICATION: PLATINUM

ELVIS VOL. 1
(EP Album)
October 19 / RCA Victor
CERTIFICATION: 2 X PLATINUM

ELVIS VOL. 2
(EP Album)
October 19 / RCA Victor
CERTIFICATION: GOLD

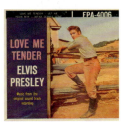

LOVE ME TENDER
(EP Album)
November 1 / RCA Victor
CERTIFICATION: PLATINUM

SINGLES
Just Because
Blue Moon
August 31 / RCA Victor

Heartbreak Hotel
I Was the One
January 27 / RCA Victor
CERTIFICATION: 2 X PLATINUM

I Got a Woman
I'm Counting on You
March 23 / RCA Victor

I'll Never Let You Go (Little Darlin')
I'm Gonna Sit Right Down and Cry (Over You)
March 23 / RCA Records

I Want You, I Need You, I Love You
My Baby Left Me
May 4 / RCA Victor

Don't Be Cruel
Hound Dog
July 13 / RCA Victor

Tryin' to Get to You
I Love You Because
August / RCA Victor

Money Honey
One Sided Love Affair
August / RCA Victor

Blue Suede Shoes
Tutti Frutti
September 8 / RCA Victor

Love Me Tender
Any Way You Want Me (That's How I'll Be)
September 14 / RCA Victor
CERTIFICATION: 3 X PLATINUM

Paralyzed
When My Blue Moon Turns to Gold Again
October 19 / RCA Victor

1957

ALBUMS
STRICTLY ELVIS
(EP Album)
January 25 / RCA Victor

PEACE IN THE VALLEY
(EP Album)
April 11 / RCA Victor
CERTIFICATION: PLATINUM

LOVING YOU
(Soundtrack Album)
June 20 / RCA
CERTIFICATION: GOLD

LOVING YOU, VOL. I
(EP Album)
June 20 / RCA Victor
CERTIFICATION: GOLD

LOVING YOU, VOL. II
(EP Album)
June 20 / RCA Victor
CERTIFICATION: PLATINUM

JUST FOR YOU
(EP Album)
August 21 / RCA Victor
CERTIFICATION: PLATINUM

ELVIS' CHRISTMAS ALBUM
(Studio Album)
October 15 / RCA Victor
CERTIFICATION: 3 X PLATINUM

ELVIS SINGS CHRISTMAS SONGS
(EP Album)
October 16 / RCA Victor
CERTIFICATION: PLATINUM

JAILHOUSE ROCK
(EP Album)
October 30 / RCA Victor
CERTIFICATION: 2 X PLATINUM

OLD SHEP
(EP Album)
November / RCA Victor

SINGLES
Too Much
Playing for Keeps
January 4 / RCA Victor

All Shook Up
That's When Your Heartaches Begin
March 22 / RCA Victor
CERTIFICATION: 2 X PLATINUM

(Let Me Be Your) Teddy Bear
Loving You
June 11 / RCA Victor

Party [R]
Got a Lot o' Livin' to Do
September / RCA Victor

Jailhouse Rock
Treat Me Nice
September 24 / RCA Victor
CERTIFICATION: 2 X PLATINUM

Santa Bring My Baby Back (To Me) [S]
Santa Claus Is Back in Town
October 15 / RCA Victor

1958
ALBUMS

ELVIS' GOLDEN RECORDS
(Compilation Album)
March 21 / RCA Victor
CERTIFICATION: 6 X PLATINUM

KING CREOLE VOL. 1
(EP Album)
July 15 / RCA Victor
CERTIFICATION: PLATINUM

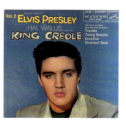

KING CREOLE VOL. 2
(EP Album)
July 29 / RCA Victor
CERTIFICATION: PLATINUM

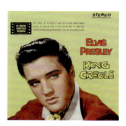

KING CREOLE
(Soundtrack Album)
September 19 / RCA
CERTIFICATION: GOLD

ELVIS SAILS
(EP Album)
November 18 / RCA Victor

SINGLES
Don't
I Beg of You
January 7 / RCA Victor

Wear My Ring Around Your Neck
Doncha' Think It's Time
April 7 / RCA Victor

Hard Headed Woman
Don't Ask Me Why
June 10 / RCA Victor

King Creole [X]
Dixieland Rock
September / RCA

One Night
I Got Stung
October 21 / RCA Victor

1959
ALBUMS
FOR LP FANS ONLY
(Compilation Album)
February 6 / RCA Victor

A TOUCH OF GOLD VOL. 1
(EP Album)
April 21 / RCA Victor

A DATE WITH ELVIS
(Compilation Album)
July 24 / RCA Victor

A TOUCH OF GOLD VOL. 2
(EP Album)
September 9 / RCA Victor

CHRISTMAS WITH ELVIS
(EP Album)
October 13 / RCA Victor

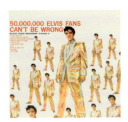

50,000,000 ELVIS FANS CAN'T BE WRONG: ELVIS' GOLD RECORDS, VOLUME 2
(Compilation Album)
November 13 / RCA Victor
CERTIFICATION: PLATINUM

SINGLES
(Now and Then There's) A Fool Such as I
I Need Your Love Tonight
March 10 / RCA Victor

A Big Hunk o' Love
My Wish Came True
June 23 / RCA Victor

1960
ALBUMS
A TOUCH OF GOLD VOL. 3
(EP Album)
February / RCA Victor

ELVIS IS BACK!
(Studio Album)
April 8 / RCA Victor
CERTIFICATION: GOLD

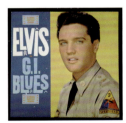

G.I. BLUES
(Soundtrack Album)
September 23 / RCA
CERTIFICATION: PLATINUM

HIS HAND IN MINE
(Studio Album)
November 10 / RCA Victor
CERTIFICATION: PLATINUM

SINGLES
Stuck on You
Fame and Fortune
March 23 / RCA Victor

It's Now or Never
A Mess of Blues
July 5 / RCA Victor
CERTIFICATION: PLATINUM

Are You Lonesome Tonight?
I Gotta Know
November 1 / RCA Victor
CERTIFICATION: 2 X PLATINUM

1961
ALBUMS
ELVIS BY REQUEST: FLAMING STAR AND 3 OTHER GREAT SONGS
(EP Album)
April 21 / RCA Victor

SOMETHING FOR EVERYBODY
(Studio Album)
May 19 / RCA Victor
CERTIFICATION: GOLD

BLUE HAWAII
(Soundtrack Album)
October 20 / RCA
CERTIFICATION: 3 X PLATINUM

SINGLES
Surrender
Lonely Man
February 7 / RCA Victor
CERTIFICATION: PLATINUM

I Feel So Bad
Wild in the Country
May 2 / RCA Victor

(Marie's the Name) His Latest Flame
Little Sister
August 8 / RCA Victor

Wooden Heart [Al]
Tonight Is So Right for Love
September 23 / RCA

Can't Help Falling in Love
Rock-A-Hula Baby
November 22 / RCA Victor
CERTIFICATION: PLATINUM

1962
ALBUMS

FOLLOW THAT DREAM
(EP Album)
April / RCA Victor
CERTIFICATION: PLATINUM

POT LUCK
(Studio Album)
June 5 / RCA Victor

KID GALAHAD
(EP Album)
August 28 / RCA Victor
CERTIFICATION: GOLD

GIRLS! GIRLS! GIRLS!
(Soundtrack Album)
November 9 / RCA
CERTIFICATION: GOLD

SINGLES
Good Luck Charm
Anything That's Part of You
February 27 / RCA Victor

She's Not You
Just Tell Her Jim Said Hello
July 17 / RCA Victor

King of the Whole Wide World
Home Is Where the Heart Is
RCA Victor

Return to Sender
Where Do You Come From
October 2 / RCA Victor
CERTIFICATION: PLATINUM

1963
ALBUMS
IT HAPPENED AT THE WORLD'S FAIR
(Soundtrack Album)
April 10 / RCA

ELVIS' GOLDEN RECORDS VOLUME 3
(Compilation Album)
August 12 / RCA Victor
CERTIFICATION: PLATINUM

FUN IN ACAPULCO
(Soundtrack Album)
November 15 / RCA

SINGLES
One Broken Heart for Sale
They Remind Me Too Much of You
January 29 / RCA Victor

(You're the) Devil in Disguise
Please Don't Drag That String Around
June 18 / RCA Victor
CERTIFICATION: GOLD

Bossa Nova Baby
Witchcraft
October 1 / RCA Victor

Mexico [AL]
You Can't Say No in Acapulco
November 15 / RCA

1964
ALBUMS

KISSIN' COUSINS
(Soundtrack Album)
April 2 / RCA
CERTIFICATION: GOLD

VIVA LAS VEGAS
(EP Album)
May / RCA Victor

ROUSTABOUT
(Soundtrack Album)
October 20 / RCA Victor
CERTIFICATION: GOLD

SINGLES
Fun in Acapulco [AM]
I Think I Am Gonna Like It Here
RCA Victor

Kissin' Cousins
It Hurts Me
February 10 / RCA Victor

Kiss Me Quick
Suspicion
April 14 / RCA Records

Viva Las Vegas
What'd I Say
April 28 / RCA
CERTIFICATION: GOLD

Such a Night
Never Ending
July 14 / RCA Victor

Ask Me
Ain't That Loving You Baby
September 22 / RCA Victor

Blue Christmas
Wooden Heart
November / RCA

1965
ALBUMS

GIRL HAPPY
(Soundtrack Album)
March 2 / RCA
CERTIFICATION: GOLD

TICKLE ME
(EP Album)
June 15 / RCA Victor

ELVIS FOR EVERYONE!
(Compilation Album)
August 10 / RCA Victor

HARUM SCARUM
(Soundtrack Album)
November 3 / RCA

SINGLES
Do the Clam
You'll Be Gone
February 9 / RCA Victor

Crying in the Chapel
I Believe in the Man in the Sky
April 6 / RCA Victor

(Such an) Easy Question
It Feels So Right
June 8 / RCA Victor

I'm Yours
(It's A) Long Lonely Highway
August 10 / RCA Victor

Puppet on a String
Wooden Heart
October 20 / RCA Victor

Tell Me Why
Blue River
December 14 / RCA Victor

1966
ALBUMS

FRANKIE AND JOHNNY
(Soundtrack Album)
April / RCA
CERTIFICATION: PLATINUM

PARADISE, HAWAIIAN STYLE
(Soundtrack Album)
June 10 / RCA

SPINOUT
(Soundtrack Album)
October 31 / RCA

SINGLES
Milky White Way
Swing Down Sweet Chariot
February 15 / RCA Victor

Frankie and Johnny
Please Don't Stop Loving Me
March 1 / RCA

Love Letters
Come What May
May 26 / RCA

Spinout
All That I Am
September 13 / RCA

If Every Day Was Like Christmas
How Would You Like to Be
November 15 / RCA Victor

1967
ALBUMS

HOW GREAT THOU ART
(Studio Album)
February 27 / RCA Victor
CERTIFICATION: 3 X PLATINUM

EASY COME, EASY GO
(EP Album)
March / RCA Victor

DOUBLE TROUBLE
(Soundtrack Album)
June 1 / RCA

CLAMBAKE
(Soundtrack Album)
October 10 / RCA Victor

SINGLES
Indescribably Blue
Fools Fall in Love
January 10 / RCA Victor

You Gotta Stop [AS]
The Love Machine
RCA

Long Legged Girl (with the Short Dress On)
That's Someone You Never Forget
April 28 / RCA Victor

There's Always Me
Judy
August 8 / RCA Victor

1968
ALBUMS

ELVIS' GOLD RECORDS VOLUME 4
(Compilation Album)
January 2 / RCA
CERTIFICATION: GOLD

ELVIS SINGS FLAMING STAR
(Compilation Album)
March 28 / RCA Camden
CERTIFICATION: PLATINUM

SPEEDWAY
(Soundtrack Album)
May 1 / RCA

ELVIS (NBC TV SPECIAL)
(Live Album)
November 22 / RCA
CERTIFICATION: PLATINUM

SINGLES
Guitar Man
High Heel Sneakers
January 3 / RCA Victor

U.S. Male
Stay Away
February 27 / RCA

Let Yourself Go
Your Time Hasn't Come Yet, Baby
May 21 / RCA Records

A Little Less Conversation
Almost in Love
September 3 / RCA Victor
CERTIFICATION: 6 X PLATINUM

If I Can Dream
Edge of Reality
December 3 / RCA Records
CERTIFICATION: GOLD

1969
ALBUMS

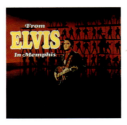

FROM ELVIS IN MEMPHIS
(Studio Album)
June 2 / RCA
CERTIFICATION: GOLD

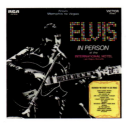

FROM MEMPHIS TO VEGAS / FROM VEGAS TO MEMPHIS
(Live Album)
October 14 / RCA
CERTIFICATION: GOLD

SINGLES
Memories
Charro
February 25 / RCA Victor

In the Ghetto
Any Day Now
April 14 / RCA Victor
CERTIFICATION: PLATINUM

Clean Up Your Own Back Yard
The Fair Is Moving On
June 17 / RCA Victor

Suspicious Minds
You'll Think of Me
August 26 / RCA Victor
CERTIFICATION: PLATINUM

Don't Cry Daddy
Rubberneckin'
November 11 / RCA Victor

1970
ALBUMS

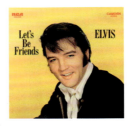

LET'S BE FRIENDS
(Compilation Album)
April / RCA Camden
CERTIFICATION: PLATINUM

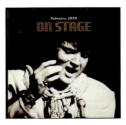

ON STAGE
(Live Album)
June / RCA
CERTIFICATION: PLATINUM

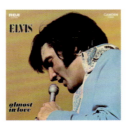

ALMOST IN LOVE
(Compilation Album)
October / RCA Camden
CERTIFICATION: PLATINUM

ELVIS' CHRISTMAS ALBUM
(Compilation Album)
October / RCA Camden
CERTIFICATION: DIAMOND (10 X PLATINUM)

ELVIS IN PERSON
(Live Album)
November / RCA
CERTIFICATION: PLATINUM

THAT'S THE WAY IT IS
(Studio Album)
November 11 / RCA
CERTIFICATION: PLATINUM

SINGLES
Kentucky Rain
My Little Friend
January 29 / RCA Victor

The Wonder of You (Live)
Mama Liked the Roses
April 20 / RCA Victor

I've Lost You
The Next Step Is Love
July 14 / RCA Victor

You Don't Have to Say You Love Me
Patch It Up
October 6 / RCA Records
CERTIFICATION: GOLD

I Really Don't Want to Know
There Goes My Everything
December 8 / RCA Victor

1971
ALBUMS

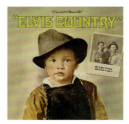

ELVIS COUNTRY (I'M 10,000 YEARS OLD)
(Studio Album)
January 7 / RCA
CERTIFICATION: GOLD

YOU'LL NEVER WALK ALONE
(Compilation Album)
March 22 / RCA Camden
CERTIFICATION: 3 × PLATINUM

LOVE LETTERS FROM ELVIS
(Studio Album)
June 16 / RCA

C'MON EVERYBODY
(Compilation Album)
July / RCA Camden
CERTIFICATION: GOLD

I GOT LUCKY
(Compilation Album)
October / RCA Camden
CERTIFICATION: PLATINUM

ELVIS SINGS THE WONDERFUL WORLD OF CHRISTMAS
(Studio Album)
October 20 / RCA
CERTIFICATION: 3 X PLATINUM

SINGLES
Rags to Riches
Where Did They Go, Lord
February 23 / RCA Victor

Life
Only Believe
April 27 / RCA Victor

I'm Leavin'
Heart of Rome
June 22 / RCA Victor

It's Only Love
The Sound of Your Cry
September 21 / RCA Victor

I Just Can't Help Believin' (Live) [AW]
How the Web Was Woven
November / RCA

1972
ALBUMS

ELVIS NOW
(Studio Album)
February / RCA
CERTIFICATION: GOLD

HE TOUCHED ME
(Studio Album)
April / RCA
CERTIFICATION: PLATINUM

ELVIS: AS RECORDED AT MADISON SQUARE GARDEN
(Soundtrack)
June / RCA
CERTIFICATION: 3 × PLATINUM

ELVIS SINGS HITS FROM HIS MOVIES, VOLUME 1
(Compilation Album)
June / RCA Camden
CERTIFICATION: PLATINUM

BURNING LOVE AND HITS FROM HIS MOVIES, VOLUME 2
(Compilation Album)
October / RCA Camden
CERTIFICATION: 2 × PLATINUM

SEPARATE WAYS
(Compilation Album)
December 1 / RCA Camden
CERTIFICATION: PLATINUM

SINGLES
Until It's Time for You to Go
We Can Make the Morning
January 4 / RCA Victor

He Touched Me
The Bosom of Abraham
February 29 / RCA Victor

An American Trilogy (Live)
The First Time Ever I Saw Your Face
April 4 / RCA Victor

Burning Love
It's a Matter of Time
August 1 / RCA Victor
CERTIFICATION: PLATINUM

Separate Ways
Always on My Mind
October 31 / RCA Victor

1973
ALBUMS

ALOHA FROM HAWAII VIA SATELLITE
(Live Album)
February 1 / RCA
CERTIFICATION: 5 × PLATINUM

ELVIS (THE "FOOL" ALBUM)
(Studio Album)
July / RCA

RAISED ON ROCK / FOR OL' TIMES SAKE
(Studio Album)
October 1 / RCA

SINGLES
Steamroller Blues (Live)
Fool
March 4 / RCA Victor

Raised on Rock
For Ol' Times Sake
August 20 / RCA

1974
ALBUMS

ELVIS: A LEGENDARY PERFORMER VOLUME 1
(Compilation Album)
January 2 / RCA
CERTIFICATION: 3 × PLATINUM

GOOD TIMES
(Studio Album)
March 20 / RCA

ELVIS RECORDED LIVE ON STAGE IN MEMPHIS
(Live Album)
July / RCA
CERTIFICATION: GOLD

HAVING FUN WITH ELVIS ON STAGE
(Spoken Word Album)
October / RCA

ELVIS' 40 GREATEST
(Compilation Album)
October / RCA

SINGLES
Take Good Care of Her
I've Got a Thing About You, Baby
January 11 / RCA

If You Talk in Your Sleep
Help Me
May 10 / RCA Victor

Promised Land
It's Midnight
September 27 / RCA Victor

1975
ALBUMS
PROMISED LAND
(Studio Album)
January 8 / RCA

PURE GOLD
(Compilation Album)
March / RCA
CERTIFICATION: 2 × PLATINUM

TODAY
(Studio Album)
May 7 / RCA

DOUBLE DYNAMITE!
(Compilation Album)
December / Pickwick
CERTIFICATION: PLATINUM

SINGLES
My Boy
Thinking About You
January 3 / RCA Victor

T-R-O-U-B-L-E
Mr. Songman
April 22 / RCA Victor

Bringing It Back
Pieces of My Life
September 20 / RCA Victor

1976
ALBUMS

ELVIS IN HOLLYWOOD
(Compilation Album)
January 7 / RCA
CERTIFICATION: PLATINUM

ELVIS: A LEGENDARY PERFORMER VOLUME 2
(Compilation Album)
January 8 / RCA
CERTIFICATION: 2 × PLATINUM

THE SUN SESSIONS
(Compilation Album)
March 22 / RCA

FROM ELVIS PRESLEY BOULEVARD, MEMPHIS, TENNESSEE
(Studio Album)
May / RCA
CERTIFICATION: GOLD

SINGLES
Moody Blue
She Thinks I Still Care
November 29 / RCA Records

1977
ALBUMS

WELCOME TO MY WORLD
(Compilation Album)
March / RCA
CERTIFICATION: PLATINUM

MOODY BLUE
(Studio Album)
June / RCA
CERTIFICATION: 2 × PLATINUM

SINGLES
Way Down
Pledging My Love
June 6 / RCA